FOOD STYLING FOR PHOTOGRAPHERS

A Guide to Creating Your Own Appetizing Art

LINDA BELLINGHAM

JEAN ANN BYBEE

WITH BRAD G. ROGERS

ELSEVIER

AMSTERDAM • BOSTON • HEIDELBERG • LONDON
NEW YORK • OXFORD • PARIS • SAN DIEGO
SAN FRANCISCO • SINGAPORE • SYDNEY • TOKYO

Focal Press is an imprint of Elsevier

Focal Press

Publisher: Marie Hooper

Acquisitions Editor: Cara Anderson

Publishing Services Manager: George Morrison

Senior Project Manager: Dawnmarie Simpson

Associate Acquisitions Editor: Asma Palmerio

Assistant Editor: Katy Stencer

Marketing Manager: Christine Degon Veroulis

Interior Design: Joanne Blank

Cover Design: Eric DeCicco

Focal Press is an imprint of Elsevier

30 Corporate Drive, Suite 400, Burlington, MA 01803, USA

Linacre House, Jordan Hill, Oxford OX2 8DP, UK

Library of Congress Cataloging-in-Publication Data

Bellingham, Linda.

Food styling for photographers : a guide to creating your own appetizing art / Linda Bellingham, Jean Ann Bybee.

p. cm.

Includes index.

ISBN-13: 978-0-240-81006-5 (pbk. : alk. paper)

1. Photography of food. 2. Photography—Miscellanea.

3. Food presentation. I. Bybee, Jean Ann. II. Title.

TR656.5.B44 2008

778′.96413—dc22

2007044859

British Library Cataloguing-in-Publication Data

A catalogue record for this book is available from the British Library.

ISBN: 978-0-240-81006-5

For information on all Focal Press publications visit our website at www.books.elsevier.com

08 09 10 11 5 4 3 2 1

Printed in China.

Dedication

To my sons, Scott and Ben, my sources of inspiration
Linda Bellingham

To my wonderful daughter, Audrey
Jean Ann Bybee

Disclaimer

The contents of this book and techniques described herein are intended solely for the purpose of preparing food for photography and are not intended for nor should they be used as methods of preparing foods for consumption.

CONTENTS

LINDA BELLINGHAM

Ever since I was young, I have been interested in the production of good-tasting and eye-tantalizing food. My first memory of working with food takes me back to the age of five when I snuck one of my mom's saucepans out into the fall garden. After coercing my dad to make a small fire in his camp stove, I proceeded to select fresh vegetables from the garden, then sliced and diced them to make my first ratatouille.

A number of instructors in both high school and college encouraged me to be creative artistically and to continue down the food path. Actually my journey to the present reminds me of a path that is built with stepping stones. As I stand on one stone, another stone of opportunity is presented to me and I get to move further down the path. I know many people have detours and forks in their career journeys, but my path has been very direct.

When I graduated from college with a bachelor's degree in home economics and education, I taught high school home economics. That job lasted two years until the first of my two sons was born. While spending a few years at home with my young children, I started a gourmet dinner club with friends. I just couldn't ignore the call to be creative with food. When events in my life forced me to seek a full-time job, I applied for work at a trendy catering business that also housed and supported a branch of the Institute of Culinary Arts where entry-level people were being trained to work in commercial kitchens. The job I applied for was a multi-hat position as instructor of the institute, chef for the catering business, and general kitchen support. Part of my interview for the job required that I do a demonstration of paté choux for the owner and the kitchen manager. I remember burning some midnight oil getting ready for the presentation, and it paid off because I was hired. I learned I would also be required to prep for and be present for some biweekly evening classes for the paying public. When my boss asked me to teach a couple of the evening classes, I knew I was doing a good job! After only a few years, the storeowner passed away and the business was dissolved. To generate income, I began making desserts at home to sell to local restaurants. One restaurant owner hired me to work as a pastry chef in his three-star restaurant. During the two years I

was there, I started my own catering business to supplement my income. The catering business was a big success. I was able to purchase a van and hire assistants. But a couple of years later when the oil business in Oklahoma took a nosedive, so did my clients' budgets for catered events. I decided to relocate to an area that was more economically diverse.

After a move to Dallas, Texas, I had the good fortune to meet a freelance food stylist who offered to be my food styling mentor. She guaranteed that during the time I worked with her, I would be introduced to photographers and art directors who might have food styling work for me in the future. She also strongly encouraged me to build a portfolio. The only thing she asked in return was that I assist her when she worked. She assured me I would make more money working with her than I could as a pastry chef. That was all I needed to hear to convince me to accept her offer. The combination of being an artsy girl and having a solid background in food, including food chemistry, nutrition, and presentation, made me a natural in the world of food styling. My career quickly progressed from assistant, to stylist, to lead stylist in the Dallas market.

I was a freelance food stylist in the Dallas commercial market for more than 20 years. When it comes to food styling, I have done it all, for both film and still pho-

tography. My client list includes many national and international food accounts: Bennigan's, Chili's, Braum's Ice Cream, Steak & Ale, Safeway, Popeye's Chicken, Sam's Club, Neiman Marcus, Harry & David, Travel Hosts, Quaker Foods, Weight Watchers, Burleson's Honey, Affiliated Foods, Fleming Foods, Fresh World Farms, Excel Beef, Earth Grain, Rainbow Bread, Fur's Cafeteria, Baskin Robbin's Ice Cream, Schlotzsky's, Wolf Brand Chili, Church's Chicken, Tony Roma, Pizza Inn, Harrigan's, Embassy Suites, Taco Tico, Del Taco, McDonald's, Long John Silver's, Taco Bueno, American Airlines, Rudy's Farm Sausage, Grandy's, Mrs. Crockett, Tyson Foods, FritoLay, and Collin Street Bakery, among others.

One of my most frequent clients, Harry & David, offered me a full-time position as stylist manager in their in-house photography studio. I accepted that offer and spent a few years working with them in Oregon. Now I am taking yet another step down my career path with the creation of this book, and I look forward to teaching seminars on food styling.

I've learned many things about food styling from various sources during my career. A great deal of my accumulated knowledge was gathered through the trial-and-error method, while some information was shared by other food stylists. However, during the last 12 years I was

called on to train several stylists and it is from those students that I learned firsthand the truth behind the phrase "the teacher becomes the student." Their ideas and creative experimentation led to numerous new shortcuts and techniques that achieved better results.

During the years I styled food in Dallas, I worked with numerous professional photographers. Some have become friends of mine including Jean Ann Bybee. Jean Ann, her husband Brad Rogers, and I maintained our friendship over the years and miles after my move to Oregon. When she and I first started working together more than 20 years ago, we realized that something special, a magically creative process, happened when we worked in the studio. When the idea of writing this book became a reality, my editor suggested I partner with a photographer. Jean Ann was my first choice.

JEAN ANN BYBEE

As a child, I played with my father's Polaroid camera that he used for work, but I did not get my first real camera until I was in college. Although I thought of pursuing photography as a career, I was told it's "a man's job." At that time there were very few female photographers in Dallas, Texas. Bowing to my parents' wishes for me to be in the medical field, I got as close to photography as I could and ended up taking x-rays. I went back to college at night to learn photography. Little by little I managed to work my way into the business. I assisted many wonderful male photographers and had to prove everyday that I could do what the guys did. So from the inside out I became a photographer.

Eventually, I received a job offer to be a shooter at a large catalogue photo studio in Dallas. I loved fashion and shot for Neiman Marcus for 9 years in both Dallas and New York. I have owned my own business for more than 15 years and shoot fashion, food, people, and products, but food is a favorite.

Shooting food is like shooting a beautiful woman: They both take lots of prep time and neither lasts very long on set. I light my food using large broad light sources for the softest lighting possible. I love the freshness of natural light on faces and on food. I often use natural light and mix it with strobe lighting for the right effect. Being fast and ready to shoot is an absolute necessity in order to be successful shooting either food or fashion.

I have a wonderful family I love. My husband works with me and takes care of managing the computer and the business while I take pictures. Our lovely young daughter is graduating from college this year.

I feel so lucky to have made a very successful career of something I love. I have been able to travel all over the

world shooting pictures. What a life! My clients include Victoria's Secret, Abercrombie and Fitch, J.C. Penney, Smithsonian Institute, Miller Brewing Co., American Eagle Outfitters, Anheuser-Busch, Calidad Foods, Collin Street Bakery, Dominos Pizza, Epicure, Harry & David, Mary Kay Cosmetics, Sara Lee, Walt Disney Productions, American Express, Dr. Pepper/Cadbury, and Williamson-Dickies.

ACKNOWLEDGMENTS

Jean Ann, Brad, and I want to express our gratitude to the numerous contributors who provided products and services for us during the photography production of this book. Thank you to the following corporations and individuals for contributing so generously to this project:

3M Home Care Division, www.3m.com

ACH Food Companies, Inc., www.karosyrup.com

The Anchor Hocking Company, www.anchorhocking.com

Angostura Limited, www.angostura.com

BernzOmatic Inc., www.bernzOmatic.com

Cardinal International, www.cardinalglass.com

Central Market, owned and operated by H. E. Butts Grocery Company, www.centralmarket.com and www.hebgrocery.com

Chimera, www.chimeralighting.com

Collin Street Bakery of Corsicana, Texas, makers of world-famous cheesecakes and fruitcakes, www.collinstreetbakery.com

The Color Wheel Co., www.colorwheelco.com

Cuisinart, 1 Cummings Point Road, Stamford, CT 06902, whose products and name are used with permission, www.cuisinart.com

Dow Chemical Company, www.styrofoamcrafts.com

East Ellum Digital, technical support and additional camera equipment, technicians; John Shipes and Neal Farris, www.eastellumdigital.com

Electron Microscopy Sciences, www.emsdiasum.com

Elmer's Products, www.elmers.com

Energy Brands Inc. (d/b/a/ Glacêau), www.glaceau.com

EVO Media, Inc., www.evo.com

Gitzo, www.gitzo.com

Hamilton Beach Brands, Inc., www.hamiltonbeach.com

Hasselblad USA, www.hasselbladusa.com

Hearthmark LLC (d/b/a Jarden Home Brands), a Jarden Corporation company, www.freshpreserving.com

Hilden Manufacturing Co. Ltd., www.hilden.co.uk

Jiffy Steamer Company, LLC, www.jiffysteamer.com

JRM Chemical, Inc., of Cleveland, OH, www.soilmoist.com

Krylon Products Group, www.askkrylon.com

Le Creuset of America, www.lecreuset.com

Lynn Kelly, designer aprons, www.lynnsdesigneraprons.etsy.com

Messermeister, Inc., www.messermeister.com

National Presto Industries, Inc., www.gopresto.com

Nik Software, Inc., www.niksoftware.com

OXO International, www.oxo.com

Polyvinyl Films makers of STRETCH-TITE plastic food wrap, www.pvfilms.com

The Procter & Gamble Company, www.pg.com and www.quickerpickerupper.com

S. C. Johnson, A Family Company, www.scjohnson.com

Table Art Cloth by bamsart.com, www.bamsart.com

Totally Bamboo, Inc., www.totallybamboo.com

Wilton Industries, Inc., www.wilton.com

X-Rite, Inc., www.x-rite.com

Zak Designs, www.zak.com

Zwilling J.A. Henckels, www.zwilling.com

Linda Bellingham wishes to thank the following individuals: Trish Dahl for her encouragement all those years ago; Dennis and Bonnie Wilson for providing comfortable lodgings for me during photography production in Dallas. My heartfelt thanks also go to Angie Bellingham and to my sons for their encouragement and support.

Jean Ann Bybee wishes to thank the following individuals: Cynthia Hall for her support and help in this project, and Aki Shiratori for hair and makeup for my portrait.

The Big client you have been waiting to work with has just called with a project. There's only one catch. The client needs you to photograph a "simple" food shot and he doesn't want to spend any money on a food stylist. Bad move on his part and a major headache for you. Here are your choices: (1) Say "No" to Mr. Big because you know that a food shoot without a food stylist can be a nightmare, but by saying no you ensure that this client will not call you about future projects. (2) You can personally foot the bill for a food stylist and hope that future business from this client will make up for the expense. This decision directly impacts your wallet and offers no insurance for winning the client's future business. (3) Do it yourself—a gutsy choice, and an all-too-common decision.

Over the years, many photographers, stylists, and photography students have contacted me with panic in their voices. There were two basic reasons: Either a client did not provide funds to hire a food stylist, or a test shot of a specific food was needed. To say the least, this is not a comfortable position for the photographer or for the person designated to work with the food. It is especially uncomfortable if the photographer is also the self-appointed food stylist.

I have been a freelance food stylist in the commercial market for nearly 30 years. My bachelor's degree in education and home economics as well as many years spent in restaurant and commercial kitchens led me to a career in food styling. In the world of food styling, I have done it all—several times.

This book does not take work away from food stylists, but rather aids photographers and others who struggle with food styling tasks when no food stylist is available. In each chapter you will find step-by-step instructions accompanied by numerous photographs illustrating techniques for preparing food for photography. Also, a final photograph depicting the finished product accompanies each chapter or chapter section. This finished shot will be an invaluable reference tool as you acquaint yourself with the styling procedures for each shot.

Preparing food for photography is nothing like cooking for consumption. The information in these chapters will help you gain knowledge of techniques as well as offer

suggestions for tools and supplies best suited for the job of food styling. Most importantly, as you transcend into the world of food styling, the techniques offered in this book will help you gain some confidence. You may discover variations for techniques presented in this book that work better for you. If so, make notations for future reference. You might find it helpful to start a food styling journal. It is my hope that this book will be a tool to help move you toward a successful food styling experience.

Some of the words and phrases used in this book are industry related. We have included a glossary at the end of the book for readers unfamiliar with these terms.

Food Styling
for Photographers

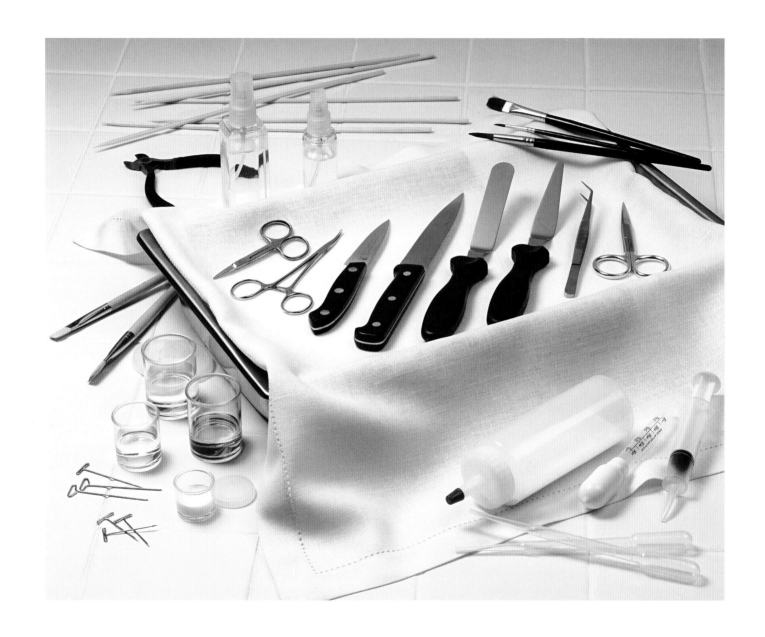

Introduction to Food Styling

During my years as a food stylist, I developed professional relationships and solid friendships with numerous other stylists, photographers, and assistants. Occasionally, photographers or assistants would ask me for advice about projects on which they were working. These projects invariably involved food they wanted to style and photograph when no funds were available for a food stylist. I offered time and assistance when possible, but due to my busy food styling schedule, advice was often my only contribution. As the years went by, I noticed that these requests for advice were becoming more frequent. I eventually recognized that the questions had increased for two reasons: Either the photographer's food client had no funds for a food stylist or the photographer was pursuing a food client and needed a new portfolio shot of a specific food. It is no wonder that with current budget reductions for advertising, especially for smaller projects, photographers are often being asked to provide food photography without the aid of a food stylist. As for the second reason, it can be difficult to find a stylist who has the time or interest to contribute to portfolio shots.

My advice to photographers is this: Always use a food stylist when your client can pay for one. In most cases, to accomplish commercial food photography, there absolutely needs to be a food stylist on the production team.

In reality, however, whether it's being done for fun, for a portfolio shot, or for a small project, there are times when a photographer or non–food stylist will venture into the world of food styling. For this reason, when you want to play with—and photograph—your food, this book will help you be successful with the food styling part of the project.

The techniques and styling methods given in this book are general guidelines for food styling. The topic of food styling is vast and at times can be very specific and complicated. It is impossible to cover everything within the confines of one book. My goal with this book is to provide photographers with a general reference source and to relieve some of the intimidation you might have about food styling. I'm going to share some knowledge that I've accumulated over the years and help you build confidence when working with food for photography. Even if you don't intend to tackle food styling yourself, the fact that you are taking time to read this book will better prepare you for shooting food. You will become familiar with the techniques used by food stylists. You will have a better feel for the pace of food styling and will not be surprised at the time it takes to prep or achieve some food styling techniques. You will also be better equipped to anticipate requests from stylists for equipment and tables in your studio.

A FEW RULES FOR FOOD STYLING

To begin our study of food styling, you should familiarize yourself with some of the unwritten rules of food styling. A few of these rules are obvious, but should be mentioned nonetheless, especially if you are new to food styling. These unwritten rules became apparent to me by way of trial and error. My hope in listing these rules and guidelines is that you will be able to avoid some of the pitfalls and disasters that can occur when photographing food. As you venture into food styling, you may discover some additional guidelines to add to this list.

(See the Glossary at the end of this book for definitions of terminology that may be unfamiliar to you.)

Rule One:

The first rule is to never eat food that has been on set or handled as a hero. I've always said that it's bad karma to eat photo food. This rule makes good sense not only because hero food is usually handled a lot, but also because it isn't always managed in ways that keep it safe for consumption. In some instances, substances are added or applied to the food that render the food unsafe for consumption.

Rule Two:

Always read safety and use instructions for equipment that is being used for the first time and as a reminder to be safety conscious when using any equipment. Simple tools and tasks can become dangerous if you aren't working "in the moment." Always follow safety guidelines for working with knives, scissors, and other sharp-edged tools—and remember that a sharp knife is less dangerous than a dull one.

Rule Three:

As you build a hero food item, sit or stand with your eyes at camera level whenever possible. Build the hero with the camera side toward you. In other words, your eyes are the camera. Focus on the front and sides of the food that the camera will see. Don't pay any attention to the appearance of the back of the hero. The camera angle is all that matters when photographing food.

Rule Four:

Never open any container on or over the set. Instead, open containers in the prep area or on a side table away from the set. Remove food items from containers in the prep area and, when appropriate, drain any moisture from the items to prevent dripping on the set. If you are using liquids on set, cover the set with at least one layer of paper towels to contain any drips where the liquids will be poured or styled. Cleanup on a hero set is not fun and it can be a very time-consuming task.

One photographer I work with told me a story about a large set consisting of numerous pieces of clear glassware that she constructed for a client. The set took hours to finalize because she had to make sure the glassware was positioned properly and was clean and dust free. One glass in the middle of the set was to be shown with champagne

in it. Before the photographer could stop him, her client popped the cork on the champagne bottle. Yes, you guessed it, right over the set. Champagne shot everywhere. The entire set had to be dismantled in order to clean the surface and the glassware. Unfortunately, the champagne incident forced them to start the project over from scratch. Needless to say, it was a very maddening experience for everyone.

Rule Five:

My rule for stand-ins is to provide a very loose translation of the hero. A few examples of my stand-ins are a wadded-up paper towel for ice cream and a brown grocery bag with a roll of paper towels in it for a turkey! Not only does this strategy give me more time and creative energy to focus on building the hero, but it doesn't set a rigid mental image for the art director, photographer, or me to latch onto. There are a few exceptions to this rule and they will be mentioned in the appropriate chapters.

I learned the hard way about stand-ins. During the first few years of my career, I usually made a realistic looking stand-in for the client to critique and for the creative team to look at while building the set. On one occasion the client fell in love with the stand-in and wanted the hero to be built exactly the same. By the time the set was finalized, the stand-in was well past its prime. My task of re-creating the hero to perfectly resemble the stand-in was painfully frustrating and time consuming.

Rule Six:

Have a plan. Be prepared. I can't emphasize this enough: Make sure you have everything that you might need in the studio the day before the shoot. The only exception to this rule is salad greens, berries, maybe flowers, and ice if you don't have room in your freezer to store it overnight.

HAVE A PLAN

The simple fact is that every shot is different. When clients make the decision to produce a selling shot, they want a shot that is unique to their product. They may choose to borrow some elements from other shots that they have seen, but their main objective is to create something new and different. Encourage clients to provide you with tear sheets (examples of previously printed work) that they like to give you an indication of what they want. Then ask them to identify elements within those tear sheets that they want included in their shot. These go-bys help you and others on the creative team by providing a starting point for the project. I have been in studios where the photographer put up a dry erase board and listed the separate elements that the client wanted in the shot. He posted the go-bys next to the board for reference. I saw how these tools helped to give the entire team direction. I've also witnessed times when the team decided to take a total departure from

its original idea based on some creative thinking by one or more of the team members. Sometimes departure from the original idea happens because the team members learn that what they thought they wanted just doesn't look good to the camera.

You can use the rules and tools just discussed as you begin planning your shot regardless of the size of your team. If you are working on a portfolio piece and going solo, the decision-making process is the same and requires just as much research and thought. Conduct preplanning for your project. This will help you determine direction and establish a better mental picture of your photographic image goal. Every decision you make in the planning stage will guide you. You will know what to purchase and you can mentally run a time-frame checklist for the prep required and for the day of the shoot. Similar to preparing a family dinner, the prep process for food photography is time sensitive. Some items can be prepped the day before final photography; however, the more perishable items will need to be prepped right before they are built on the hero plate.

BE PREPARED

In general, the food gathering, preparation, and hero process require a lot of table space, so you will need to have ample room to work. If you don't have tabletop space available, set up tables using sawhorses and plywood sheets, or rent folding cafeteria-type tables from a party rental store before you start shopping. You'll want to have the tabletop space available when you arrive at the studio with your food products.

Also, consider the refrigeration space available in your studio. If you are planning a project with lots of perishable or frozen ingredients, you may need to rent extra refrigerator and freezer appliances from a local rental store. You'll want to get the appliances a day or two before you shop for the food for your project so the appliances will have time to come to proper storage temperature. Check the appliance temperature settings. Place a thermometer inside the appliance and check the temperature after 24 hours to certify the appliance is holding the correct temperature. Make sure any refrigerators you plan to use for photo food are not too cold because tender items could freeze. A refrigerator should be in the 40° to 44° Fahrenheit range for photo food. Actually, I prefer 44°F for photo food because I've had a few experiences with salad greens freezing when the refrigerator was full and set on 40°F. By ordering the appliance a few days ahead of the shoot, you will be able to determine if it is working properly. That also gives you time to request the rental agency to repair or replace an item if necessary. Appliance rental businesses usually deliver and set up their appliances as well as pick them up at the end of the rental period.

> **Rule Seven:**
> Learn to shop like a stylist. The quality of the items you purchase for your shoot will directly impact the appearance of your final image. Quality and perfection of each item you purchase are the goals. If you don't bring quality items to the studio, you won't bring quality to the camera.

For a novice, shopping for a photo shoot may sound like an easy task. You've shopped plenty of times, right? Well, stylists take shopping to the extreme. If you are planning to attempt your own food styling, you will be wise to brush up on some stylist's shopping tips.

SHOP WISELY

Tip 1: Shop at the best groceries available. Some markets are known for specific types of groceries such as bakery, produce, or meats. Find the absolute best markets that provide the types of food you need for your shot and shop at those places. If you are fortunate to have one overall wonderful grocery market, like I did for this book, even better, because one-stop shopping will save you lots of time. During photography production for this book, I shopped at Central Market in Dallas, Texas, for everything.

Tip 2: Take a few flat, low-sided boxes to the market to create a smooth surface that won't mar the tender items you select. The boxes that hold a case of individual water bottles work great. I keep several of those boxes in my trunk. If you don't have boxes and the grocer doesn't have any that are a good size for your project, ask the checkout clerk for a couple of large paper bags. Lay the bags flat in your shopping cart to create the desired smooth surface.

Tip 3: Be extremely picky when you select grocery items for photography. You want to purchase only the very best examples of each item you need as well as duplicates of each item for insurance. Foods to be cut or cooked will need more than one backup. Additionally, you may need stand-ins or extras for testing purposes.

Tip 4: Purchase nonperishable items a day or two before the shoot. If possible, perishable groceries should be purchased the day of the shoot.

LOOKING FOR A HERO

There is a process stylists go through during the prep phase of photography that is called the *hero process*. The hero process is the process of looking through lots of one kind of item to find the perfect, or hero, examples of that item for your shot. This is a picky, picky process. It usually involves looking at numerous trays filled with one kind of food. Sometimes it means going to several markets to find the perfect examples of certain items.

Looking for a hero: hamburger buns contending for hero status.

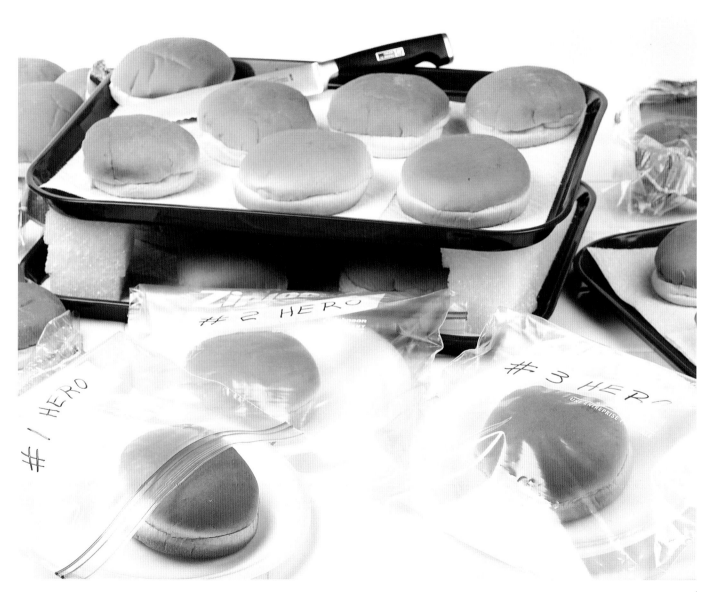

Let's consider the bun on the hamburger that is featured in Chapter 6, the burgers and sandwiches chapter. The description of the bun hero process is discussed in that chapter. More than a dozen packages of hamburger buns were carefully selected and purchased to find the perfect bun for this shot. If you have a baker nearby who is willing to sell a flat of freshly baked buns, you're fortunate. However, even that measure does not guarantee a hero.

Once the buns are in the studio, each bun must be scrutinized to see if it is hero quality. This process is the same for almost every food item that goes into photography. It's as if the items participate in a beauty pageant to determine the winner and runner-ups. The items that win are ranked and assigned numbers to indicate their ranking. They are of high value to you at this point.

> **Rule Eight:**
> Protect the hero food. Whether the hero items are on a table in the studio or in the refrigerator, freezer, etc., be sure they are identified as hero items and not for consumption. Once found, the hero items must be cared for in ways specific to each type of item to maintain hero quality until photography is completed.

Many tears have been shed over hero food that was consumed by studio crew members or clients before the shot was made. Because the items had not been properly marked as hero food, the crew was blissfully unaware that they were eating the star product that a stylist had carefully shopped for and selected after looking at hundreds of examples. We can only hope they appreciated how perfect the item looked as they ate it!

> **Rule Nine:**
> Before you make a final capture or shoot film of your hero, double-check the set to make certain there are no visible tools, supplies, paper towels, etc., within the crop of the shot. Yes, I've been guilty of this.

TOOLS OF THE TRADE: ASSEMBLING YOUR FOOD STYLING KIT

Being prepared also means having the tools and supplies available that are needed to style the specific foods you are working with on each project. Just as having the right tool for the job applies to handymen, it also applies to food styling. The right tools can make short work of some tasks. And, in the world of food photography, both time and timing are crucial.

Basic Kit Components

For most food styling projects you will need some specific tools and supplies. You will see many of these tools in the technical working shots within this book. The basic components of your styling kit should include the following:

- *Tweezers.* A pair of long-handled, bent-tip style tweezers is a versatile and often used tool in my kit. I have more than one pair. My favorite tweezers are from Electron Microscopy Sciences (www.emsdiasum .com), Style 24, Part No. 72880-DB with a 90% bent end, and Style 24, Part No. 72880-DS, which has a straight end.

- *Spatulas.* I use 9-inch Wilton Comfort Grip tapered spatulas and 9-inch Wilton Comfort Grip angled spatulas, both of which have offset bends. I have at least two of each in my kit at all times. Wilton makes spatulas of different shapes and sizes, parchment paper, concentrated gel food coloring, piping gel, cake pans, cake levelers, etc. (www.wilton.com).

- *Knives.* I keep numerous knives in my kit. You will probably want to have a 3-inch paring knife, a 6-inch chef's knife, two 10-inch chef's knives, especially if you work with cheesecake, an 8-inch serrated knife, and a tomato knife. I use both Messermeister knives (www.messermeister.com) and Henckels knives (www .henckel.com).

- *Knife sharpener or steel.* There are only two important things to consider about the type of sharpener you use. The most important one is that you must be safe and comfortable using it. The other is that the sharpener must provide a really sharp edge on your knives.

- *Small, sharp scissors.* I use fisherman's fly-tying scissors.

- *Kitchen scissors.* I use both Messermeister and Henckels.

- *Brushes.* You will need an assortment of artist's brushes and pastry brushes.

- *Hand tools.* These include peelers, a zester, rubber spatulas, etc. I like the OXO Good Grips brand (www.oxo.com).

- *Long wood skewers and toothpicks.* The skewers are usually sold in bulk packages advertised for shish kebabs. I've seen two thicknesses of skewers on the market and both have specific advantages, so I keep both in my kit.

- *Bulb-type dropper.* My personal favorite type of dropper can be found at pharmacies. They are used to dispense liquid medicine to children and come in several different styles and sizes. I also like a bent-tip plastic syringe like that used by dentists. You might ask your dentist about them at your next appointment.

- *Spritz bottle.* These can be found at beauty supply stores. The best fine-spray tips with a controlled area of spray are found on push-down type spray heads rather than trigger sprayers. I use a smaller push-down type spritz bottle for most projects. However, I also have a larger capacity trigger sprayer that is handy for keeping salad greens, floral items, etc., misted during prep.

- *Small containers for liquids.* Especially when you go to set, it's nice to have small containers for liquids such as water, oil, corn syrup, and coloring agents. Empty plastic egg cartons work very well for this task because, when opened flat, the egg cups hold as many as a dozen different liquids and the top tray is perfect for brushes. They can also be recycled and used for your next styling job.

- *Small and large wire cutters.* I use small cutters to cut skewers, toothpicks, etc. The large ones are used less often, but occasionally come in handy.

- *User-friendly plastic wrap.* I have to admit that STRETCH-TITE plastic food wrap made by Polyvinyl Films has been my favorite for several years. It's easy to work with, is strong, and the packaging design keeps the end of the wrap very accessible.

Equipment Often Used for Food Styling

Cooking equipment that comes in handy for food styling is as follows:

- *Steamer.* I use a hand steamer, Esteam, manufactured by Jiffy Steamer Company (www.jiffysteamer.com).

- *Trays.* Plastic trays are almost indispensable to a food photo shoot. I have quite a few of them and they have numerous uses. Restaurant equipment stores often have cafeteria-type trays at a reasonable price.

- *Bowls.* I have a variety of nonbreakable bowls in my kit, especially patented Gemini Bowls, offered by Zak Designs (www.zak.com). Zak also makes a large variety of other items, including colanders, trays, and measuring spoons and cups. I also use glass bowls, batter bowls, and measuring cups of various sizes made by Anchor Hocking (www.anchorhocking.com). Cardinal Glass International makes some wonderful prep bowls and a large assortment of glassware and serving plates (www.cardinalglass.com).

- *Mixer.* Because of the wide variety of tasks it can handle, I keep a Cuisinart Quick Prep in my kit. When I'm working on a fake ice cream shot,

I take along a Cuisinart DFP-14BC food processor (www.cuisinart.com). I also use a Hamilton Beach hand mixer with stand. It comes with three different beater attachments.

- For deep-fry jobs, I use my Hamilton Beach 12-Cup Oil Capacity Deep Fryer because it is very portable (www.hamiltonbeach.com).

- *Griddle.* I rely on my Presto Tilt'N Drain griddle (www.gopresto.com).

Supplies Often Used in Food Styling
You should have the following supplies handy because they are often used for food styling:

- *Gelatin.* Gelatin acts as a thickening agent and does not require heat to activate it. This product can be found in many cooking supply stores as well as some health food stores. You can also purchase gelatin on the internet at www.countrykitchensa .com.

- *Piping gel.* This type of gel is used because it has a smooth consistency and adds sheen to sauces. Wilton piping gel comes in a 10-oz tub and can be purchased at cake supply stores or purchased online at www .wilton.com.

- *Clear polyurethane spray and dulling spray.* I use Krylon Crystal Clear and Dulling Spray as well as Krylon paints for a variety of uses (www.askkrylon@sherwin.com).

> **SAFETY NOTE** Spraying food and items that touch food with dulling spray, a clear gloss polyurethane, or paint renders food unsafe for consumption. Be certain to clearly mark all trays and containers of foods that have been sprayed as NOT EDIBLE.

- *Clear corn syrup.* I use Karo corn syrup.

- *Paper towels.* Where there's a food stylist, there are usually paper towels. I use Bounty brand.

- *Glass cleaner.* I use Windex glass cleaner. A good rule is to clean any glass, plate, or flatware surface with glass cleaner before going to set. Cleaning a plate after it's on set with food is not fun.

- *Scrub sponges and scour pads.* I like Scotch-Brite heavy-duty scrub sponges and scouring pads for cleanup and for special techniques with vegetables.

> **SAFETY NOTE** Some techniques are specific to food styling and render food unsafe for consumption. Be sure to mark clearly all foods that have been scrubbed as inedible.

- *Isopropyl alcohol.* If you get a splash of liquid on plates or glassware on set, isopropyl alcohol on a cotton swab or paper towel can be used to remove spots or filmy residue from plate surfaces.

- *Cotton-tipped swabs.* Swabs are useful for all kinds of tasks and are always on my set tray.

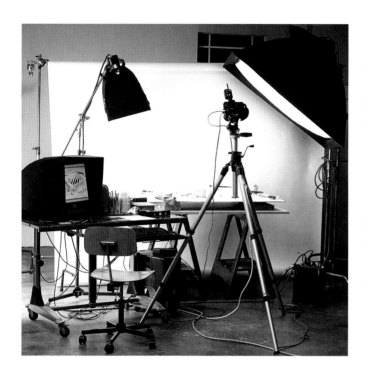

PHOTOGRAPHER'S COMMENTS—Notes on the Stylist Kit Set

This shot is of the set that is used throughout the book for technical and working shots. To achieve continuity in the appearance of our technical shots, I decided to use the same lighting for all of the technical shots with exceptions only for specific products that need special lighting techniques.

The white set has two Chimera lightbanks, one small key light and one medium fill. I use Chimera lightbanks to give an even, soft light to all shots. I used the same camera and lens for all shots on the technical set to maintain color and lens perspective.

The white seamlessness acts as a background and also serves as a large fill card that lights the stainless steel in this shot.

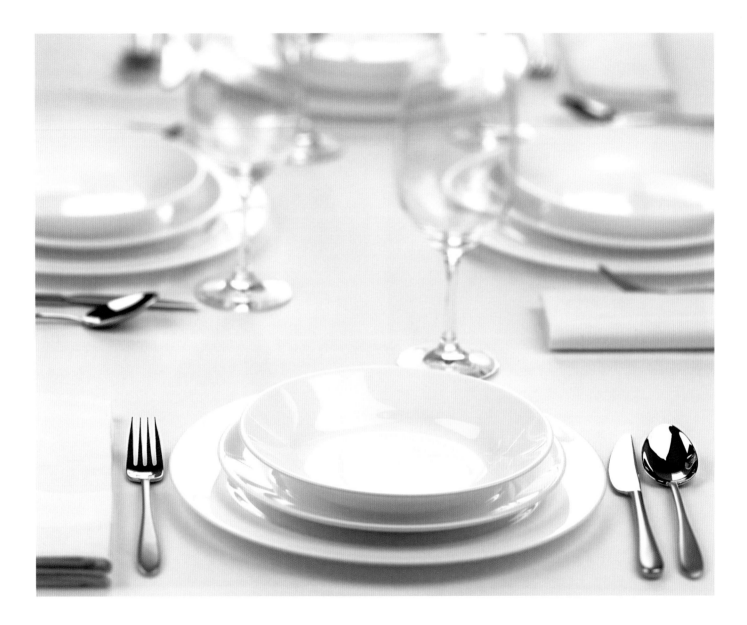

SETS AND SETTINGS

BASICS TO CONSIDER WHEN PLANNING FOOD PHOTOGRAPHY

An empty plate can be beautiful. But let's assume you have a plan to photograph food on that plate. You've looked at tear sheets, thought about the food, and made some decisions. Maybe a specific food item is the driving force for your planning. You are ready to start choosing a plate, its color and pattern, the arrangement of food on the plate, and the set surface. What about a napkin, textures, colors of the set, etc.? Do you want flatware in the shot? Glassware? Flowers? Do you feel a little over-whelmed? Don't. Asking yourself some specific questions will take the guesswork out of your planning and give you a specific direction for your project.

WHAT'S THE POINT OF THE SHOT?

First of all, what's the point of the shot? Is it to sell a specific food or to sell plates or flatware? Are you more interested in an artsy editorial shot? And my favorite question: Is the shot you are planning going to be used strictly as a portfolio piece? I love asking this question because I have seen so much portfolio photography that was well executed and beautiful, but the shots didn't have a point. I have to admit that I committed this crime myself back when I was starting my career. I worked with photographers on portfolio shots and the goal was always the same: to achieve a beautiful shot. Now when I see such shots, they don't appeal to my emotions, my intellect, or my appetite. After being in the world of food and food photography for over 30 years, I finally get it.

If you are going to spend time creating a beautiful photograph, make sure you can identify a focal point for the

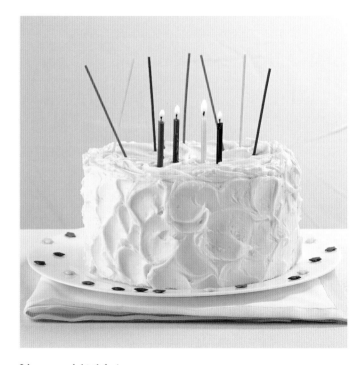

It's someone's birthday!

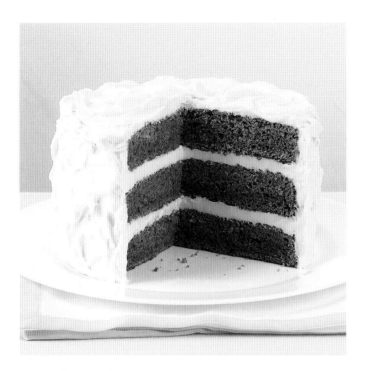

Are we selling this cake?

shot. Create a shot that will stir emotions, tell a story, make mouths water, or make the viewer wonder how in the world you did that.

When you sell food via photography, the goal of the stylist and photographer is to make the viewer want to buy that food. The guidelines for photography taken expressly to sell food have changed during the past 20 years. Today's commercial food photography shots are much tighter on the food. The mood of the shot is created by lighting and by insinuated atmosphere. Now, that's a great term, "insinuated atmosphere." When you look at a picture, you should get a quick read of what's happening before you have time to blink. The shot tells you a story.

Now we're selling cake!

Oh look, someone was having a piece of cake with their coffee and they must have gone to answer the door because the coffee looks freshly poured and that cake looks so yummy. It looks like they were just about to take the first bite. I bet they can't wait to get back to it.

What's the focus of your shot? What story do you want to tell? When you can answer these questions, you will be able to begin deciding other issues. Keep in mind that the story of your shot should be simple.

NOTE Refer to the chapter on desserts for details about the cake and frosting techniques used in this chapter.

HOW TO MAKE FOOD POP IN THE IMAGE

Having a good grasp of the focal point and the story you want to tell will help you determine the setting or atmosphere for the shot. The focal point should be quickly identified by the viewer. This is called "pop" or separation. Since we're talking specifically about food, you want the food to visually pop in the image you will be creating. There are decisions you can make during the planning phase that will help make the food, the focal point of your shot, pop.

The most important thing to remember when creating an image specifically for the pop factor is to keep it simple. More elements in the shot mean more distractions for the viewer's eyes. Less is best.

TIPS FOR CHOOSING SETS AND SURFACES FOR FOOD PHOTOGRAPHY

It's time to make decisions about the set and surface for the presentation of the food. Think about the color, texture, and visual weight of the food item you're shooting. By *visual weight,* I mean things like density and whether the item is dark or light colored and what size it is. For instance, a pan-seared thick filet of beef is dense. It's mainly brown with some red if it's cut open, which makes it heavy with color. It's not huge but it is substantial. Will it need other foods as accompaniment? It could be shown alone on a plate. However, even if you shoot close up for a tight shot, the filet might be more interesting if enhanced with other foods that have nondemanding colors and textures. To make the food you're featuring pop in the shot, the featured food should stand out when combined with other foods. This can be achieved by lighting and color. What foods and food colors will complement your photo food? Refer to the color wheel.

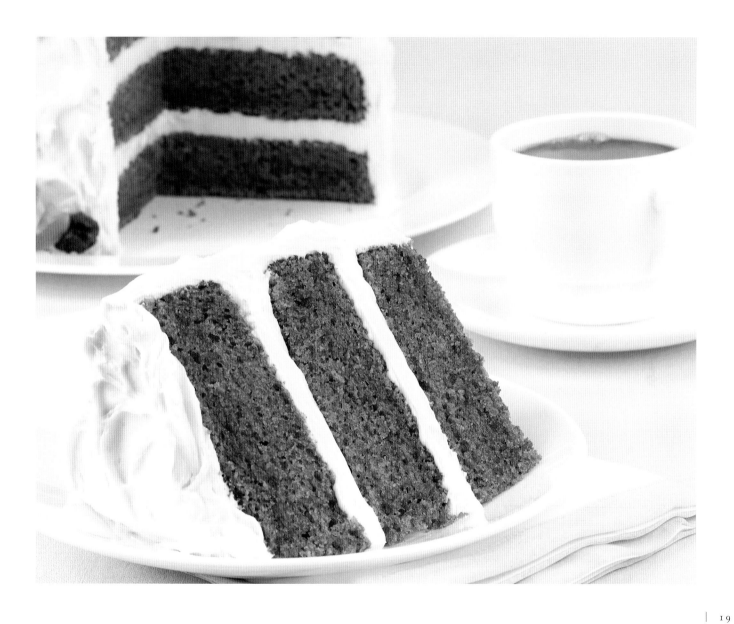

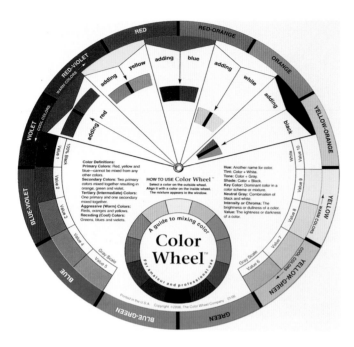

Here's a quick color lesson. The three primary colors are red, blue, and yellow. The three secondary colors are purple, orange, and green. Tertiary colors result when a primary color is mixed with a secondary color. Different shades of colors are the result of mixing a color with white or black. Colors that are on the opposite side of the color wheel are called *complementary*. For instance, purple and yellow are complementary, as are blue and orange, and red and green. These colors contrast with

each other, yet at the same time make each other more active and exciting to the eye.

As a general rule, lighting, focus, and color will make the focal point of your shot pop. A combination of these three elements can be used to enhance the objectivity of your shot, both the food and the story. There are plenty of examples in this book. Each full-page image went through a creative process before the final capture was made. The photographer and I were the creative team. We used the questions I've mentioned in this chapter as tools to help us reach decisions about the set and setting for the food in all our images.

If the set is full of lively colors, chances are the food will not be the focus. Choosing colors for the set that are pleasing to the eye but not brilliant with color is a good idea. Using different shades or tints of the same color in the set helps to ensure that the food will be the focal point. Differences in texture of items in the same color family, and lighting of the set, will create a pleasing environment for the hero food. To draw the viewer's eye to the focal point food, keep more colorful items near your food rather than at the perimeter of the shot.

All this having been said, don't be afraid to experiment. Break the rules if you want because you may be very successful. Try using surfaces with your food that are not

customarily used with food. Just tell the story you want to tell and make the food pop.

Table Setting Tips

These are guidelines for setting a formal table. It's good to be aware of the correct placement for table setting components even though creative license is often used to position table elements in photography. Traditionally, flatware is arranged in the order in which it will be used during the meal, building from the outside in toward the plate. As a reference tool, this image shows a full place setting with napkin, the smaller salad fork, dinner fork, knife with the blade turned toward the plate, soup

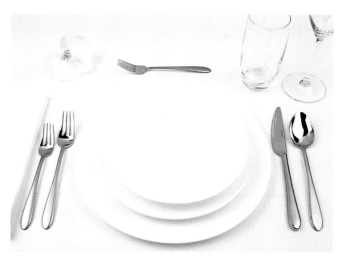

spoon, and dessert fork positioned horizontally above the plate. If coffee is to be served with dessert, a coffee spoon can be placed above the top of the plate parallel with the dessert fork. The water glass is directly above the knife with a wine glass to the right of the water glass. The napkin is shown here to the left of the forks, but it can also be placed on top of the empty plate.

Working Fabric on the Set

If you have fabric on the set as an element in the shot either as a surface or background, you need to be armed with some knowledge about how to get it to look the way you wish.

Always check the fabric content and run a test on a small piece of the fabric to make sure it can withstand the heat of a dry iron and tolerate the moisture generated by a steamer or steam iron. Start your test with a dry iron. You'll need to determine what level of heat works best with the fabric. Then you'll want to determine if steam or water sprayed onto the fabric leaves any marks or residue after the fabric is ironed dry.

If a photography surface is to be totally covered with a fabric, for instance, a tablecloth, you will want to start out by covering the shooting surface with a layer of white felt. Felt comes in a variety of widths and can be purchased at most fabric stores. You might want to purchase several

yards of the felt so you will have plenty around the studio for future projects. Using felt under fabric on a hard surface offers many advantages. It will give the hero fabric surface a softer appearance since placing a fabric over a wood surface can make the fabric look flat and hard. When felt is under the hero fabric, the fabric will accept light on the set in a warm and fuzzy way instead of being hard and unfriendly. The felt will allow you to iron or steam directly on the hero fabric on the set surface without

damaging the table underneath. It will also help contribute to any slight ridges for textural interest should you choose to make them. But regardless of whether you choose a flat or manipulated surface, the felt will lend a richer quality to the hero fabric set covering.

With the felt laid smoothly over the shooting surface, you can proceed to cover it with the hero fabric covering you've chosen. If the specific fabric responds well to moisture, you can spritz the fabric with water and iron it

smooth on the set. This technique is especially good on fabrics with cotton and linen content. You will need an additional tabletop surface on which to lay napkins and other smaller fabric items after they've been ironed. Once napkins are ironed, I like to keep them flat until they are folded and placed on the set. Use a stand-in to determine the style of folding and placement of the napkin in your shot. Fabric that is used as a background in a sweep or backdrop can be steamed as it hangs in place on a horizontal bar on the set.

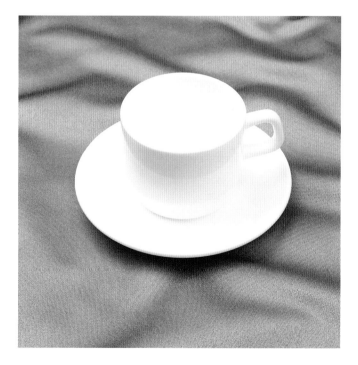

If a flat fabric surface looks uninteresting to the camera, areas of interest can be created in the fabric. Visual interest is made by soft ridges or movement in the fabric and by the way the set lighting creates shadows around the ridges. The lighting on your set will be instrumental in making magic happen with a fabric surface. After the fabric is ironed, the first thing you do is look at the fabric from the camera to make certain the iron removed all unwanted wrinkles. To create slight movement, similar to ridges on a topographical map, place both of your clean hands flat on the fabric in the area where you want some interest in the surface. Gently press your hands closer to each other until the fabric bunches slightly. It might be necessary to put a weight or small heavy object on different areas of the fabric out of view of the camera to maintain the ridges. Look from the camera either by placing your head directly in front of the lens to view the set or by taking a capture. If you find the ridges need to be maneuvered, use the same technique until you are pleased with the appearance. Depending on your lighting and the angle of light that is hitting the surface, the ridges will cast a shadow. That's what creates the interest. Smaller or less puffy ridges cast smaller shadows. Once you get comfortable with the process of creating ridges, start practicing to create multidirectional ridges because they are more interesting and less distracting.

Supplies used to create the full-page dish shot at the beginning of this chapter:

- Arcoroc dishes and flatware
- Cardinal International glassware
- Hilden International 100% Egyptian cotton table covering and napkins

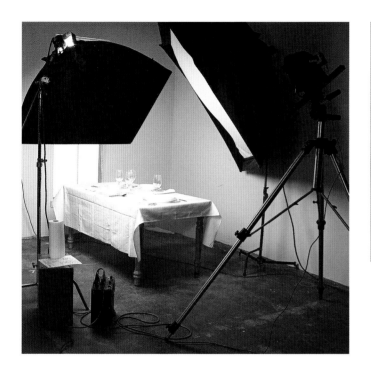

PHOTOGRAPHER'S COMMENT—Notes on the Dish Set at the Beginning of This Chapter

This editorial style shot of a white table setting for four with no food is a backlighting dream. I used a Chimera lightbank to give a soft white glow over the table and a medium bank on the left side to even out the light and fill the shadows. Both banks were set on very low power so the majority of the light was natural since we built the set in front of one of the windows in my studio. My point of focus was in the middle of the bowl in front, and with the low power of the strobe packs and use of ambient light, I easily got a shallow depth of field.

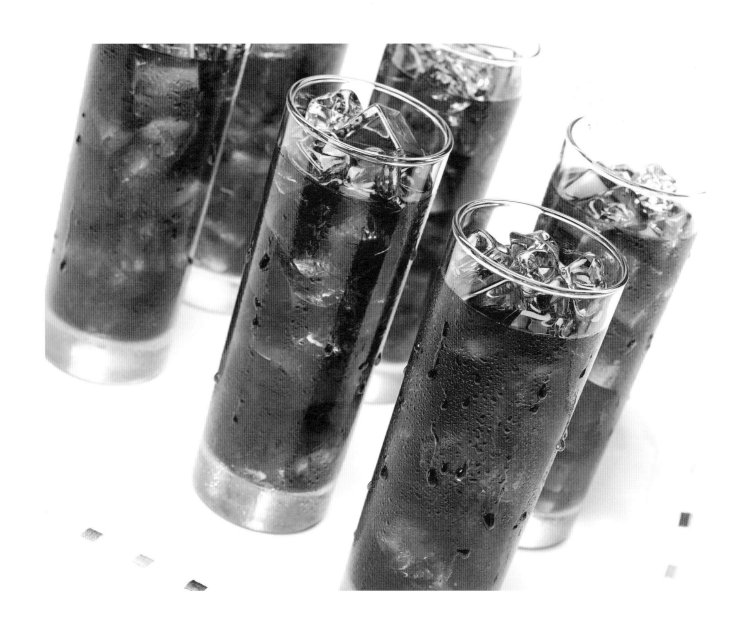

CHILLING FACTS ABOUT COLD BEVERAGES

The problem with shooting a cold beverage is that once you finalize the set and pour the cold liquid into the glass, you have to wait until frost and condensation forms before completing photography. Then, you have a very short window of time to capture the perfect shot. By using the techniques in this chapter you can fake the effects on the glass and have more control of the appearance of the glass as well as more time to achieve the shot! The first time you read the descriptions of these techniques, you may think that they are a lot of trouble. But if you try them, I believe you will not only appreciate the effects, but also adopt them for future use. The techniques described in this chapter will give you a good foundation to send you down a successful path toward achieving the look you want when photographing "cold" beverages.

Let's start with a little common sense. When you pour a chilled beverage into a glass, condensation will form on the outer surface of the glass up to the fill line, giving a frosted effect. This look is appropriate for any chilled beverage without ice. When you add the element of ice to a beverage, the condensation is enhanced and eventually drops, rivers, or runs develop on the outer surface of the glass. This appearance can be appropriate for all iced beverages.

Sometimes condensation is created on the inside of a glass. For example, if a hot beverage is poured into a clear glass container, visible condensation will form on the inside of the glass between the top of the liquid and the top of the glass. You can achieve this appearance with the techniques described in this chapter. Simply work the techniques on the inside of the glass. It's a little more tedious process than when working on the outside of a glass, but it can be done.

In many ways faking these effects is more forgiving than working with natural physics. The techniques in this chapter will give you a stable finish on the glass allowing you unrestricted time for adjustments to the lighting, the set, and other factors. Using techniques to fake frost and create condensation on a glass also eliminates problems on the set. If you want to use the real beverage with real ice, by all means do so. But there are many instances when using the actual beverage with real ice just won't work.

TRICKS OF THE TRADE The stand-in or non-hero glass is an extremely important tool in beverage photography. It will be the guinea pig that allows you to determine many issues, such as the fill line for the glass, the color of the hero liquid, and the timing to capture bubbles and fizz created by carbonation.

THE BEVERAGE OF CHOICE

When shooting a cold beverage, you may have options available regarding the liquid in the glass. In many cases the real beverage will work fine. In fact, in some instances, the real beverage is the only choice, especially when photographing carbonated drinks, which must be freshly opened and poured right before final photography. Beer is not included in this discussion. There are many techniques that apply specifically to beer styling for photography and warrant an entire chapter-length discussion perhaps better saved for another book.

> **TRICKS OF THE TRADE** I prefer using canned carbonated beverages when possible. Open a new can each time you fill a hero glass. Use a large-mouthed funnel to pour the carbonated beverage directly from the can into the glass on set. Cover the area of the set around the pour with a couple layers of paper towels before starting to pour.

If you are uncertain about your choice of whether to use a real versus a substitute liquid, run some tests. Put the actual liquid in a stand-in glass and let it remain there undisturbed for an hour or two at room temperature. If the liquid appearance has not changed after that length of time, you can be fairly comfortable using it on set. But if it changes in any way, leaves a film, or creates a ring at the fill line, you might want to consider using a substitute.

I like to use the real beverage for white wine photos. Room temperature white wine is transferred into a hero glass that has been treated with the frost technique. The wine and glass will remain hero quality all day, unless fruit flies get into it. They can be removed with tweezers.

Red wines, normally served at room temperature, don't require glass treatments. However, they may require testing before they are photographed because some red wines are opaque. If you want to capture light through a red wine, it's often necessary to water down the real thing. This maintains the correct color family of the wine but also gives enough transparency for light to bounce through the liquid.

Milk and cream often pick up a slightly blue color to the camera. My milk of choice is either half-and-half or Elmer's Glue-All. Most often the glue works best at full strength right out of the bottle.

FROSTED GLASS PREPARATION TECHNIQUES

This technique uses dulling spray to achieve the frosted appearance on a glass. The frosted look indicates to the viewer that a chilled liquid is in the glass. Dulling spray

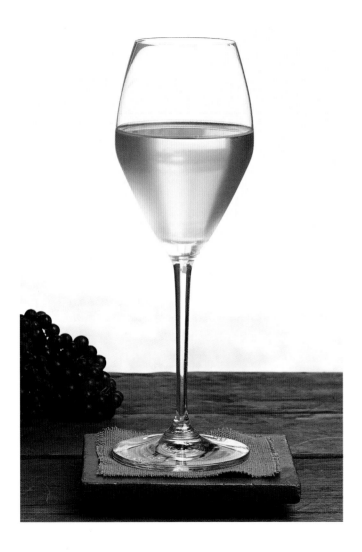

is normally used to remove shine or gloss from a surface but in this technique, it creates a foglike layer on the glass. One of the advantages of using dulling spray is that it can be easily washed off the glass with soap and water when you are finished with the project or if you need to re-apply the spray.

Prep the glass a day or two before shoot day. This will allow you more time on the actual day of photography to attend to other issues on the set. Just remember to store the treated glasses in a dust- and moisture-free environment, such as in a cabinet or under a cover of some type. I often use a large clear glass bowl and invert it over the treated glass. That way, others in the studio can see that there's something under the bowl. It is also a good idea to put a sizable warning note on the cover over the glass or near the glass so no one touches it regardless of where the glass is stored.

Use the stand-in glass on set to determine the fill line in the glass. Once the level is determined, turn your attention to the hero glass. Clean the hero glass inside and outside using soap and water. Dry the glass with a paper towel. Next, clean both inside and outside of the glass with glass cleaner. From this point forward, avoid touching the glass directly with your hands. Refer to techniques for moving the glass during prep and to the set in a separate section in this chapter.

To protect the part of the glass that is not going to be treated, run a strip of matte tape, masking tape, or painter's tape around the top edge of the glass so that the bottom of the tape is at the approximated fill line. Assuming the glass will be standing upright on your set, be cautious to keep the tape in a horizontal line parallel to the top of the glass. If needed, use a level to make sure the tape is horizontal. Once the tape is in position, firmly press it to the glass surface.

TRICKS OF THE TRADE Leave a 2-inch length of tape sticking out at the end of the tape after you wrap it around the glass. Fold the 2-inch tape back onto itself to create a 1-inch tab. This tab will allow for easy removal after all treatments on the glass are completed.

If any of the glass is exposed between the top of the glass and the tape you just positioned, you will need to cover that exposed part with tape also so that, when you're done taping, none of the glass above the fill line is exposed.

When using a glass that has a stem or foot, you'll want to protect those areas also because those areas don't normally frost. To do that, run a piece of tape around the top of the stem just under the bottom of the glass, leaving a tab on the tape for easy removal. Wrap the stem of the glass with a paper towel and secure the paper towel to the band of tape with a small piece of tape. The paper towel doesn't need to be tight because its only purpose is to keep any spray from hitting the stem. Use another piece of paper

towel to cover the foot of the glass and tape it in place. Once this is completed, you're ready for dulling spray.

To maneuver the glass during the prep process, push a clean, dry paper towel inside the glass, creating an open pocket that you can put your hand, or at least a few fingers, into. By spreading your fingers out so they contact the glass through the paper towel, you can maneuver the glass. Depending on the shape of the glass, you may actually be able to pick up the glass. This method will help

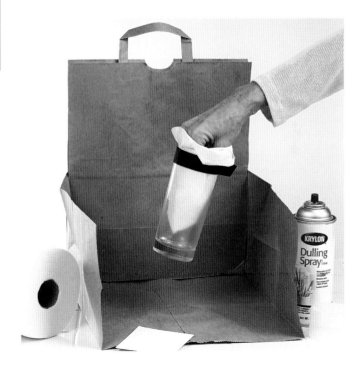

you avoid getting any fingerprints on the glass. Before using this technique for the first time, practice on a non-hero glass to gain confidence.

TRICKS OF THE TRADE The easiest way to make a temporary spray booth for small items is to use a brown paper grocery bag. Tear out one side of the bag, leaving the bottom and other three sides intact. The bag will sit or lay flat on a work surface to give you a three-sided "booth" with a floor. Spray in a well-ventilated area or outside.

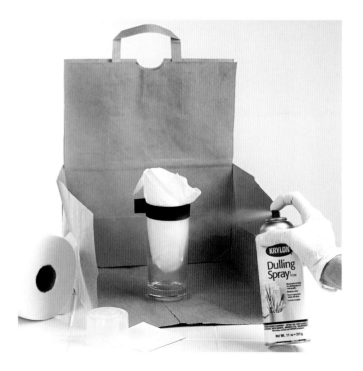

Set the glass in the center of the spray booth. You might want to cover the top of the glass with a sturdy piece of heavy paper or cardboard to ensure that no spray enters the glass. Push the paper towel far enough inside the glass to allow the cardboard to sit flat on the top of the glass.

Shake the can of dulling spray before beginning to spray and every minute or so during use. Holding the dulling spray can about 12 inches from the glass, spray the side of the glass facing you with a single light coat using a horizontal movement beginning and ending your spray strokes a couple of inches on either side of the glass. Turn the glass 180 degrees and repeat the spray process until the entire glass is sprayed. Be sure to replace the cardboard on top of the glass until you are finished spraying.

I usually apply two light coats of dulling spray to the glass to avoid any runs. The spray washes away easily if you need to start over, but you will have to replace the tape. This will complete the frosting effect.

If the frosting effect is your final goal, you can remove the tape when the dulling spray is dry. Avoid touching the frosted area of the glass. If your final goal includes condensation, don't remove the tape at this time and leave the glass in the paper bag booth where it will reside for the remainder of your prep work.

Supplies used to complete the frosted effect for the white wine shot:

- One hero glass and one stand-in glass
- Windex glass cleaner
- Bounty paper towels
- Krylon dulling spray
- One large standard brown paper grocery bag
- 4-in. × 5-in. piece of heavy paper or poster board
- Small level
- White wine
- 3/4-in.-wide black matte tape found at art supply stores or masking or painter's tape

PHOTOGRAPHER'S COMMENT—Notes on the White Wine Set

I used a mixture of backlighting and strobe on this shot. The backlighting gives the curves and shape of the glass without reflections in the glass. I used a small Chimera lightbank on very low power to light the front of the set. The backlight also glows through the wine and frosted glass. No fill cards were used because they might create unwanted reflections. The lens and Hasselblad 39MS were set to capture the ambient light. A sheer beige material was taped over the window to soften the outside light and give a warm glow to the set.

CREATING CONDENSATION

My favorite technique to mimic condensation involves corn syrup rather than glycerin, which some stylists prefer. However, I use corn syrup mainly because I have developed a certain comfort level with it. One advantage with using corn syrup is that the water in the mixture evaporates overnight and the corn syrup will harden, leaving a semipermanent treatment. In fact, if you handle the glass carefully and avoid getting the

outside of it wet, you can reuse the same glass several times. It's even possible to handle the outside of the glass with clean, dry hands once it's completely dry.

> **TRICKS OF THE TRADE** If you are working on an iced beverage shot, begin your glass prep by using the frosted glass preparation technique just described. Most of the frost will disappear later when the glass is sprayed with the corn syrup mixture; however, the frosting technique lays a foundation on the glass, helping the corn syrup drops be more stable.

One photographer I work with had a glass I treated this way and he was able to reuse the same glass over a one-year period. He told me how he stored the glass between uses during the year. He kept a white card over the top of the glass, which prevented dust from gathering inside, and he placed the glass in a cupboard to avoid dust on the outside. Just remember that the finish on the glass is water soluble!

You will find it helpful to read through this entire procedure before beginning the application of condensation and drips. This effect is achieved by using a small spray bottle filled with a mixture of clear corn syrup and water. My favorite spray bottle is a 2-oz bottle with a push-down spray top. It can be purchased from a beauty supply store for less than $2. You'll need a bottle with a nozzle that sprays a mist rather than a stream. Because straight corn syrup is too thick to spray with this type of bottle, you will need to thin it slightly with just enough water to allow it to be sprayed. I use very warm tap water because it seems to mix with the corn syrup faster. There's no magic formula to follow because the

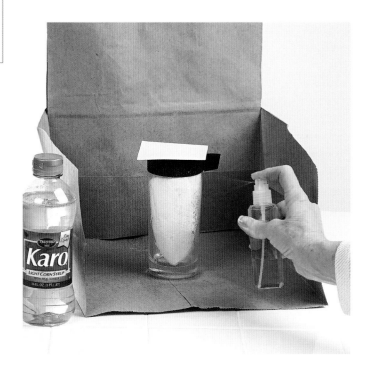

mix of corn syrup to water depends on the particular sprayer you use. However, the mixture is approximately three parts clear corn syrup to one part warm water. You'll want to practice spraying the mixture onto a piece of cardboard or a non-hero glass. It may take a couple sprays in one area before drops form. If your mixture is spraying out of the bottle in a solid stream you may still get a good effect when the liquid forms into drops on the glass. However, if it's too disconcerting or not working as you wish, thin the mixture with a tiny bit more water.

When you are ready to spray the hero glass, put the heavy paper or cardboard on the top of the glass as described in the frosted glass technique. Spray from a distance of 8 to 10 inches using a vertical stroke this time, moving from top to bottom of the glass. Less spray is better at first until you see how the drops accumulate on the glass. Some of the drops will combine to make larger drops and drips within a minute of spraying, so allow a little time for the mixture to move before you continue to spray the glass.

Carefully turn the glass to achieve spray coverage on all exposed surfaces of the glass. Once you're satisfied with the drop effects, let the spray on the glass settle for one hour. You will definitely need to remove the glass from the brown bag booth after one hour to prevent the bag from sticking to the glass due to the stickiness of the corn syrup. Move the glass to a safe predetermined place. A prep surface or small acrylic cutting board works well for this purpose.

Once the glass treatments are completed, the next step is to remove the black tape. Again, using the fingers of one hand inside the paper towel within the glass to keep it steady, carefully remove the tape by pulling the tabs you made when you applied the tape. If applicable, also remove any tape and paper towels from the foot or stem. Look at the glass from all sides to determine camera front. Finally, remove the paper towel from inside the glass. If time permits, I allow the treated glass to dry overnight before final photography.

Supplies needed to complete a glass with condensation effects:

- One hero glass treated with frosting effects
- Karo corn syrup, clear
- Cotton tipped swabs
- Small spritz spray bottle
- Windex glass cleaner

The technique for moving the glass at this stage of the process is a little different than during the prep phase. You are now working with a hero glass. Use this technique to move the glass from this point forward. Make sure your hands are very clean and dry. Lay one hand flat over the top of the glass, and tip the glass back enough to allow you to slip a couple of fingertips from your other hand under the bottom of the glass. Lift the glass and transport it to a predetermined location. Rest the back edge of the glass on the surface. Slide your fingers out

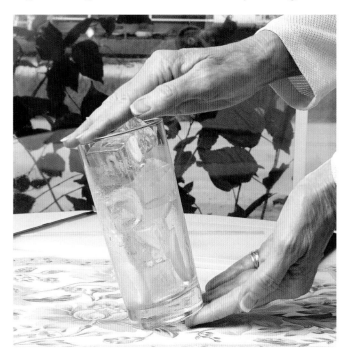

from the bottom of the glass using your hand that is flat on the top of the glass to leverage the glass to prevent it from falling over. Tip the glass upright to rest in the safety of a predetermined location until it is needed on the set. This same technique should be used to transport the glass to set.

> **TRICKS OF THE TRADE** Don't panic if you find any smudges or overspray in the top section of the glass that was under the tape or on the stem and foot of the glass. You can do any necessary touch-up spot cleaning with a cotton-tipped swab that has been dipped in glass cleaner—but make sure it's not wet enough to drip! I usually squeeze the cotton swab between my fingers to remove any excess glass cleaner before touching it to the hero glass.

BUILDING ACRYLIC CUBES IN A GLASS

We now take a look at arranging acrylic ice cubes in the hero glass. The process discussed next assumes you are also using fruit in the glass with the ice cubes; however, the technique is the same when using only acrylic ice cubes. Refer to the chapter on garnishes for information about making citrus wheels and slices. The beauty of using acrylic ice cubes is that they will not move when liquid is added to the glass. If there are fruit slices or wheels styled within the glass, the acrylic ice can be styled to hold the fruit in place. These same guidelines can be used to arrange real ice in a glass. However, be

aware that real ice will float and move within the glass when liquid is added. If you've used real ice and fruit wheels, that means everything will move and continue to move until the ice has melted. You will need to be prepared to work fast!

A long wooden skewer is a useful tool when building acrylic ice cubes and fruit within the hero glass. Begin with one or two cubes in the bottom of the glass. Then place the first lemon wheel flat against the inside of the glass so it also rests on the bottom of the glass. As you build the inside of the glass with cubes and fruit, arrange the components at different alignments. Tilt some cubes on their sides and place fruit at different heights within the glass. The fruit slices will show best if they are flat against the inside of the glass. Place the side of the fruit slice showing the color of the rind so it will be visible to the camera. The finished drink will be more attractive visually if you position the top ice cube at an angle so one corner of the cube slightly breaks through the surface of the liquid. Use the line created by the tape and dulling spray to determine how high to build the cubes.

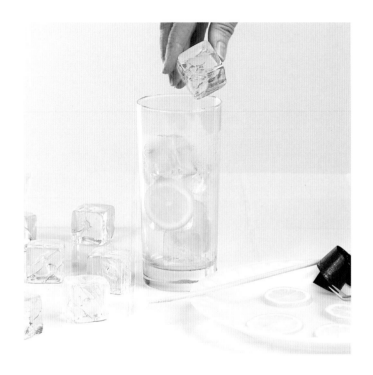

On Set

Once the glass is on set, you need to see how the lighting interacts with the acrylic ice cubes. Light tends to bounce into and out of acrylic cubes and can cause some undesired effects. Adjustments can be made to the angle of any offending cubes. When you make changes to acrylic cube positions, use a wooden skewer to nudge the cubes. Be aware that small moves make a big difference in the way light comes through acrylic cubes. If a cube near the bottom of the glass needs to be adjusted, you may be able to nudge it enough to eliminate the light problem. However, it might be necessary to remove

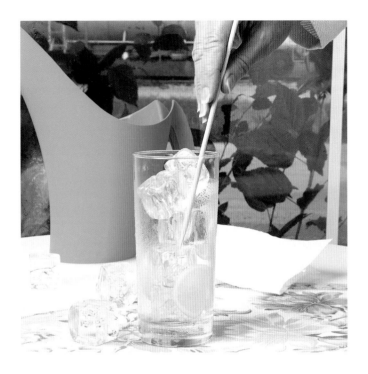

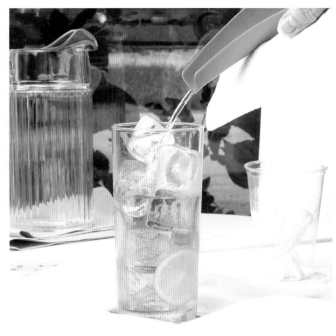

a couple of cubes from the glass in order to adjust the offender.

Once the cubes are positioned within the glass, check the condensation drops on the glass exterior to determine if additional drops are needed. It is often easier to make this determination after the hero liquid is in the glass. Regardless of when you apply this technique, use a syringe or small eyedropper to place nondiluted clear corn syrup in very small amounts to achieve drops or runs where desired.

ADDING LIQUID TO THE HERO GLASS

Now we are ready to add the liquid. My favorite pitcher for pouring liquids on set is actually an inexpensive plastic garden watering can with an extra long spout designed to water houseplants.

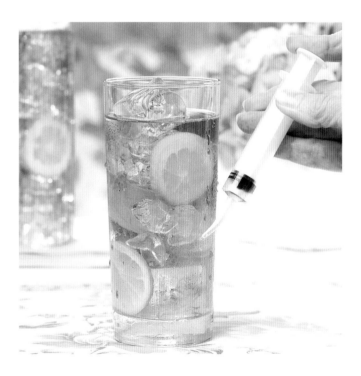

Transfer the hero liquid into the pouring pitcher and go to the set. Have a few paper towels at hand. Position yourself so your eyes are at camera level or, better yet, ask someone for assistance to look from the camera while you pour to tell you when the liquid level is even with the fill line. Position the pouring spout near the center of the glass, but to avoid splashing do not aim directly at an ice cube. Pour in a slow stream to keep the liquid flowing in an even manner, avoiding any splashing and/or dripping. Pour the level of liquid in the hero glass up to the frost fill line made during the frosting and condensation processes. For extra insurance against any drips, hold a folded paper towel under the pouring spout after you pour to protect from drips as the spout moves away from the glass.

MAKING AND PLACING BUBBLES

Immediately after they've been poured into a glass, many beverages naturally have bubbles on the surface of the liquid. The appearance of bubbles gives a freshly poured and a more interesting appearance. Bubbles on

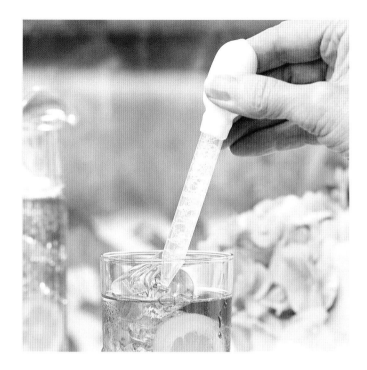

times. Keep squeezing the dropper bulb until you see several bubbles the size that you want floating in the cup.

When everything on set is ready for final capture, working at the set and using the dropper, suction a few bubbles into the dropper. Choose bubbles that are the size you want floating on the hero beverage. Wipe the outside of the dropper with a paper towel before depositing the bubbles on the beverage surface.

There isn't a magic formula for how long the bubbles will last. Some hang around for a long time, some are short lived. You will need to watch them during the photography process. If bubbles burst, they can be replaced.

Supplies used to make surface bubbles:

- Clear liquid dish or hand detergent and water
- Plastic bulb-type dropper
- Cup or mug
- 1/4 cup of the hero liquid

The image of ice tea on a sunny table was created using all the techniques in this chapter. Both the pitcher and glass contain acrylic cubes of different sizes and shapes. The glass was treated with frosting and condensation

the surface of a photo drink can be made by using some of the hero liquid plus a clear liquid dish or hand detergent. Using clear dish detergent to make the bubbles will keep the bubbles looking more natural. To make and place bubbles, use a plastic dropper. Put about 1/4 cup of the hero liquid into a mug or cup, and mix 1 tablespoon of clear liquid dish detergent into it. With the tube end of the dropper in the liquid, quickly squeeze and release the dropper bulb several

techniques, and additional drops and drips were added to the glass exterior using a syringe filled with clear corn syrup. Bubbles were floated on the liquid surface. The liquid used in both the glass and pitcher is actually a mixture of water and brewed coffee. You can use real tea; however, I have experienced occasions when it looked a little cloudy to the camera.

Supplies used to complete the iced tea shot:

- One hero glass treated with frosting effect and condensation treatment
- One stand-in glass
- Cardinal International pitcher and glass
- One small artist's brush
- Cotton-tipped swabs
- Acrylic ice cubes and shards
- Long wooden skewer
- Plastic bulb-type dropper
- Plastic bent-tip syringe
- Pouring pitcher or small garden watering can
- Brewed coffee and water
- Windex glass cleaner
- Karo corn syrup, clear
- Bounty paper towels
- Six lemons, for lemon wheels (refer to chapter on garnishes, Chapter 12)

REMOVING LIQUID FROM A HERO GLASS

There are several ways to remove liquid from a hero glass. Of course, you can always just pour the liquid out of the glass, but this will likely endanger the exterior of the glass and will not permit any future use of the glass. If you want to preserve the techniques on the glass exterior, here are two methods I prefer to remove liquids from a hero glass. I have a large syringe that was purchased at a ranch and veterinary supply store. (Basting syringes are similar in size and will serve the same purpose.) You can remove the needle for this technique, if you wish. The syringe is narrow enough to fit into most glasses. It normally takes several fillings of the syringe to empty most glasses but this is a perfect nondrip method for liquid removal.

Another method is to create a siphon. This method is especially useful for pitchers and containers that hold a lot of liquid. I use a length of clear flexible plastic tubing 1/4 inch in diameter and 18 to 24 inches long. Siphon the liquid into a different container.

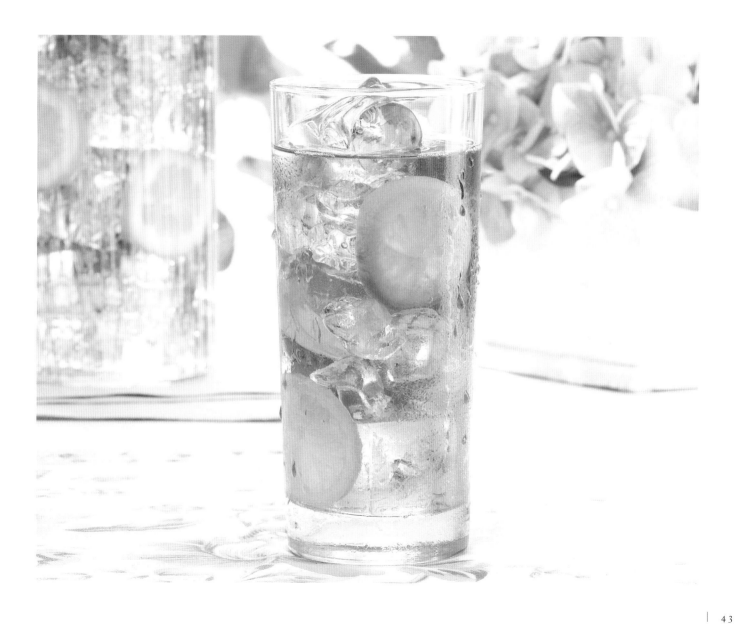

When all liquid has been removed from the hero glasses and/or containers, remove the acrylic cubes from the glass. Carefully insert a paper towel into the glass. The paper towel will absorb any liquid remaining in the glass and will create a means for you to move the glass as you did in the earlier treatment procedures.

Supplies used to create the full-page image of red beverages opening this chapter:

• Glasses treated with frost and condensation techniques

• Cardinal International Islande 12-oz acrylic ice cubes and shards

• Red liquid (I used pomegranate juice as a base and added water and liquid red food coloring)

• Karo corn syrup, clear

PHOTOGRAPHER'S COMMENT—Notes on the Iced Tea Set

Let the sun shine in! For a fresh glass of tea we are in the window this time. We set this shot up a few days before the day of the shoot to know exactly what time of day would be perfect—in this case, 4:15 p.m. I balanced strobe and natural light with a medium Chimera lightbank and small lightbank for an overall brightness to balance the stream of natural light coming through the window. We opened the window to prevent any reflections and let the wind blow.

PHOTOGRAPHER'S COMMENT—Notes on the Chapter-Opening Shot with Glasses Containing Red Beverage

Not a sunny day? No problem! I use a Chimera Lantern lightbank at the back of the set. This little beauty works like a soft sun, a little ball of light. It evens out the background and wraps light around the edges of the glasses. A soft fill with a medium lightbank at camera does the trick. Once again no need for reflectors or fill cards. Pulling focus with my Hasselblad H3D makes the front glass the hero.

SLUSHY DRINKS: THE MAGIC FROZEN MARGARITA

> **SAFETY NOTE** This method of creating a slushy drink is for photography purposes only. The mixture is not for consumption!

I remember years ago renting a margarita machine for a photo shoot. It took a couple hours for the machine to chill the mix to the perfect slushy consistency. Both the photographer and I had to be completely ready for the hero. He had to have the lighting perfected and I had to have numerous glasses prepped because the photo life of the slushy mixture was less than 2 minutes, even though the building air conditioner had chilled the room to a point where the crew members were all wearing sweaters!

With new technology a very realistic fake slushy frozen margarita can be made for the camera. With the right supplies and tools the process is quick and simple and produces great results. The photo life of the hero mixture will be about five times longer than that of a frozen mix.

> **TRICKS OF THE TRADE** Use the margarita mix you purchased for color matching only. The high acid and sugar content of some margarita mixes interferes with the Soil Moist granules' absorbent qualities. For these same reasons you'll want to avoid using sport drinks that have a higher acid or sugar content.

Pour four cups of Glacéau Vitaminwater Tropical Citrus sport drink into a large clear glass container. Your task is to closely match the color to the margarita mix. I usually remove the label from the margarita mix bottle for a better visual of the color. The sport drink will need a little green coloring added to it. With a toothpick or skewer tip, pick up just a touch, not even a drop, of liquid green food coloring and stir it into the sport drink. A little green food coloring makes big changes, so go slow. To better match the margarita mix, I chose to add a hint of

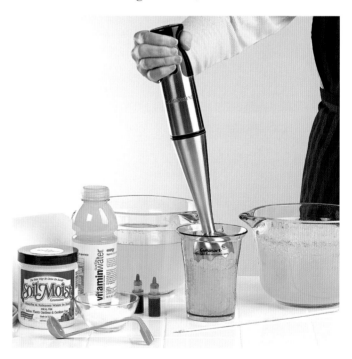

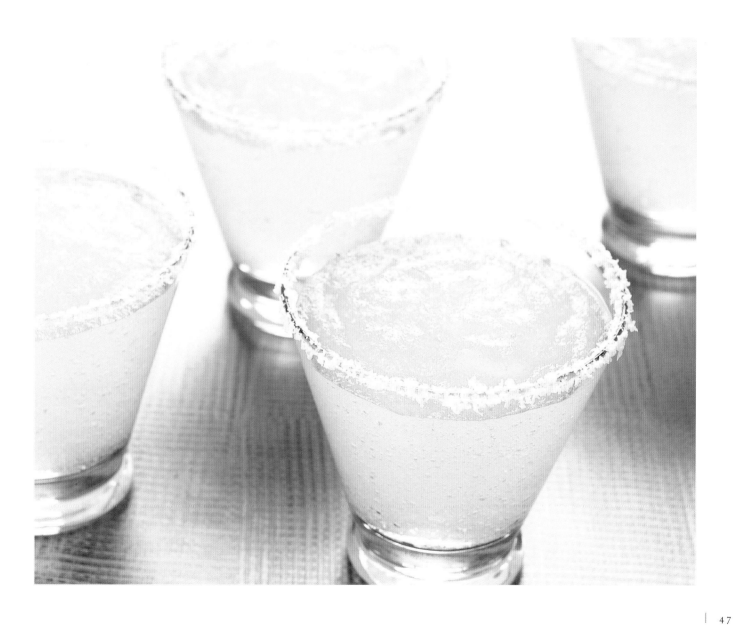

blue to the mixture in our shot. Your mixture may appear clearer than the margarita mix at this point, but don't worry about that because the next steps will correct the appearance. For now, just match the color to the margarita mix.

Once you are content with the color, transfer about one-half of the liquid into a large glass mixing bowl. Reserve the remaining liquid for later use. Stir four level tea-spoons of Soil Moist granules into the mixture in the glass bowl. Let the mixture set for 10 minutes. Surprise! It's grown and looks icy. Remove a few cups of the mixture to a blending beaker or bowl with tall sides. Using the blender or a Cuisinart Quick Prep mixer, blend the liquid for a few seconds. If the mixture becomes too thick, add a little of the reserved mix without granules and blend again. Keep blending until the gel granules are small and appear like slush.

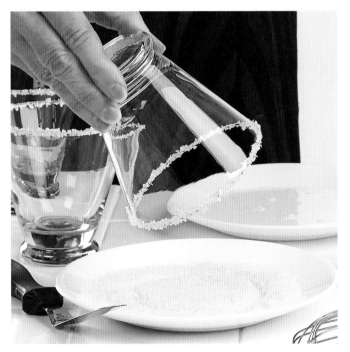

Before applying any treatments to the hero glasses, remember to clean them with soap and water. Dry the glasses with clean paper towels. Next, clean the glasses both inside and outside with glass cleaner and dry with clean paper towels. Make certain your hands are clean and thoroughly dry before handling the glasses. To salt the rims of the hero glasses, separate the yolk from the white of one egg. Put the egg white into a small glass bowl with about 1 tablespoon of cool water. Mix the egg white and water thoroughly with a whisk. Pour the mixture into a plate. On another plate, put a level layer of margarita or gourmet salt about 1/8th to 3/16th inch thick. Use a spatula to level the salt. Holding one glass upside-down, dip one edge of the glass into the egg white mixture and rotate the glass in a circular motion to coat all edges.

TRICKS OF THE TRADE If you put the glass flat into the egg white mixture, the pressure created within the glass will force the egg whites unevenly inside the glass. To avoid this, angle the glass to rotate through the egg whites while one edge of the glass is above the liquid.

When the glass rim is coated with the egg mixture, continue holding it upside-down. Remove any drips with a cotton swab. Dip the glass into the salt mixture using the same rotating circular motion. Gently push the edge of the glass through the salt but avoid pushing the glass

down too hard because it will mash salt away from the edge of the glass rim. Place the glass right-side up on a clean surface. Level the salt in the plate with the spatula before dipping the next glass. Repeat the process for all hero glasses.

Going to Set with the Margaritas
We used some of the original margarita mix in our stand-in glasses to help compose this shot. When the

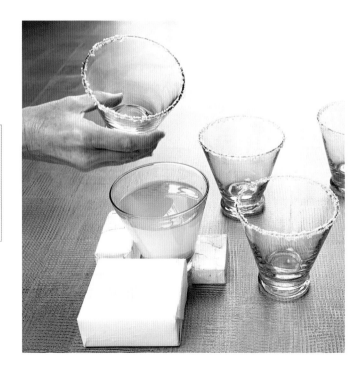

arrangement of glasses on your set is comfy to the eye and to the camera, you can replace the stand-ins with hero salt-rimmed glasses. Working with one glass at a time, block a stand-in glass on three sides to mark its position. Lift the stand-in glass straight up and off the set. With very clean hands being careful not to touch the salt, place the hero glass within the blocks marking the spot for the glass. Repeat this process for each glass in your shot.

When you transfer the margarita mixture into the hero glass, again take care not to touch the salt rim with your hands, tools, or with the margarita mixture. When all the glasses are filled, use a wooden skewer to break up any undesirable bubbles or areas of light refraction. Use a spoon to add additional margarita mix to mound up for a realistic presentation. With the back of the spoon, gently press the mix to create swirl or textural patterns as you wish. Before final photography, use a bulb or

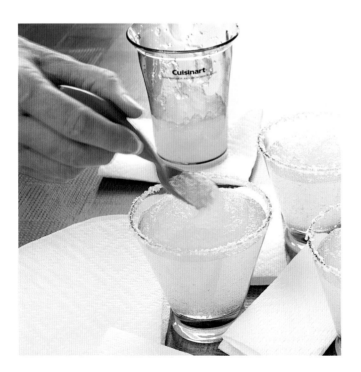

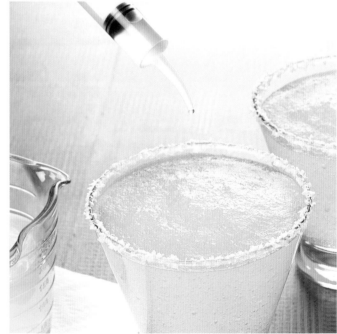

syringe dispenser to add some of the reserved liquid to the top surface of the drink to give it a slushy, just-made look.

> **SAFETY NOTE** I know this photo beverage looks tempting, but do not drink this margarita!

Supplies used to complete the margarita shot:

- Cuisinart Quick Prep CSB-77 and mixing beaker

- One bottle margarita mix (for color reference only)

- Hero glasses treated with frosted effect, Anchor Hocking 13-oz Martinique stand-in glasses

- Sport drink (I use Glacéau Vitaminwater. Buy extra for the crew to drink. It's really good!)

- Soil Moist granules

- Two Anchor Hocking 2-quart clear glass batter bowls

- Clear Anchor Hocking 8-oz three-way pour glass measuring cup

- Zak Designs measuring spoon and mixing spoon

- Two small Cardinal Glass glass bowls

- Small OXO Good Grips whisk

- Windex glass cleaner

- Bounty paper towels

- Two Arcoroc dessert-size plates

- Wilton Comfort Grip 9-inch angled spatula

- Liquid food coloring kit

- Long wooden skewer

- Plastic bulb-type dropper

- One egg white

- Gourmet coarse salt

- Cotton-tipped swabs

- Hand-painted surface by Brad G. Rogers

PHOTOGRAPHER'S COMMENT—Notes on Margarita Set

If you don't have a window in your studio . . . get one! Or, open your door, shoot in your house, or go on location for drink or liquid shots. You can't control the weather but it really doesn't take much daylight to get the effect. I have warm-colored walls in my shooting area around my windows. This warms the entire set. Again, I have used a small Chimera lightbank for fill, high and to the side. No fill cards were used because they can cause reflections in the glass. The Hasselblad H3D with telephoto lens is the perfect choice for this kind of shot.

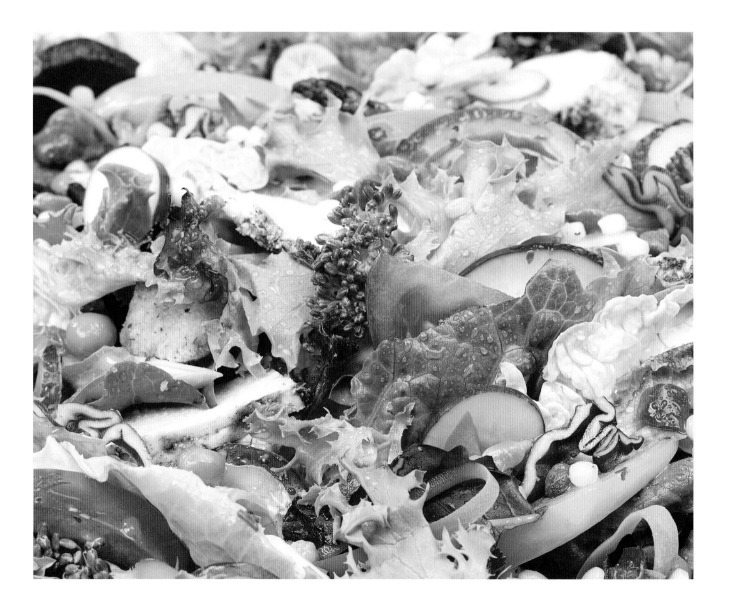

MAKING A SALAD FOR THE CAMERA

For the stylist and photographer, shooting a salad is literally a creation of art. In a well-built, well-lit salad the vibrant colors, textures, and dimension are a feast for the eyes. Your eyes are taken on a voyage through the image's beautiful landscape.

SELECTION OF SALAD INGREDIENTS

When you shop at the produce market for photograph quality salad ingredients, purchase a wide variety of items so you will have them available in the studio when you build the hero salad. Without ingredients that have color and texture differences, the salad will appear monotonous and boring. So, choosing ingredients is extremely important. Think of color wheel opposites and complementary colors as you select vegetable and other salad ingredients.

Have a larger variety of ingredients in the studio than you expect to use. Prep and hero all items before you begin to build the salad. As you compose the salad, you will appreciate having a large color palate of ingredients from which to choose.

Red onion slices with purple tones, and bell peppers in yellows, reds, and oranges are good examples of items that contrast with salad greens both in texture and color. Tomatoes, pomegranate seeds, herbs, and spices offer color and textural interest. Carrots and mandarin oranges have a lot of potential for shape and lend wonderful orange tones; something as simple as adding an orange element can visually pull the salad together.

Don't forget items like sliced beets, pickled vegetables, canned mandarin orange segments, and croutons that are found on shelves at the market. Be sure to check the deli department too, because there may be some great ingredients to be found there that won't require prep work. Gourmet baby greens add color and textural interest to a salad. The tight growth pattern of baby greens will create a bunch of color and texture in a small space, and they mix well with other types of lettuce for a photo salad base. Also, consider using the cooking methods discussed in the chapter on vegetables (Chapter 8) for some of your salad ingredients. Refer to Chapter 12 on garnishing for more ideas about cutting produce for a salad.

NOTE Techniques used for creating pasta, potato, and vegetable salads for the camera are more similar to the methods used for pasta and sauces than to those used for making green salads. Refer to the chapter on pasta (Chapter 5) for those techniques.

SHOPPING AND HANDLING TECHNIQUES FOR PRODUCE

Whether you're making a salad with greens or fruit, quality and freshness are essential. If you have worked

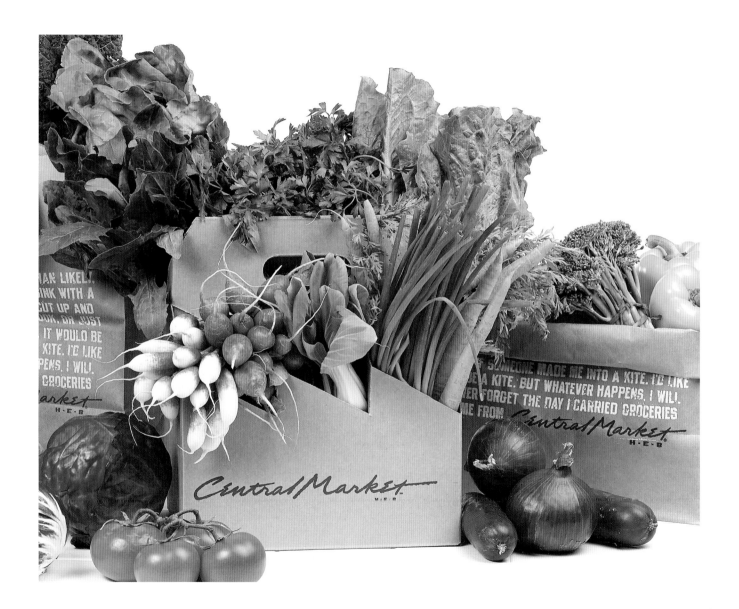

with a food stylist on a photo shoot that involves produce, you are already aware of the careful shopping that took place before the stylist arrived. As the stylist unpacks the contents from grocery boxes and bags, you are immediately aware that the beautiful, blemish-free produce is treated like royalty: It's pampered and carefully tended and nurtured.

For you to achieve success with your project, you'll need to adopt a stylist's care with selection and treatment of produce. Refer to Rule Seven in Chapter 1 for additional information.

Handle everything gently, avoiding hard contact with anything, especially the plastic or metal grid of a shopping cart or basket. Avoid stuffing tender items into plastic bags. And when you use plastic bags, place only a small number of items in each bag. Tell grocery checkers, before they start ringing up your selections, that you are purchasing items for a photo shoot and you would appreciate their care in handling the items. You need to supervise the bagging process or, better yet, do it yourself to make sure all items are safe. Use separate boxes or paper bags for all greens, tender fruit in one layer in boxes, etc. Once you select produce from a store's display, it is up to you to be its guardian and protector.

TRICKS OF THE TRADE If your climate is too warm or too cold, you will need to preplan to have insulated coolers available to protect tender items such as greens during transport from market to studio. They'll wilt if too hot and freeze or bruise if too cold. Due to the temperature sensitivity of salad greens and fragile produce, it helps to keep the studio temperature a tad on the cool side the day of the shoot. I would recommend a temperature in the mid to upper 60s. If this isn't possible or practical, you can rig a large, mesh-metal strainer containing some dry ice pellets about 8 inches above the hero salad as you build it. The cold from the ice flows downward. Do not touch the dry ice with bare hands because dry ice will freeze and burn skin on contact. Use tongs to maneuver the dry ice into and out of the mesh strainer. Also, be sure to check the temperature settings on the refrigerators in the studio to avoid freezing lettuce and produce. I've experienced frozen produce a few times because I forgot to check the setting on the refrigerators.

TIPS FOR KEEPING SALAD GREENS FRESH

Salad greens will perk up, refresh, and stay fresh appearing longer if they have a quick bath in cold tap water with Fruit Fresh Produce Protector mixed into the water according to directions on the packaging. Shortly before beginning the salad build, place small bunches of greens into a large bowl or a clean sink filled with cold tap water and the produce protector. This process requires using small batches of greens so they are not crowded or mashed into

the water. Gently swirl the greens in the water for a few seconds. Using your hands, with fingers slightly apart, let the majority of water drain from the greens before placing them into a salad spinner. Once spun dry, place the greens on trays lined with paper towels. Placing a single layer of greens on each tray, rather than piling them up, will give you easy visual reference for hero selection while building the hero. Cover the tray with damp paper towels, wringing them out first so they won't be too heavy. Repeat this process for all of the salad greens. Refrigerate the trays of hero greens until you are ready to build them into the hero salad. If the paper towels covering the salad greens dry out, you will need to mist them with water to keep them moist until you're ready to use the greens.

Other produce items used in salads should be cleaned and placed on trays. Produce for photography does not require washing unless it appears dirty. Even then, most debris can be wiped away with a moist paper towel. If you are building the hero on the same day as your marketing trip, produce other than greens can be kept at room temperature. Wait to cut any produce items until just before you are ready to build the salad.

Be sure the knives you are planning to use are sharp before cutting produce. Most produce has skin that is tougher than the interior. If your knife isn't sharp, as you make a cut through the skin of the produce, the skin will tear,

resulting in a rough edge and bruising of the flesh around the cut. As you cut produce for the hero salad, lay the pieces on trays for easy selection as you build. Trays of cut produce can be covered with damp paper towels and plastic wrap, and stored in a refrigerator until you begin to build the salad. Sliced, shaved, or pared carrots should be kept submerged in ice water until built into the salad.

If your refrigeration space is limited, you can use spacers to sit on each tray corner that will allow tray stacking without crushing the tray contents. The spacers can be wood or craft foam blocks of the same size. This trick works well for numerous applications when storage space is limited in the studio and/or in the refrigerator.

SALAD SUPPORT TECHNIQUES

Before you begin to build a salad for photography, you need to take into consideration the size of the salad.

Although most salad ingredients aren't heavy, you'll probably be adding colorful things to the top of those greens. The accumulated weight of those items can cause the greens to sink or collapse. And a "moving" salad is not an option for photography. If the salad is on a serving plate, it may not be necessary to provide a support structure.

If the salad is to be photographed in a bowl, regardless of the depth of the bowl, I normally begin the salad build by inverting a clear glass bowl within the hero salad bowl. Start by placing some salad greens in the bottom of the hero bowl so that the inverted support bowl will rest on the greens. These greens will conceal the rim of the support bowl where it touches the inside of the hero bowl. The inverted bowl provides solid support for the heavier salad ingredients that will be added to the top layers of the salad.

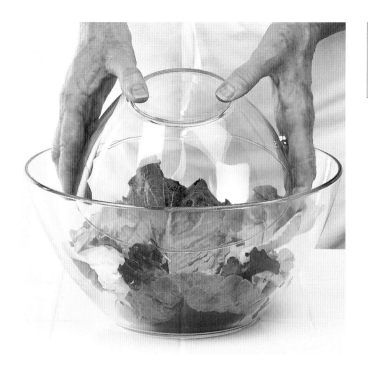

HOW TO DRESS A SALAD FOR PHOTOGRAPHY

An oil-based salad dressing causes salad greens to collapse and will make everything in the salad slippery and difficult to style. For this reason, you don't want to toss dressing into a salad for photography the same way you would at home. If you choose to show that a dressing has been applied to a salad, there are some tricks to consider. The most interesting aspect of a salad dressing for photography is the small bits of herbs and spice flakes. These can be added to the salad by first misting

Build salad greens between the two bowls to further conceal the inverted bowl. Using this method doesn't totally prevent cave-ins, but it helps. The longer a salad waits on set for final capture, the higher the chances are the salad will settle and the perky fresh appearance will be lost. Another method for creating support within a photo salad is to use STYROFOAM cut into an appropriate shape for the hero bowl. Spray the craft foam with spray paint in a color close to lettuce green and use salad greens to hide the support from the camera's view.

the salad with water and then sprinkling herb and spice flakes onto the salad. The water helps to hold the herbs and spices in place. Herb flakes and spices can also be mixed with a light oil dressing and applied with a brush to all of the non-greens produce in the salad before it is built into the salad.

If you want to achieve an appearance of dressing on the salad, once the salad is built, use a small bulb dispenser or eyedropper to place dressing in areas around the salad. If you choose, you can touch some dressing in a few areas on the greens using a small artist's brush or bulb-type dispenser, but don't go crazy doing this or the dressing will cause your salad to collapse.

BUILDING THE SALAD AND TAKING IT TO SET

> **TRICKS OF THE TRADE** When you build the salad, work on set with your eyes at camera level. This troubleshooting technique is good to remember whether building a hero on set or off set. The camera angle is all that matters for photo food. As you build any hero plate in the prep area, protect your back and neck. Avoid slouching or bending to maintain your eyes at the approximate camera relationship to the plate. Instead, use a box or other solid platform to raise the plate to duplicate the right height relationship for the plate so that your eyes will be at camera height.

As you start building the top layer of the salad, work some of the hero greens into the layers of lettuce below. Once the height of the salad is achieved, and you are pleased with the alignment of the greens, it's time to start placing other ingredients for color. If an element in your salad is heavy and sinks into the salad, it will need to be supported. The support allows you to keep the heavy item within the camera view. To support a heavy piece of produce or meat, insert a toothpick into its base

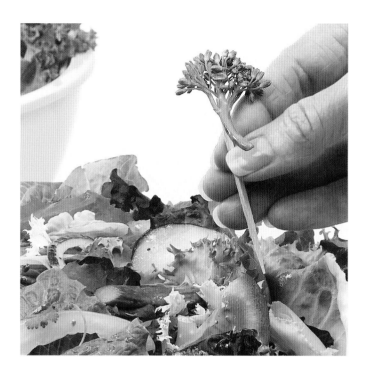

spray. Salad ingredients that were previously brushed with salad dressing or oil may need a touch-up.

Supplies needed to complete the green salad shot:

- OXO Good Grips salad spinner, swivel peeler, Y peeler, and carving and cutting board
- STRETCH-TITE plastic food wrap
- Bounty paper towels
- Messermeister San Moritz elite 6-inch chef's knife
- Henckels Twin Four Star II utility knife and kitchen shears
- Cardinal International glass bowls
- Fruit Fresh Produce Protector
- EMS-style 24 bent-tip tweezers
- STYROFOAM
- Zak Designs small colander and Gemini Bowl
- Pastry brush and artist brushes
- Cafeteria trays
- Spritz bottle filled with water
- Small bulb dispenser
- Toothpicks
- Small wire cutters

and adjust the length of the toothpick to keep the item at the desired height within the salad. Use a lettuce edge to make sure the toothpick isn't visible to camera.

ON SET BEFORE FINAL PHOTOGRAPHY

The salad will look fresher to the camera if it is lightly misted with water before final photography. Use paper towels to protect the sides of the bowl/plate from over-

PHOTOGRAPHER'S COMMENT—Notes on the Green Salad Set

Up close and personal. Once again there's no time to waste on this shot. The salad starts to lose freshness pretty quick. We used a bright white set for a crisp, fresh look with lots of light bouncing around for an even effect overall. Bright white is always a good background for food if you are really going in close for detail of the food. Three Chimera lightbanks were used: a small one on the background and two medium lightbanks on each side of the set.

FRUIT SALADS

I really enjoy styling fruit salads. The range of possibilities for design compositions is infinite. Fruit salads can be simple, casual, elegant, or complex. But, perhaps the reason fruit salads are so fun for me is because I enjoy working with the rich and vibrant colors of fruits. Fruits and berries offer a bevy of potential for using complementary colors and textural variances.

> **TRICKS OF THE TRADE** Due to the extremely short photo life of most fruits, you will need to have a stand-in to work the set and lighting. Even though you will use a rough stand-in, it will help you determine the style of build for the fruit salad and the desired height of the build. The stand-in will also be useful as you make decisions about whether peelings will be removed or left on specific fruits, the shape of cut fruit, etc. Depending on your shot, some fruits, such as apples and pears, have more color interest with the peeling left on.

Techniques for Fruit Prep

Because berries are extremely perishable, I normally purchase them the day of the shoot. I don't wash raspberries, blackberries, blueberries, or grapes, and I handle them as little as possible. They are gently placed on trays lined with paper towels until needed. Strawberries get a quick bath in a large bowl of cool water and Fruit Fresh Produce Protector then placed on trays lined with paper towels. Refer to the chapter on garnishing (Chapter 12) for helpful techniques when working with strawberries and the green strawberry tops.

Because most of your fruit ingredients will have been purchased on the day of the shoot, most fruits will be fine if left at room temperature. Lay them out on trays or on a tabletop so the fruits are not touching. If you had to shop the day before photography, you will need to ensure that the overnight temperature in your studio is between 60 and 65 degrees. Lay an inverted bowl, baking pan, or cardboard box over the fruit to protect it from drafts and insects. Make sure the item covering the fruit doesn't touch the fruit. It's also a good idea to put a note on bowls and boxes covering fruit, informing studio personal that hero fruit is being protected and to keep their hands off!

> **TRICKS OF THE TRADE** Bananas produce a gas that acts as a ripening agent for other fruits, so keep them in a separate holding area. On the other hand, if you purchased fruits like peaches, pears, and mangos that are underripe, you can somewhat speed the ripening process overnight by placing them with a ripe banana in a brown paper bag or under a glass bowl.

The cutting of fruits must be performed immediately before final photography. Make sure your knives and peelers are sharp. Before you start to cut fruit, mix 4 to

quick visuals of all the fruit when building the hero salad. When all the fruits for your salad are cut, start to build the hero fruit salad.

TRICKS OF THE TRADE Because of the fragile nature of most fruits, especially after being peeled and cut, you will need to handle the fruit very tenderly. To remove fruit pieces from the water bath I usually use my hands with fingers held slightly apart for drainage rather than a kitchen implement that might bruise the fruit.

6 cups of cool water and the recommended amount of Fruit Fresh Produce Protector in a bowl. I prefer using separate bowls for each type of fruit. When you start peeling and cutting the fruit, you will want to work safely but quickly. First remove any unwanted peel from the fruit. Give the peeled fruit a quick dip in the water bath. Then cut the fruit into desired shapes and immediately immerse the pieces in the water bath again. Lay the individual cut pieces on a plastic tray and lightly cover the tray with plastic wrap. This method will give you

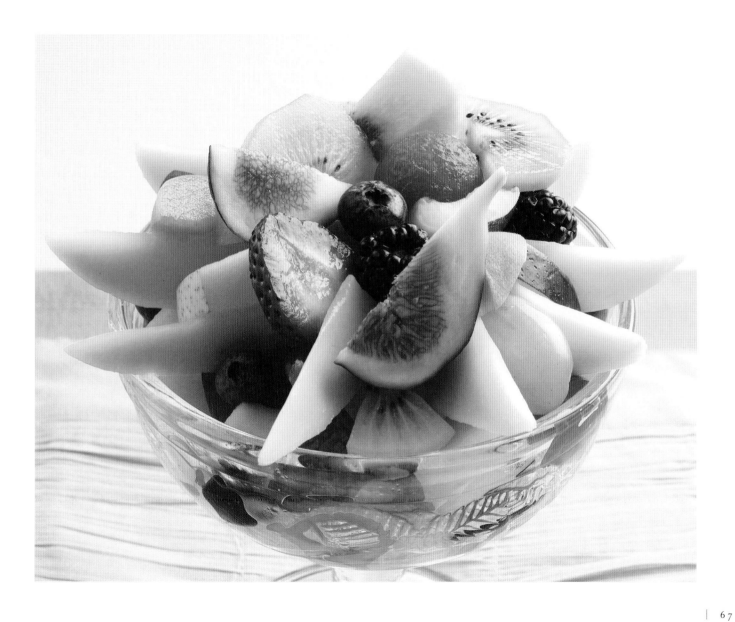

Melon balls are easy to make if you have the right tool. Most melon ball tools have scoops on both ends. The scoops are usually slightly different in size so you will want to determine which size works best for your needs. Practice before you start to make hero melon balls. Cut a melon in half lengthwise. Remove all seeds from the melon with a metal spoon. Place the melon ball tool on the cut edge of the melon in the richest color area, avoiding the rind as well as the area where the seeds form. With the scoop of the melon ball tool, cut into the melon

flesh, using a twisting motion of your wrist while pressing gently down into the melon flesh. There may be one small flat area on the ball and you will want to hide it as you position the melon ball within the fruit salad.

If you want to remove the peel from a soft fruit such as a mango, peach, or pear, you should use either a sharp paring knife or a sharp vegetable peeler. Because the flesh is tender and easily bruised, take care when handling and grasp the fruit gently. After the peel is removed, dip the fruit in a Fruit Fresh Produce Protector water bath. The fruit may have unwanted ridges after the peeling process. At this point, it may be necessary to smooth the texture of the fruit with a paring knife. Be sure to dip the fruit into the water bath after this process.

Building a Fruit Salad and Taking It to Set
Let's take a look at some tricks you can use to enhance the dimension of a fruit salad. If your hero fruit salad is to be in an opaque bowl, fill the bowl two-thirds full with a thick instant mashed potato mixture that acts as a filler. If your fruit salad is in a clear bowl, you can still use the mashed potato filler, but be careful to conceal the potato mixture with fruit as you build the salad. Using this technique gives you a sturdy base for the fruit salad and also gives you the opportunity to create height differences in the salad by adding or taking away some of the mashed

potatoes. Use a tapered spatula to make adjustments in the height of the mashed potato mixture. The mashed potato mixture can also be useful in getting height in fruit salads on plates or to give support to individual fruit pieces. Keep in mind that you can only use the potato mixture when you can hide it with fruit so the camera won't see it. The mashed potato mixture also absorbs any excess juices from the fruit. The toothpick technique as described in the green salad section of this chapter can also be used to support fruit pieces. However, you will need to be extra cautious to avoid pushing the toothpick completely through the fruit.

When you build the hero fruit salad, use the differences in colors and textures of the fruit to create interest and beauty.

Dressing a Fruit Salad

Fruit salads photograph best with no dressing. However, if your fruit salad is to have a dressing, the best way to apply it is either with a brush or with a spritz bottle. If a dressing normally appears thick or heavy visually, it will not photograph well applied in its usual consistency. To photograph these types of dressings successfully, the mixture must be thinned considerably and brushed onto the fruit pieces before they are included in the hero build. After the salad is built, a thicker

consistency of the dressing can be added in selected areas with a dropper or applicator bottle. Using this method gives the fruit pieces interest and prevents a goopy mass appearance.

As you build the salad, and during the time on set before final photography, you will need to brush the fruit with the Fruit Fresh Produce Protector/water mixture to keep it moist. The fruit must appear luscious and juicy to the camera. If you are shooting on a plate and excess liquids begin to build up on the surface of hero plate, use cotton swabs or small folded squares of paper towels to absorb the excess liquid as needed.

Supplies used to complete the fruit salad shot:

- Cardinal International hero bowl and work bowls
- Fruit Fresh Produce Protector
- Henckels Twin Four Star II 3-inch paring knife
- OXO Good Grips Y peeler, melon baller, utility cutting board
- Zak Designs bowl
- STRETCH-TITE plastic food wrap
- Wilton Comfort Grip 9-inch tapered spatula
- Bounty paper towels

- Spritz bottle
- Plastic trays
- Large work bowls
- Baking pans or boxes if needed to cover fruit overnight
- Small bulb-type dropper or syringe
- Dehydrated mashed potato mix, mixed with hot water to stiff consistency
- Toothpicks
- Small wire cutters
- Pastry brush
- Small artist's brushes

PHOTOGRAPHER'S COMMENT—Notes on the Fruit Salad Set

The lighting on the fruit set is very directional and low. I decided to sidelight with the window light. A small Chimera lightbank in the back works perfectly. The light on the front of the fruit is dark and rich.

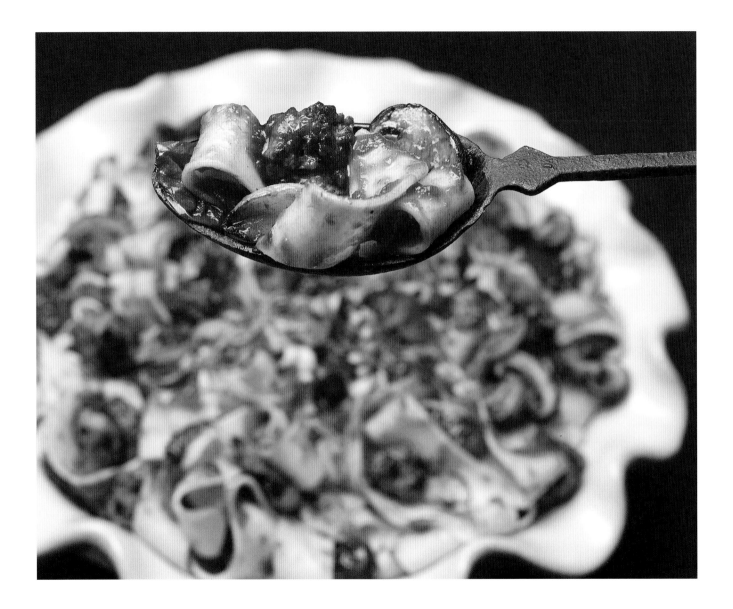

PASTA AND SAUCES

Almost every month food magazines feature a pasta shot. Pasta is a versatile, healthy, trendy food that can look stunning when prepared for the camera. To a stylist, pasta is akin to a blank canvas for an artist. Adding other ingredients for color and texture allows the stylist to use pasta as the medium to build a presentation with depth, color, and interest for the camera. By following some basic guidelines, you too can learn to make beautiful pasta dishes for photography that will make the viewer's mouth water.

Before you start to plan a pasta shot, it is helpful to look at examples of printed photography featuring pasta. Find samples to use as go-bys that contain a few of the elements you want to achieve in your final shot. Notice lighting, setting, textures in the set, as well as the pasta itself. Make notes about what you like in each shot. Once you have a list of desirable elements, you will have the basic criteria to begin planning your shot.

One of the things that makes pasta shots so beautiful is the depth created within the pasta arrangement. Long flat pastas, such as fettuccini and pappardelle, make graceful swirls and swoops when you employ good pasta techniques to create pockets of depth. Some of these pockets are nice to keep as they are, whereas in others you might choose to place different ingredients or sauce. Garnishes give yet another layer of interest to a pasta

dish. I occasionally add fresh snipped herbs or a sprinkle of gremolata garnish on pasta after it is built and right before final photography.

Because pasta is not an extremely perishable food, the pasta prep can take place early on the day of photography. Once the pasta is prepped and safely stored, you can prep the sauce and other ingredients before assembling the hero dish.

PERFECT PASTA FOR THE CAMERA

First you'll want to look at the uncooked pasta as it comes from the manufacturer's packaging. Remove any obviously broken or cracked pieces. Follow directions on the pasta packaging for recommended water volume for cooking. Use a large kettle or stockpot to heat the water.

TRICKS OF THE TRADE Add 2 to 3 tablespoons of vegetable or olive oil to the water before dropping the pasta into the boiling water. The oil helps prevent the pasta pieces from sticking together. After you add the pasta to the water, give the pot a gentle stir with a long-handled wooden spoon. Use a wooden spoon because the edges of a metal spoon might damage the pasta.

Your goal is to keep the water at a low boil during the entire cooking process. Because adding the pasta to the water will cool down the temperature of the water, start

adding pasta when the water is at a full boil. The movement of the boiling water helps keep the pasta from sticking and also cooks the pasta more evenly. Adjust the temperature under the pot to keep the water at a consistent low boil.

As the pasta cooks, the outer surface areas of the pasta directly exposed to the water cook first. Pasta also absorbs water as it cooks, causing the pasta to swell in size. Once the full size is reached, the inside of the pasta may still be

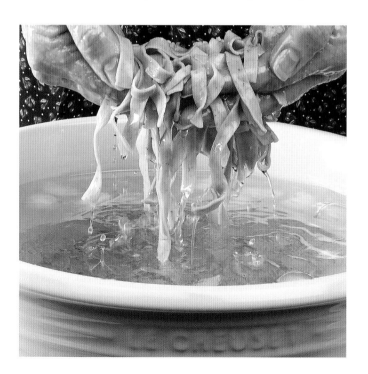

a little raw. However, to the eye the pasta pieces look cooked and the edges are still distinct. That's when it's perfect for photography. It is still a little too firm for consumption, but it doesn't matter as long as the pasta looks cooked. When it reaches this stage, remove the pasta from the heat and immediately drain it into a large colander. Quickly transfer the pasta into a large bowl or kettle filled with cold tap water and six to eight cubes of ice. To transfer the pasta, simply tip the colander and let the pasta slide into the cold water. The ice will melt away quickly.

The cold water will quickly cool the pasta. Once cooled, the pasta must be removed from the water. This prevents it from absorbing more water, making it fragile and not as well formed.

Handling the pasta gently, use your hands to drain the water from the pasta and place the pasta into gallon-size Ziploc bags, which have been premarked as *hero* with a felt-tip marker. After placing about 2 cups of pasta in the bag, if any water has collected, tip the bag and drain the water. Add 1 tablespoon of olive or vegetable oil to the bag. Remove some but not all of the air from the bag and seal it. Gently rotate the bag to coat the pieces with oil. Use additional Ziploc bags for the remaining pasta. Place the bags on a tray and keep at room temperature until you have prepped all other ingredients and are ready to build the hero.

Dried herb flakes can be added to each bag of pasta at this time allowing the flakes to be completely random. After styling the pasta, any herb flakes in undesirable places can be removed with tweezers before final photography. Fresh herbs should be added immediately before final photography.

SAUCES FOR PASTA AND VEGETABLE SALADS

The main object of a pasta sauce in photography is to add color and interest to the pasta dish. The trick is to achieve the desired look without weighing the dish with too much color or liquid. Your goal is to make the viewer automatically think *this is a pasta dish with sauce.* (These same techniques also work for potato, pasta, and other vegetable salads that don't contain salad greens.)

The most common pasta sauces are tomato, pesto, oil, or cream based. Regardless of the type of sauce, you may need to manipulate the consistency of the sauce before applying it to the pasta. Good-quality pasta sauces are available in grocery or deli markets and are a great time-saving tool for food styling. However, some sauces are too thick in consistency to use just as they come out of their containers.

So the first step with the sauce is to determine if it needs to be thinned. Pour 1/2 cup of the sauce of your choice into a work bowl and give it a stir. Notice the consistency of the sauce. Conduct a test by dropping one piece of the hero pasta into the dish of sauce. Roll the pasta in the sauce until it's covered. Hold the pasta in your hand and look at it carefully to determine if the coverage of sauce produces the look you want to achieve. Keep in mind that after the pasta dish is built, you will be able to add more sauce to the dish if you desire.

If you decide the sauce needs to be thinned, begin by thinning 1/2 cup of the original sauce. The thinning agent you choose depends on the specific sauce you are using. Some helpful thinning agents are Wilton piping gel, which adds a translucency and soft sheen to the sauce and will look good to the camera; half-and-half; or olive oil. Start by adding 1 tablespoon of thinning agent to the 1/2 cup sauce. Test the sauce on one piece of pasta as before. If more thinning agent is necessary, keep track of the amount needed to reach the preferred consistency. During construction of the hero dish, if more thinned sauce is needed, use an additional 1/2 cup of the original sauce plus the same amount of thinning agent. Cover the bowls of pasta sauce by placing plastic wrap directly on the surface of the sauce, and mark them to distinguish thinned verses original sauce. If you are not shooting on the day you perform this test, you will have to remember your formula for the sauce and mix a fresh batch on the day of the shoot. If you are shooting the day the test is performed, set the bowls

aside but do not refrigerate. It's a good plan to write down and keep a journal of successful food styling formulas and techniques for future reference.

Sauce will be applied to the pasta either immediately before it is built into the hero dish, or immediately after the hero is built. The decision about which method to use should be based on your comfort level. For example, you can add a little sauce to the pasta before building the hero dish. This method can be messy and I recommend building the hero away from the set, but it is a good way to ensure the pasta is covered with sauce. Or, you can build the hero with plain pasta and, after the hero dish is built, brush the sauce onto the pasta. When I built the pasta for the chapter opening shot, I built the hero bowl and spoon with pasta and brushed the sauce on the pasta after the build was completed. If you want a heavier sauce appearance, you will be more successful using the technique for applying a light sauce to the pasta before building it in the hero bowl and then using a bulb dispenser to deposit more sauce in strategic locations within the hero dish after it is built.

FOOD ADDITIONS TO THE PASTA

Now you're ready to prep other ingredients you've selected to add to the pasta. At this time you should have the pasta stored in Ziploc bags and have determined a formula for the pasta sauce. Turn your attention to prepping the other ingredients that are going into your hero pasta dish. If using meats in the dish, you should refer to the chapter on meats (Chapter 7) for prep techniques. Pan-seared meat adds extra interest to pasta dishes. All vegetable items in your dish need to go through the hero process. Some vegetables may need to be blanched, baked, or cooked on a griddle. Refer to the chapter on vegetables (Chapter 8) for prep techniques. If you use fresh herbs or garnishes, you will need to prep them right before final capture. Refer to Chapter 12 on garnishes for prep techniques for snipped herbs and garnishes.

BUILDING THE PASTA

To achieve height in a bowl of pasta, you'll need to provide a solid structure to create the extra height because pasta coated with oil will naturally settle down into the bowl rather than pile up. Use a spacer that is similar in color to the pasta to create height. The spacer's size will depend on the size of your hero container and on the height you want to achieve. Remember to keep the height realistic. Pasta towers are not naturally occurring phenomena.

If you use a spacer to add some height or support for the pasta and other ingredients, you will need to position the spacer in the clean hero bowl before beginning to build the pasta dish.

The spacer in this shot is a disk of STYROFOAM. I like using it for several reasons. It is lightweight, can be spray painted any color, and is useful in case heavier food elements need to be secured with a toothpick. I painted the STYROFOAM spacer with Krylon spray paint to match the pasta color, making the spacer easier to hide. If you follow this technique, make a spray booth as described in Chapter 3 to catch any overspray, and spray outdoors or in a well-ventilated area.

The STYROFOAM disk must be secured to the bottom of the bowl by some means. I use a double-sided sticky foam tape to cover the bottom of the disk before placing it in the bowl, but several small pieces of replaceable rope-type weather stripping found at hardware stores could also be used to secure the spacer. The spacer should be secured because if it moves around you'll have a great deal of trouble building the dish and transporting it to set. Remember, there's a lot of oil on the pasta, so everything is slippery.

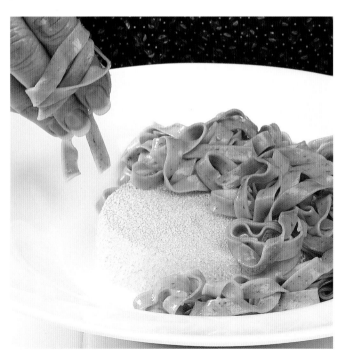

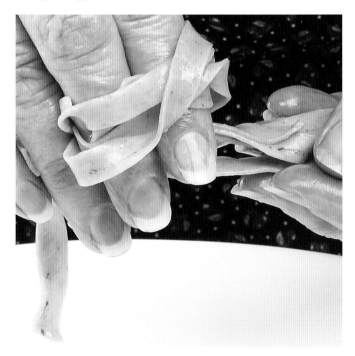

For long pastas I use a technique of twirling two or three lengths of the pasta around two fingers to create some interesting loops. Once the pasta loops are placed in the hero dish or container, a couple of the individual loops can be manipulated at slightly different angles or positions to get a more natural look.

> **TRICKS OF THE TRADE** If the ends of long pasta are sticking out and visible to the camera, the pasta can look messy and the visual flow of the dish is interrupted. This is why the ends of long types of pasta are normally hidden from the camera. As you build each unit of twirled pasta into the dish, tuck the ends of the pasta down into the bowl under the pasta loops or hide them behind other food elements in the bowl.

Work with one bag of pasta at a time as you build the hero pasta dish. Drain any liquids that have accumulated in the bag by tipping the bag to one side. If you have decided to brush the sauce onto the pasta after it's built, begin by pouring one bag of pasta into a clean large work bowl so you can distinguish individual pieces as you build the hero. Eventually the oil will be absorbed into the pasta and it will stick together. So if the pasta you are working with gets sticky, add a little more oil. If you instead decided to coat the pasta with sauce before build-

ing the hero, pour the pasta into a clean large work bowl and add a few tablespoons of the sauce formula to the pasta and mix well using your hands to gently toss the pasta and sauce together. Check the coverage to verify that it has the appearance you seek for your shot.

Build the pasta into the hero bowl so the entire area of the bowl is filled with pasta. Once the pasta build is established, you will be ready to add the other ingredients. When all ingredients are in place, you will then brush on additional sauce and add concentrated areas of sauce using a bulb applicator if desired.

> **TRICKS OF THE TRADE** Dealing with any liquid or sauce on the set is tricky. Mistakes and drips happen. As a time-efficient and set-protecting method, use paper towels to help protect all areas that could be targets for drips and splashes. This is especially true when you have oily substances near the set. I also keep some paper towels in my lap or nearby so I can wipe my hands occasionally, making sure my hands don't become a dripping offender while I'm working on set. If drips or small areas of sauce get on the hero plate or bowl, they can be cleaned with a cotton swab that has been moistened with Windex glass cleaner. Use each end of the swab for one swipe at the offending drip or spot. Then throw the swab away. This is a lesson I learned many years ago. If you try to reuse a cotton swab for a second swipe, it will likely make a bigger mess.

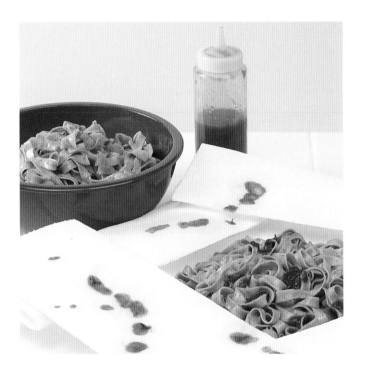

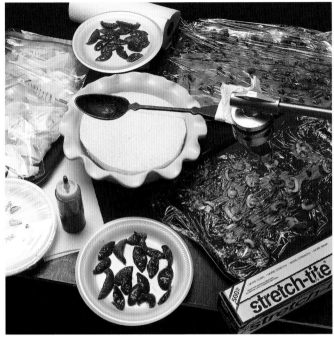

Time is a crucial factor when you begin building the hero dish since you will be working with time-sensitive hero items, which means that before you start, make sure you have all of the elements ready and within reach. Also, have all of the tools and supplies you anticipate using handy. If you build the hero on set, be sure to have a side table available to hold trays of hero food items, as well as tools and supplies for building the hero dish.

ADDING A SPOON OR OTHER FLATWARE THAT WILL HOLD FOOD

Our hero shot at the opening of this chapter shows a spoon of pasta suspended over a bowl of pasta. This image was planned so that the viewer's focus would be on the spoon. The addition of spoons, forks, and serving pieces shown holding food in an image can be very useful tools in getting the camera and viewer very close

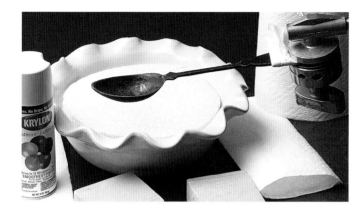

to the food. Our spoon was securely positioned on the set so all apparatus supporting the spoon was out of the crop and off-camera. Because the spoon was the primary focus in this shot and, hence, the most time sensitive, the bowl was built first.

Supplies used to complete this shot:

- Le Creuset stockpot and stoneware 7 1/2-qt mixing bowl
- Pappardelle pasta
- Messermeister chef's knife
- OXO Good Grips Colander
- Ziploc gallon-size bags
- Two Anchor Hocking Prep Bowls
- Zak Designs Gemini Bowl, medium size
- STYROFOAM, 1 inch thick
- Krylon spray paint
- Wilton Recipe Right medium baking pans and applicator bottle
- Double-stick foam tape
- Wood mixing spoon
- Cotton swabs
- Olive oil

- Long-handled wooden spoon
- Hero spoon and apparatus to support the spoon on set
- Hero bowl was also the stand-in bowl
- Henckels kitchen and herb scissors
- Bounty paper towels
- STRETCH-TITE plastic food wrap

- Windex glass cleaner
- Hand-painted surface by Brad G. Rogers

PHOTOGRAPHER'S COMMENT—Notes on Pasta Set

Darker, richer, moody set. One medium Chimera lightbank at the back of the set angled in gives me the effect I need for the shot. The light hits the bowl and spoon with fall-off in the front of the spoon. The selective focus tells the story. The spoon is actually more than a foot away from the bowl. No fill cards or reflectors were needed because of the broad light source. When using a C-stand and knuckle to clamp the spoon into position, be sure to protect the prop spoon with a cloth, paper towel, or tape.

POTATO, PASTA, AND VEGETABLE SALADS

If you are building a potato, pasta, or vegetable salad that does not contain salad greens, the techniques used for pasta sauces and building a pasta hero are more appropriate than the salad techniques. Refer to Chapter 8 for prep techniques for the vegetables in your salad and follow the sauce techniques in this chapter for creating the look of dressing on less fragile ingredients in your salad. During the prep of the potato salad shot featured with this chapter, I used my hands, rather than tools, to mix the ingredients with dressing in order to

avoid damaging the fragile cooked potatoes. Dressing application for other ingredients that are more fragile must be completed with a brush rather than tossed before building the hero salad.

To make a creamy dressing for vegetable salads, start with about 1 cup of sour cream in a work bowl. Because pure white isn't always the color of choice for the camera, you can alter the color by whisking some creamy Dijon mustard into the dressing. Make enough of the original dressing mixture so you can reserve about 1/4 cup for use on set in case it's needed. The dressing must be thin enough to coat the elements in your salad but thick enough to stick to the surfaces. Use a small amount of cream, a little oil-based salad dressing, or marinade if the dressing needs to be thinned.

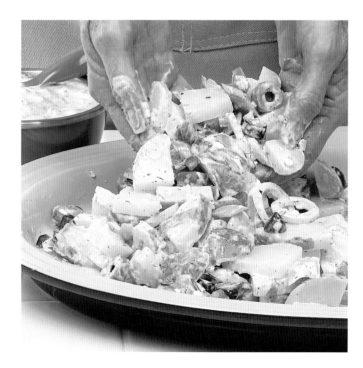 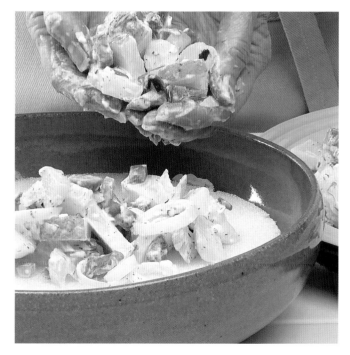

Gently toss the salad ingredients with your hands to incorporate the dressing. If you want the salad dressing to appear heavier once the salad is built, you can place small amounts of the reserved thicker dressing with a dropper, syringe, or applicator bottle in selected areas of the salad. You can also choose to brush some of the reserved thicker dressing on some of the salad components. If there are spices or fresh herb flakes in the dressing, you will need to add some of them at this point and also reserve some to add to the finished, dressed salad on set. A salad of this type is often garnished with a sprinkling of minced herbs or a garnish that is complementary to the salad.

Supplies used to complete this shot:

- Vegetables in the salad include red skin potatoes, celery, green onion, roasted red peppers, fresh red and green peppers, marinated black and green olives

- Studio props

- Le Creuset stockpot and stoneware oval platter

- Cardinal Glass prep bowls

- Henckels chef's knife

- Messermeister Take-Apart utility scissors

- Bounty paper towels

- Paper plates

PHOTOGRAPHER'S COMMENT—Notes on the Potato Salad Set

Rich moody lighting worked great on this shot. This shot was all about texture. The set uses wood, burlap, a rustic plate, and pottery. I used a 40% grid over a medium Chimera lightbank and another lightbank to bounce light off my warm beige walls. No reflectors were necessary with this bounce effect.

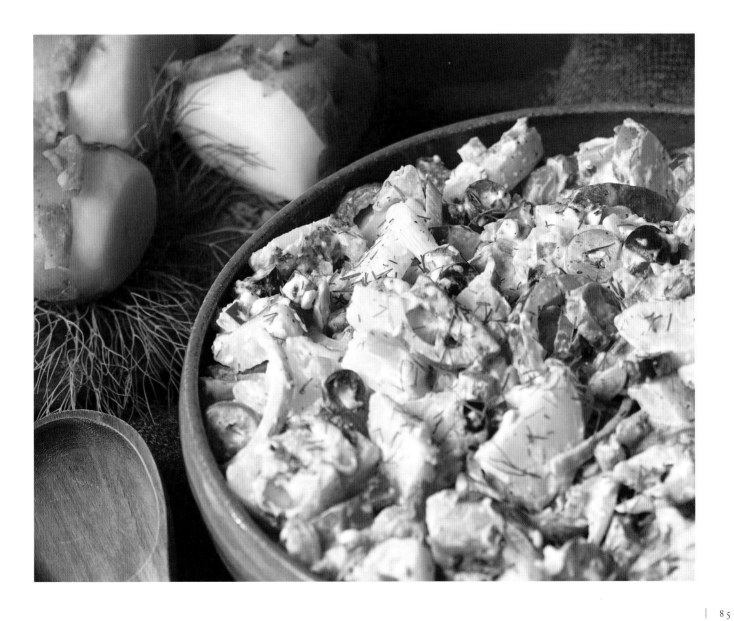

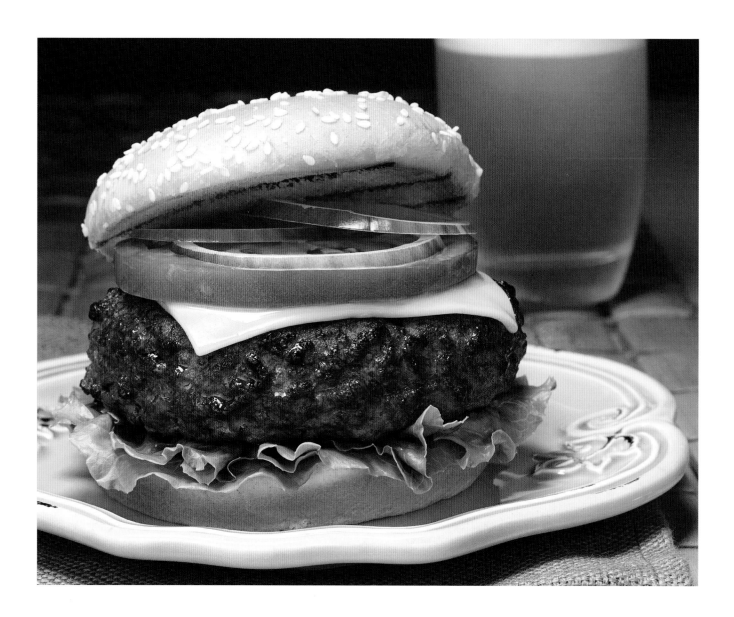

BURGERS, SANDWICHES, AND BEYOND

THE HAMBURGER

If you plan to photograph a hamburger or hot dog without a stylist, you are indeed brave. What might seem to be an easy project before you begin will surprise you at how complicated and difficult it can become. If, knowing this, you still plan on forging ahead, the information in this chapter might save you from some common pitfalls. My recommendation is that you read the entire section on buns and burgers and make sure you have a good understanding of the techniques before you proceed. This is all part of being prepared.

A photographer I've known for many years recently shared a story with me about his styling endeavor to create a hamburger for an editorial piece. There wasn't a budget for a stylist and the person in charge of the editorial article instructed the photographer to go to a hamburger restaurant, purchase a hamburger, and shoot it. Fortunately, the photographer knew that scenario was a disaster in the making and called me for advice. Because he was 2,000 miles away from where I live, I did my best to talk him through the process. With my best wishes, and I'm sure his too, the sections of this chapter on buns and burgers are for the brave explorers in the world of hamburger styling and photography.

Finding the Perfect Hamburger Bun

The most difficult aspect of making a burger or hot dog for photography can be the task of finding a hero bun. Ideally, you should purchase a tray of freshly baked buns from a local baker. Realize that the baker may need a few days' notice to meet the order, so be sure to call several business days before you actually need the buns. If you don't have that option, it is possible to find a prepackaged hero bun. In fact, the buns used to create the hero for this chapter were taken from prepackaged buns.

Preferably you should shop for buns early on the day of photography; if time doesn't permit that, then shop the day before you plan to complete photography. Regardless of when you actually buy the buns, you need to scout out the best place to shop for buns well before the day of your shoot.

The search criteria you must follow in order to be successful finding hero buns isn't tough, but the stares you may get from fellow shoppers at the market could be embarrassing, so wear blinders as you shop. Refer to Rule Seven in Chapter 1 for additional shopping information.

When you handle buns, a light touch is absolutely mandatory. Even picking up a package of buns can make dents in the buns and requires a gentle hand. Common

sense will tell you that hero buns will be on the top of the grocer's display. Chances of finding a hero bun in a package of buns that has another package on top of it are very slim. Prepackaged buns normally have two layers and are usually presliced, thus the top layer will likely be the only place you'll find a hero bun.

As you start to search for the hero buns, keep in mind that the heroes will need to be perfect on the crown. Look for buns with smooth crowns or domes that are blemish free, have no creases along the edges, and have a consistent golden coloring. When you find a bun qualifying as a hero candidate, don't worry if the edges where the bun was sliced between the top and bottom bun overlap a little. This imperfection can be corrected later at the studio.

When you do find a package that looks like it could contain a hero bun, treat the bag as gently as you would a newly born baby. When picking up the bag, a process that works well for me is to pinch the plastic packaging on two opposite ends of the bag to offer just enough control to lift the package. Gently place the bag on the flat box or paper bag surface in the cart—single layer. Do *not* stack the packages!

My rule of thumb for buns is to choose three or four hero buns for each burger or hot dog in a photo project. Deter-

mine how many bun packages to purchase based on the number of hero candidates you can identify through the packaging. Perhaps you'll get lucky and find more hero buns in the packages after you open them back at the studio, but don't count on it. The non-hero buns will be useful because they can serve as stand-ins or guinea pigs for the bun treatments. You'll want to practice all of the bun procedures on a stand-in and get comfortable with the techniques before you work on the hero bun.

When you are ready to check out at the market, ask the clerk not to handle the bun packages. (Yes, you'll have to share your story about doing a photo shoot, yada yada.) Consider purchasing a non-hero package for the clerk to scan, allowing you to transport the hero packages undisturbed to your vehicle—it's worth the price! I usually transport the buns in boxes on a flat surface, for instance, in the trunk of my car, so they will be less likely to slide around.

Once you have the bun packages at the studio, be aware that exposure to air and poor handling techniques are a bun's enemies. You are now the keeper of the buns, their guardian, protector, and their personal bun beautician. Designate a large flat surface with good lighting where you can sort through the buns. I prefer to sit on my God-given buns while working through the purchased buns because this process takes time.

Using a non-hero package you should practice and get comfortable with bun handling before addressing bags that may contain hero buns. This exercise will also get you into the mode of handling the buns carefully. With scissors, cut the plastic packaging covering the buns so you can lift the top layer of buns out of the package. Slide your hands under the top layer of buns and remove them from the package. Be aware that some bakers use a technique that causes the buns to connect slightly. If the buns you've purchased are attached, you will need to support the entire layer while removing it from the packaging. Place the layer of buns on the work surface and, using a serrated knife, gently separate the buns. No squeezing the buns, please!

TRICKS OF THE TRADE Once hero buns are identified, they need to be protected. Buns are easier to manipulate and heroes are more easily viewed if each bun is on a separate paper plate. The plate and bun assembly will slide into a gallon-size Ziploc bag. Carefully inspect all of the heroes and mark numbers on the plates or bags to indicate #1, #2, #3, etc., in order of hero preference. This technique provides a quick reference when building the hero, so if anything happens to damage the hero during styling, the next contender can be quickly identified. Remember to save some of the non-hero buns so you can practice bun treatments later and for stand-in purposes.

Using sharp scissors, trim the portion of the bun that has overlapped along the precut edge. Hold the scissors at an angle matching the precut edge angle. The scissors will be parallel to the flat surface of the bun. Trim away the excess bun edge. Make sure you cut a smooth edge that looks very straight and natural. It may be necessary to trim the edges of both the top and bottom of the hero buns. When this step is completed, place the top hero bun, resting cut side down on the paper plate, back into the Ziploc bag. Place

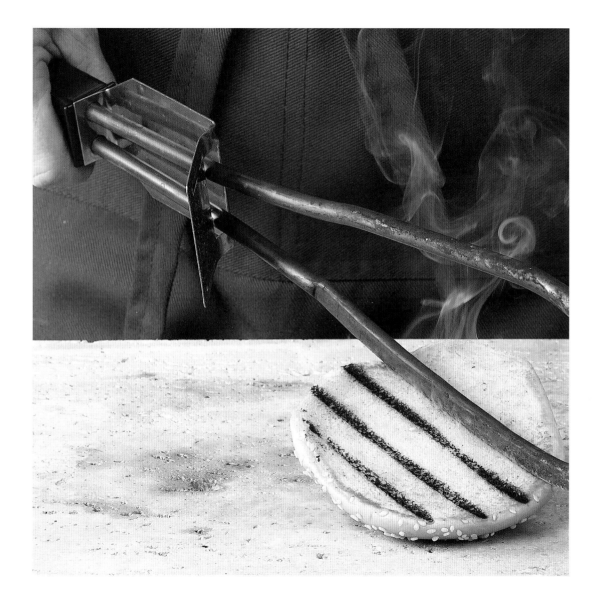

the bottom hero bun resting with cut side up on a separate plate in a separate bag. Mark the plates of both top and bottom buns according to the bun's hero ranking.

We decided to toast the hero bun top and make grill marks on it. If you want to follow this approach, use a clean skillet or griddle surface heated to medium-low heat. Brush the cooking surface with melted butter. Also, brush the cut side of the top bun with melted butter and place it on the preheated cooking surface. Do not mash the bun. It will brown along the edges that touch the pan. Use a nylon cooking spatula to lift the edge of the bun to check the color of the bun several times during this process. Remove the bun from the pan when the edges that touched the griddle are golden. Preheat an electric charcoal lighter. I had my charcoal lighter customized so that one side of the heating element is narrower. I used the narrow side of the hot lighter to make grill marks on the bun as shown.

SAFETY NOTE Electric charcoal lighters become very hot. Follow the manufacturer's manual for safety procedures and instructions on how to use such a lighter. I use a landscaping stone as a surface for food items whenever I apply a torch or electric charcoal lighter to the food. The stone absorbs some fats that might be liquefied during torching or branding and it also provides a safe non-flammable surface as you work. The stone is also a safe place to lay the charcoal lighter to heat up and cool down before and after use.

Once you have three or four hero buns for each bun represented in your shot as well as buns reserved to use as stand-ins, you can turn your attention to other elements in the shot. Working with a stand-in burger, determine the arrangement of food elements in your burger. For instance, starting with the bottom bun and building upward, our burger's order of elements is bun, lettuce, meat, cheese, tomato, red onion, and top bun. You may want a different building arrangement. This decision should be made during the planning stage. A few words of advice: Cheese is easier to handle and looks more realistic if it is applied directly on top of the meat rather than elsewhere in the burger.

Prepping Burger Components
Let's assume that you are planning to build a burger similar to the burger image in this chapter.

Here's what you will need and the techniques you can use in achieving this look.

For a typical burger construct, I normally purchase two heads of either romaine or leaf lettuce. Normally the outer leaves of the lettuce head are not hero quality, but under those leaves you are likely to find the leaves best suited for burgers. Hero leaves will be a rich green color with unblemished ruffle rimmed edges. Remove the hero leaves from both heads of lettuce. To store the lettuce

until you are ready to build the hero burger, place two or three whole leaves together in a gallon-size Ziploc bag. Refrigerate the lettuce in bags in the vegetable drawer of your refrigerator.

For your first time building a burger, I recommend that you use one large-diameter tomato slice rather than overlapping slices, which are more complicated to build into a burger. In the future, with one burger experience behind you, you may choose to use more than one slice in an overlapping arrangement. But as a good place to start, one slice is best. Prep the slices to be 3/8 to 1/2 inch thick. When a tomato slice is placed on top of cheese, juices from the tomato might run onto the cheese. This is a problem because the moisture will discolor the cheese rather quickly. If the interior surface of the tomato slice will not be visible to the camera, you can avoid this situation. With a spoon, remove the juicy interior of the tomato leaving the outer meaty edge only. Be aware that this technique might not work if you plan to put overlapping tomato slices on the burger.

If you choose to add additional elements or overlapping elements like red onions or pickles, keep in mind that they will contribute to the height of your burger. Depending on the camera angle and the dimensions of your shot, the height of your burger could be an important issue to consider.

My favorite cheese for burgers is prepackaged, individually wrapped cheese slices. Yes, that's right, prepackaged slices. They look good to the camera, handle well, melt well, and are very predictable. Because the fat content and ingredients of prepackaged cheese slices are very consistent, they make a good choice for photography. Also, they are thin enough so that you can overlap two or more slices with the corners offset, creating more visual interest.

Prepping Burger Patties

When purchasing burger meat for a photo burger, choose ground beef with 10% fat. You will want to make two or three patties for each hero burger in your shot as well as stand-in patties. Purchase 1 pound of meat for every four burger patties you plan to make. You can shop for the beef the day before shoot day.

Look at the go-by shots you've collected. Normally the only parts of the burger patty that are visible to the camera are the edges or sides of the patty. Notice the shape of the edge of the burger patty. Some are very square and appear almost premanufactured, whereas others have a rounded edge, making them look more custom or handmade. After deciding which appearance you want to achieve, it's time to form patties for the hero burger. Even though the burger patties will not be thoroughly cooked during the prep process, some of the diameter of the patty will shrink up when the patty is cooked.

I normally make patties 5/8 to 3/4 inch thick. You will need to make patties match the thickness as determined by the look you have chosen for your burger. Form the patties so the meat is tightly packed together. If there is a lot of air remaining in the patties, they tend to fall apart. Pay attention to the shape of the patty edges in order to create the look you want. The patties can be seared at this point, if you are ready to build the burger, or wrapped individually in plastic wrap and refrigerated overnight. When you unwrap each patty, confirm that the patty edges have remained in the desired shape.

You need a hot griddle or large flat skillet to cook the patties. Brush the cooking surface with vegetable oil. Preheat the cooking instrument to 350°. Place one beef patty on the cooking surface until it is no longer red and releases easily from the cooking surface. It is not your goal to cook the meat at this time, but rather to brown the meat only until it no longer appears red. Carefully turn the patty over using a spatula. Cook the patty until the down-side is no longer red. The edges may still be pink. That's OK.

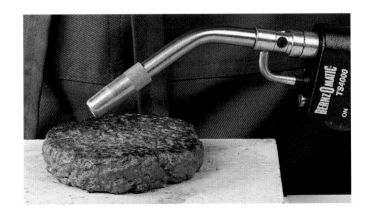

As you work with the patties, you will need to select heroes. As you finish torching each patty, place it immediately into a disposable aluminum baking pan that is filled with 2 to 3 inches of cool vegetable oil. Keep the patties in a single layer and use additional pans of oil if necessary to accommodate all of the hero patties. For easy identification of heroes, you will want to mark pans containing the hero patties. All of the patties need to be completely submerged in the oil to delay discoloration. Cover the pan with plastic wrap so that it touches the oil surface, and set the pan with oil and burger patties aside until you need them for the building process. Because you will be building the hero shortly, store the patties in oil at room temperature.

Adding Color to the Burger Patties

At this point, the burger patties appear cooked on the outside, however their color is not appealing. You will be brushing color onto the hero burger patty right before placing it on the hero burger assembly. There are several ways to color meat patties. Here are two methods I often use.

You can purchase hoisin sauce from the market. The sauce is thick as it comes from the jar. Put some of the sauce in a small bowl and stir it well. Normally it can be brushed onto the patty at this point. I realize using hoisin sauce sounds like a quick-and-easy approach, but the results may vary depending on several factors. My favorite, and a more reliable method to color patties and meats in general, is to make a coloring agent. Pour about 2 tablespoons of vegetable oil onto a plate. To the oil add 1 teaspoon of gravy coloring and 1 teaspoon of Bitters of Angostura plus 1/4 teaspoon of clear liquid dish detergent. Mix the liquids together using an offset palate knife or pastry brush. The liquids will need thorough mixing and should thicken during the mixing process. With an artist's brush, brush a small amount of the color on a stand-in patty. Check the color. More brown can be achieved by adding more gravy coloring and a redder color can be achieved by adding more Bitters of Angostura or a tiny amount of liquid red food coloring. The color can be diluted by adding more vegetable oil.

Building the Hero Burger

Up to this point, you have used a stand-in burger to prepare the set and to perfect the lighting as far as you can. Before you begin to build the hero burger, you must be happy with the lighting and the set because the hero burger will have less than a 15-minute life on set. Use the stand-in burger as a reference for the hero burger build and for the placement of cheese corners in relation to the camera. Before you remove the stand-in burger from the set, mark the camera front on the stand-in

with a little piece of tape for reference as you build the hero. To build the hero burger you will need a work surface that is large enough to hold many items and to give you ample space to work. Assemble burger components, tools, stand-in burger, and supplies on that table, and find a stool to sit on as you work. Remember your eyes will need to be at camera height in relation to the burger as you build. To achieve this, adjust either the height of the hero build area or your stool height to get the correct relationship. This adjustment might be accomplished by using a wooden box of the right proportion under the hero plate.

Place the hero burger bun bottom on a clean dry surface or on the clean hero plate. Take one leaf of hero lettuce from the bag. Beginning at the stem end of the lettuce, carefully tear around the stem and rigid center vein to remove it from the leaf. This technique will give you a flexible length of lettuce while maintaining the attractive ruffle edges. Lay the resulting lettuce strip on the bun with the ruffle edge on the outside, making it curve to conform to the curve of the bun. The lettuce ruffles should break over the edge of the bun in a few places. Gently move the lettuce into a good position. Secure the lettuce to the center area of the bun with toothpick halves. Insert the toothpick pointed end first through the lettuce and bun at a diagonal angle. After completing the lettuce

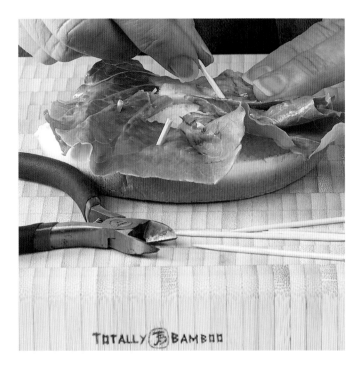

arrangement around the bun, tear or cut away any excess lettuce that may be on the back side of the burger. Snip away any toothpicks that extend more than 1/8 inch above the surface of the lettuce.

Using a nylon spatula, remove the #1 choice of meat patty from the vegetable oil and place it on a work plate. Pat the top and edges of the meat with paper towels to remove excess oil from the patty surface. Brush the coloring agent onto the patty with a large artist's brush. Take

care to completely cover the top and side edge surface with color. You will most likely need to add additional color mixture or oil to the meat patty before final photography takes place, so take the color mixture and brush to set. The meat should not look dry to the camera.

Pick the patty up with a spatula and hold the meat closely above the bun assembly. Make certain you have identified a side of the patty as hero to face the camera and you are indeed holding that side toward camera. By approaching the bun assembly slightly from the back or off-camera side, as you place the patty, you should be able to nudge it up against the back side of the lettuce ridges closest to camera. This maneuver will help ensure that the lettuce ridges are not trapped by the weight of the burger. Be careful not to disturb the lettuce position or to transfer coloring from the meat to the lettuce where it is visible to camera.

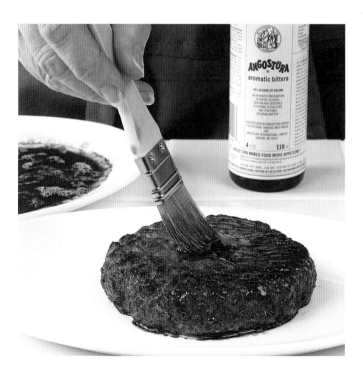

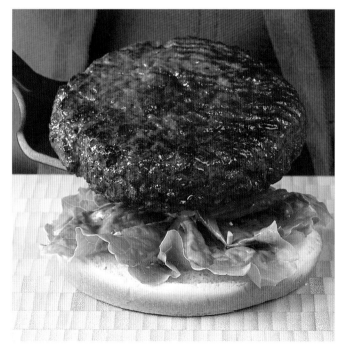

Now you are ready to shape the cheese using your steamer and place it on the hero. Unwrap one slice of cheese and place it on the spatula so two or three corners of the cheese are overlapping the spatula edges. Be sure to use a spatula without slots. A spatula with slots won't work for this task since the cheese will melt down through the slots and hold that formation. If you are using more than one slice of cheese in your burger, at this time place the additional cheese slices on the spatula, positioning the slices with the corners in the arrangement you chose, because during the steaming process the slices will stick together, making later repositioning impossible. Maneuver the spatula near the steam so the cheese is in the direct path of the steam. Hold it in this position just until the cheese corner goes limp. Rotate the spatula if necessary so each of the corners of cheese the camera will see is steamed until limp. Place the cheese onto the patty so the wilted corners of cheese are visible to camera in the predetermined position.

SAFETY NOTE Always read the manufacturer's instructions and warnings before using a steamer. Remember that steam is very hot! The direct flow of steam from my Jiffy Esteam makes it easy for me to safely use it for cheese. Be sure to unplug the steamer immediately after use.

TRICKS OF THE TRADE Gently brush the wilted cheese edges with a soft artist's brush dipped in liquid household cleaner that has a pine or orange oil ingredient base. It seems strange, but a light coating of liquid cleaner helps the cheese look freshly melted for a longer period of time and slows the drying process. If the cheese starts looking dry, it will need to be replaced.

Because the tomato on our burger is a one-slice arrangement, I shopped for rather large tomatoes. However, the

tomatoes were not quite as large as I would like for the proportion of the burger. Three hero slices were cut immediately before building the burger. To get the biggest diameter slice, one slice was taken from the widest part of three tomatoes. The slices were placed on separate paper plates. I rotated the plates to see all of the edges of the tomato skin, chose a hero, and found the best side of the hero tomato for camera front. Because the interior of the tomato would be visible to the camera in

the shot for this chapter, I could not remove the juicy interior of the tomato slice. Therefore, I knew the juices from the tomato would eventually discolor the cheese and I had to move quickly to ready this burger for final photography.

There is a trick that will make the tomato slice appear slightly larger in diameter to the camera if necessary. Determine the edge of the tomato that is to be toward camera. With a sharp knife, make a cut beginning in the center of the slice and going through the tomato skin on the back or off-camera edge. Lift the tomato with a spatula and place the hero tomato on the burger, making sure the cut edge faces the back off-camera part of the burger. Gently spread both sides of the cut edges of the tomato apart. As you spread the tomato apart, keep looking at the camera side of the tomato to make certain the movement isn't creating any ripples in the edge. You can only push apart the tomato wedge so far before affecting the front. If it ripples, you may have to discard that tomato slice and select another. Using toothpick halves, pin each side of the tomato through the cheese and the meat patty to hold it in place. Snip any toothpick ends that extend more than 1/8 inch above the tomato surface. You will need to occasionally brush the edge of the tomato with an artist's brush wet with water until final photography is completed.

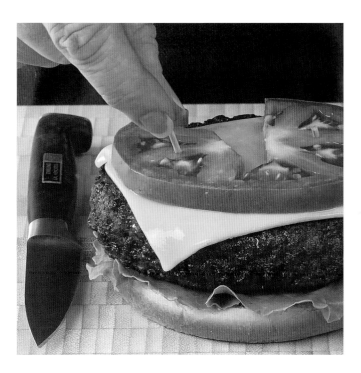

On Set with the Hero Burger

The burger is ready to go to set. The burger is sturdy and easily transported at this stage. Any additional elements for your burger, such as onion slices or pickles, should be added on set because they are more difficult to stabilize, making the burger more difficult to transport.

Make certain you have the necessary tools and supplies to complete the prep on a table near the set. You'll need the burger bun top, additional hero lettuce and other burger components, mustard or mayonnaise in an applicator bottle (optional), small containers of burger color, oil, water, and an artist's brush for each liquid, paper towels, cotton-tipped swabs, and tweezers.

After positioning the hero plate on set, protect the area of the set around the plate by laying a few paper towels in front and to the side of it. Arrange any additional burger ingredients on the burger and secure them with toothpicks. Place the bun top on the burger. Take a capture shot to check the positioning and build of the burger. Make any adjustments needed. You need to keep the meat and vegetable components moistened with the appropriate liquids until final photography is completed. This helps to ensure the elements will maintain a fresh appearance.

When you are pleased with the burger on set, if you are embellishing your burger with condiments (mustard,

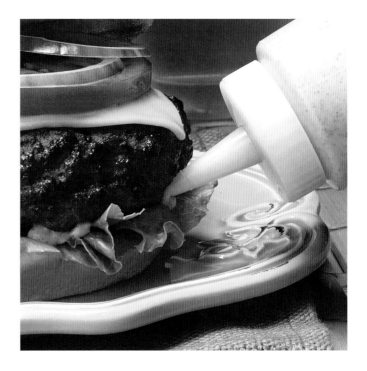

mayonnaise, etc.), identify where you want to place the condiments on the hero burger. It's difficult to make a precise decision for placement of these condiments prior to this point because of variables in lettuce and other ingredients. But you should have a basic idea of placement based on viewing the stand-in previously on set. Use an applicator bottle to insert small amounts of the condiments. Take another capture shot for a final check

of the hero. Before final exposure, refresh the meat with dabs of the coloring agent using an artist's brush and be sure to wet the tomato and onion edges with an artist's brush dipped in water.

Supplies used to complete this shot:

- Henckels kitchen scissors and 3-inch paring knife
- Totally Bamboo cutting board
- Messermeister tomato knife and nylon slotted turner
- Presto Tilt'N Drain griddle
- Ziploc bags, gallon size
- Le Creuset reversible griddle
- Bernz-O-Matic Professional Culinary Torch
- STRETCH-TITE plastic food wrap
- Toothpicks
- Small wire cutters
- Landscaping stone
- Electric charcoal lighter
- Paper plates
- Work plate
- *Optional:* Dijon mustard and applicator bottle

PHOTOGRAPHER'S COMMENT—Notes on the Hamburger Set

This hero burger is a beauty. It's a very tight shot with only a small Chimera lantern for lighting placed directly overhead with the black skirt attached to knock light off the background. I have a white fill card to the left to fill the front of the burger. This little ball of light wraps beautifully around the hamburger and does not blow out the bun.

THE WHOLE SANDWICH

Techniques for building a whole sandwich are similar to the techniques used to build a burger. However, creating a hero sandwich can be a little more forgiving than building a burger simply because there are often more elements present in a sandwich. The various sandwich elements allow for manipulation to create visual interest. This is especially true when thin deli meats are used in combination with specific techniques to build a sandwich. The meat edges, as shown in our hero shot, can be styled to create interest and depth.

Choices for bread on a photo sandwich can be specific if you are selling bread, or the bread choices can be vast if you aren't. The same rule applies to other sandwich elements. If you are selling or featuring a specific brand or item, during the preplanning for the shot, most of your decisions will be built around the featured item.

The choice of bread, in a whole sandwich shot, will greatly influence the appearance and direct the lighting and mood of the shot. Because the top piece of bread in a photo sandwich usually consumes a large portion of space in the shot, it becomes a big focal element. Once you have chosen the type of bread for your whole sandwich, you can begin to plan the other elements in your sandwich.

Shopping for Sandwich Elements

I purchase meat and cheese sliced by the deli personnel who cut the items specifically as instructed for each item. You must explain that the thickness of the items you order is important and you would like to inspect the first and second slice before they proceed with slicing the remainder of each item. Let them know you would appreciate special handling of the items, with sheets of deli-paper between each slice of cheese. Also, ask the deli attendant to put no more than 1/2 pound in each package. And when you place the packages in the shopping cart or basket, make sure no other items rest on top of the deli bags.

Prepping Sandwich Ingredients

Use the same techniques you used to find hero hamburger buns when looking for hero sandwich bread. Look for even color and ingredient disbursement as well as an interesting and beautiful crust surface. Protect the hero bread using the paper plate and Ziploc bag method described in the hamburger bun section.

> **TRICKS OF THE TRADE** If the bread you have selected for your hero sandwich is taken from a sliced loaf, remember that sliced bread is highly susceptible to drying out when exposed to air. The best way to protect the hero slices is to cover each hero slice with a slightly damp paper towel before enclosing it in its plastic bag.

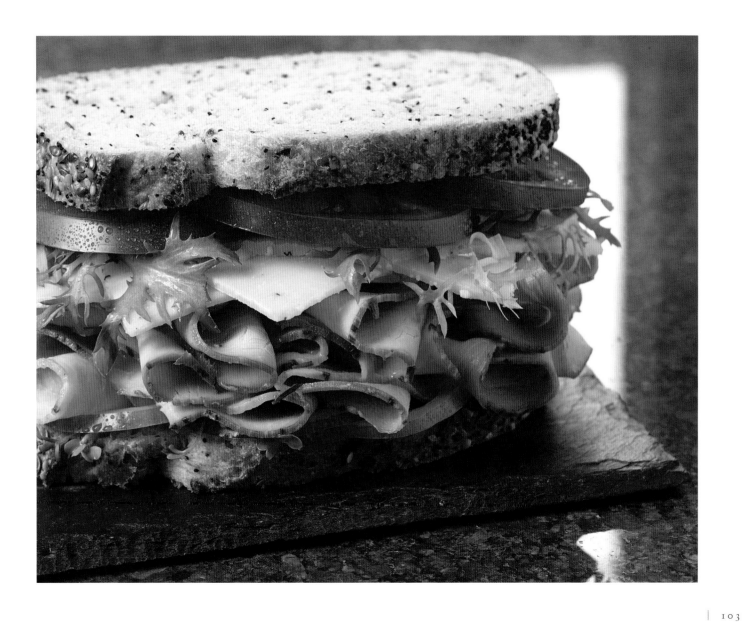

To prep lettuce for a sandwich, remove the whole leaves from a head of lettuce, discarding any leaves with damaged edges or discolored areas. If the lettuce is visibly dirty, you will want to wash it in a bath of water and Fruit Fresh Produce Protector. Spin the lettuce leaves dry in a salad spinner. Place two or three hero whole lettuce leaves into a one gallon-size Ziploc bag. Place all of the bags of lettuce in the refrigerator vegetable drawer until you build the hero sandwich. Bean sprouts and other sprouts should be washed in a bowl of cold water. The empty seed casings will float to the surface of the water and should be discarded. Place the sprouts on a paper towel–lined paper plate. Slip the sprouts and plate into a Ziploc bag and refrigerate.

For tomato prep, slice ripe red tomatoes using a serrated tomato knife. The slices should be thick enough to hold together, but normally not more than 1/2 inch in thickness. Lay the slices on a plastic tray, cover tightly with plastic wrap, and refrigerate. It's best not to cut tomato slices less than 1/4 inch thick because they often become flimsy and require support. If it turns out your tomato slices do need support, thin sheets of acrylic can be used. Acrylic sheets bound in pads are sold at art stores. Cut circles out of the acrylic material that are slightly smaller than the hero tomato slices. As you build the sandwich, if the tomato slices need support to keep their shape, place one acrylic circle under each tomato slice. Note that you will have to be creative when using toothpicks for the build if acrylic circles inhabit the sandwich.

If I am confident with the cheese as I see it packaged at the deli, I will use the cheese as it comes out of the deli packages when I build a hero sandwich. If you aren't comfortable doing this, then you should work through the cheese looking for hero slices. Cull through the cheese slices quickly since exposure to air will dry the cheese within a few minutes. As you find a hero slice, place it on a paper plate. Lay a piece of the deli-paper snugly over each cheese slice and cover the plate with plastic wrap. Refrigerate the plate of hero cheese until you are ready to build it into the sandwich.

Other vegetable sandwich ingredients should be hero sorted and stored on plastic trays or paper plates covered with plastic wrap until ready to construct the hero sandwich. If you choose to cut vegetables such as peppers or radishes perform these tasks and hero those items during prep time early on the day of the shoot. Items such as black olives and roasted peppers that are purchased in cans or jars should be drained and sliced if necessary and hero sorted. Place items of this type on paper plates or plastic trays, cover with a damp paper towel, and then cover tightly with plastic wrap.

Building the Hero Whole Sandwich

When the lighting and set are finalized, it's time to build the hero. Because there are usually numerous elements in a sandwich, you will need a large table space on which to assemble all of the components, plus space for your tools and supplies. You will need to cut approximately 10 toothpicks in half. Keep the cutters and extra toothpicks nearby during the building process.

> **TRICKS OF THE TRADE** Because a photo sandwich is difficult to handle after it's built, whenever possible, I build the hero on the hero plate. It is not a good idea to build a sandwich on set due to the amount of room needed to assemble items and because it can be a messy job. If for some reason you must transport an already-built sandwich to set, I recommend building the sandwich on a large flat metal spatula. Turn the handle of the spatula to the back or opposite side where you will be working. Support the spatula handle with a stable object like a brick that is the right height so the metal spatula will lay flat on the surface where you are working. If the spatula wants to slide forward, tape the handle to the support. After the sandwich is built, remove the support from the spatula and carry the sandwich resting on the spatula to the set. Carefully slide the sandwich onto the hero surface on set.

Start with the bottom piece of bread and build the sandwich upward in the order you've planned. As you construct the sandwich, if one of the elements is leaf lettuce,

use the same techniques as described earlier in the hamburger section. Other types of lettuce and sandwich elements can also be pinned into position using toothpick halves. Snip ends of toothpicks as you build so they do not extend more than 1/8 inch above the secured element.

This is the technique I used to achieve the appearance of the deli meat in the sandwich images in this chapter. Work with one hero slice or half slice portion of deli meat

at a time. A hero slice of deli meat will not have torn edges, nor holes or discolored areas. Gently fold and gather the meat with your fingers. The fold doesn't have to be perfect; in fact more interest is created if the edges are slightly uneven. Pin the bundle in place on the sandwich with a toothpick that has been cut in half.

> **TRICKS OF THE TRADE** After all sandwich ingredients are positioned with the exception of the top piece of bread, transport the sandwich to set. Top the sandwich with a piece of stand-in bread so you can determine if the sandwich is level. Building a whole sandwich that is completely level to the camera can be difficult. By using a stand-in bread top until the sandwich is level, you will ensure that the hero bread is not damaged or exposed to air for too long.

The sandwich elements can be very uneven, and adjustments may need to be made to level the sandwich before you put the hero bread topper in place. If the top element in the sandwich interior is something that is fluffy and nonrigid like lettuce, sprouts, or meat, then your chances of achieving a level sandwich are better. However, if the top element is a rigid item such as onion or pepper slices, you may need to place a support within the sandwich to make a level surface for the bread topper. A piece of the same vegetable that is on the top of the sandwich structure would be my first choice for a support; however, you

may need to use a folded paper towel, piece of cardboard, etc., to make the sandwich level. Just make sure the support is not seen by the camera.

On Set with a Whole Sandwich
Here's a list of supplies you will need on set: a sampling of all sandwich components, tweezers, small cutting board, 3-inch paring knife, small container for water and oil with artist's brushes for both, paper towels, toothpicks and small wire cutters, the hero bread top still in the protective bag/plate assembly, and a paper plate holding several dampened paper towels.

> **TRICKS OF THE TRADE** Here are some techniques to help protect the hero sandwich on set. When the hero bread is placed on top of the sandwich, a damp paper towel should be placed over it. Gently lay the towel on the bread, removing it only to adjust final lighting and to make captures or film exposures. Spritz the paper towel occasionally to help cool the air around the sandwich. This helps to keep the components fresher appearing for a longer time. If the top piece of bread starts to dry, it must be replaced with another hero slice.

You will need to keep vegetable ingredients looking fresh until final capture or film is exposed. Black olives will need a light brushing of vegetable oil. Tomato slice edges,

pepper slices, pickles, etc., will need to be brushed with water. All vegetable components in the hero sandwich should look fresh for final photography. And don't forget to remove the paper towel covering the top piece of bread! Don't laugh—it's happened.

BUILDING A HALF OR CUT SANDWICH FOR PHOTOGRAPHY

Creating a half sandwich for photography is more complicated than making a sandwich and simply cutting it in half. You will need to build the cut sandwich with bread and ingredients that have been precision cut for the size of your sandwich. Constructing the half sandwich in this way gives you total control over the sandwich's appearance and maintains the quality look of all ingredients.

Elements in half sandwiches need to appear as if they've been cut along the incision of the sandwich. They are prepped with the same techniques as described earlier in this chapter for the whole sandwich. However, the build process is a little different. To achieve a realistic appearance, you should cut the elements aligned with the cut edge. Typically, I use a pair of sharp scissors for this task right before building each element into the sandwich. I have seen some printed shots of half sandwiches and cut sandwiches photographed for advertising purposes built

with some elements on the incision edge that weren't cut. They did not appear realistic.

Start your cut sandwich project by making a template of heavy paper that is the shape and size you choose for the hero sandwich bread. Position the template on one slice of bread. The template will make you aware of any crust edges that might be seen by the camera and thus becomes a tool that allows you to better determine hero bread. When you find a piece of hero bread, cut it using a

serrated bread knife. Take care not to crush or tear the bread as you cut. At this time, cut all pieces of hero bread that are to be built into the sandwich. Place each hero bread piece on a separate paper plate. Cover the bread with a slightly damp paper towel and slide the plate into a Ziploc bag until needed during the build process.

As you build the sandwich, cut each element right before positioning it on the hero sandwich. Secure sandwich elements with toothpick halves. Form the deli meat bundles

as described in the whole sandwich section of this chapter. With sharp scissors, cut a straight edge on the ruffle edge of the bundle of meat, maintaining some of the natural edge for interest. Position the meat bundle in line with the cut edge of the sandwich. Remember, you are only concerned with the camera view of the sandwich.

Cut sandwiches are difficult to transport—a cut piece of bread doesn't provide much support, especially after it has been jabbed with numerous toothpicks. Also, depending

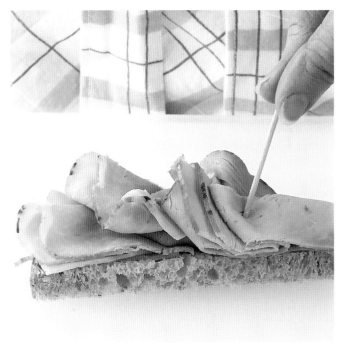

on the relationship of the sandwich to the camera, the sharp triangular edges of a cut sandwich may allow the camera to see more than one edge of the sandwich. If you are building the sandwich in the prep area, once the meat is on the sandwich, you might choose to finish building the sandwich on set and to the camera. Refer to the On Set with a Whole Sandwich section in this chapter for supplies needed on a table near the set.

As you finish building the interior elements of the cut sandwich, use a piece of stand-in bread to determine if the build is level to camera. The hero bread topper will need to sit flat and not appear to float above the sandwich or have gaps seen by the camera between the bread and interior of the sandwich. It is often helpful to position two toothpick ends extending about 1/4 inch above the top element to hold the hero bread topper in place. Again, refer to the On Set with a Whole Sandwich section in this chapter for techniques to use before final capture or film exposure.

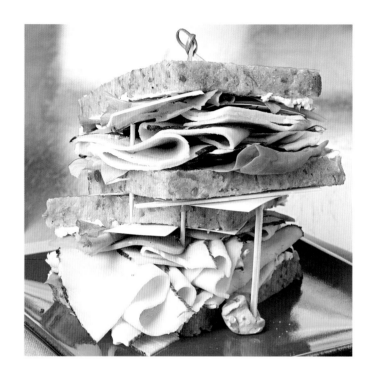

OK, I'm busted. This is the back of the hero sandwich halves after the final exposure. You can see that I had to support the sandwich structure. The bread would not hold the weight of the top sandwich ingredients and it was necessary to insert a section of poster board under the bread. Even that wasn't enough to stabilize the structure, so I cut a length of skewer and secured one end of it to the plate with windowpane putty. The other end is resting on a flat wood pickle fork that I dug out of the studio props and wedged under the bread. Yes, I was moving quickly. The rigidity of the fork gave enough support for the tall sandwich arrangement to hold its shape. The only important thing is the camera didn't see a thing!

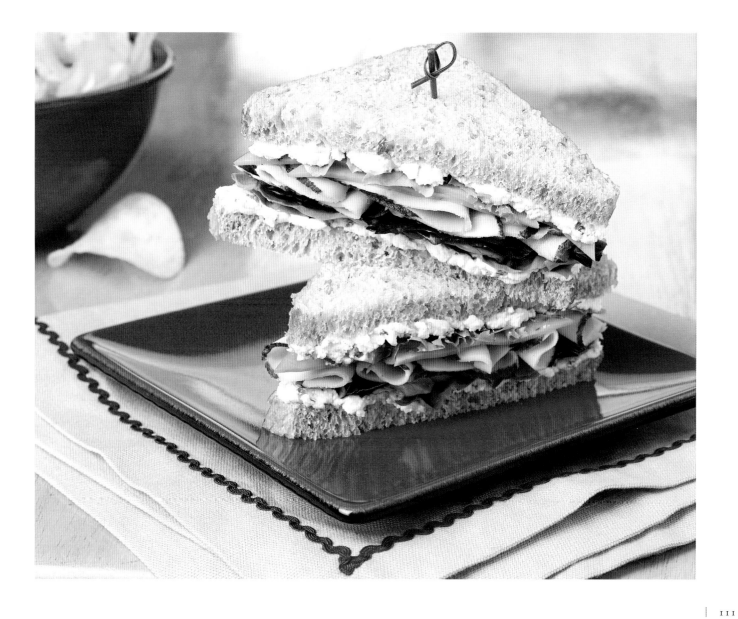

PHOTOGRAPHER'S COMMENT—Notes on the Half Sandwich Set

Gotta shoot fast! Positioning the sandwiches on top of each other is risky business. My lighting is a mix of soft window light and the Chimera lantern for background and back lighting of the set. A medium lightbank in front and white fill card are used. My Hasselblad H3D is secured on a Gitzo Pro Studex tripod for stability.

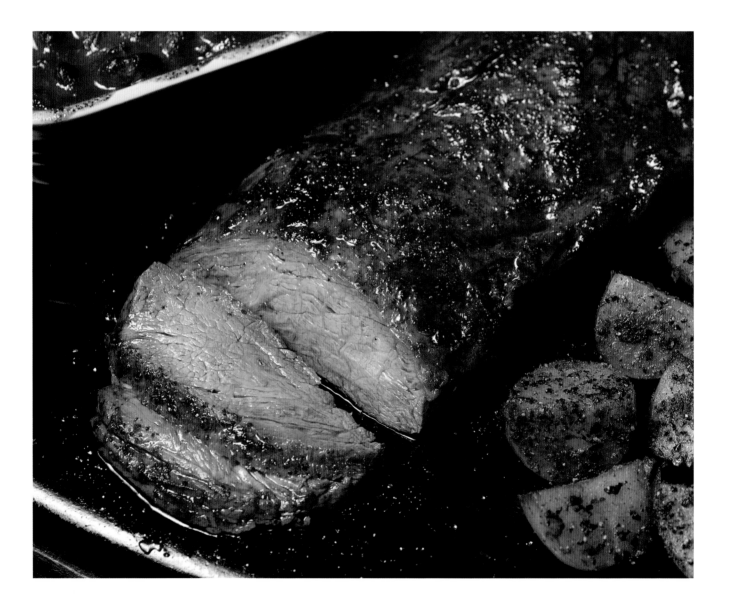

MEETING MEAT HEAD-ON

BASIC 101 FOR PHOTO MEAT

> **SAFETY NOTE** Keep in mind this chapter is about meat to be photographed and not eaten. The food styling rule about not eating photo food definitely applies to all photo meat.

To help you understand some of the techniques used with different varieties of meats, several presentations accompany this chapter with descriptions of the methods used in achieving each. Realizing the vast scope of this topic, my goal was to select a few general categories for meat styling. It might be necessary for you to combine steps from a couple of different techniques to achieve the appropriate appearance for the particular photo meat you are using.

As you progress through the planning stage of a shoot including some type of cooked protein, consider the decisions to be made: How will the meat appear to be cooked? Will the meat be cut? Also, what foods will accompany the meat? Answers to these questions will determine the series of steps needed in creating the desired appearance for the meat in an image. Use a stand-in to determine the position of the hero meat and other foods on the hero plate. This will make building the hero plate much easier to accomplish when you go to set. Have a plan!

As always in food styling, shopping plays a crucial role. Meat for photography should be purchased from a quality meat market. I like talking with the butcher and telling him I'm shopping for a photography project, explaining the cut of meat I'll need. Sometimes I take along a go-by photograph to show him. In the description of the meat, I give him rough dimensions of the meat cut that I'm shopping for. I usually purchase three or four duplications of the same cut for one hero and perhaps a few more if the hero meat is to be shown sliced for the presentation.

All of the butchers I've worked with are very eager to please their customers. I normally inform the butcher that I am happy to pay for any excess fat on the cuts I purchased. At the studio, I would trim some of the fat away, but leave a thin layer of fat since it browns nicely when styled with a torch flame.

> **TRICKS OF THE TRADE** The shape of a particular cut of meat may determine that only one side of the meat will work as the hero. For instance, if the cut of meat you are planning to photograph has a traditional and specific shape, like a T-bone steak, chicken half, or rack of ribs, the position of the meat in relation to the camera will be specifically driven by the side of the meat that you want to present to the camera. Therefore, because only one side of the cut will be considered the hero, you will need to purchase double the amount of cuts, giving you adequate options for hero selection.

For photography, two methods are commonly used to achieve the actual cooking of meat from four-legged creatures. Both methods will be described in this chapter, along with guidelines to help you choose which method will work best for you. If you are unsure about which method to use, it would be wise to purchase meat for testing purposes to practice techniques and to identify the method that works best for the particular cut of meat you've planned for your image.

NOTE If you are working with meat that has bones, refer to the later section titled Styling Meat with Bones for the Camera. The steps used to present slices of cooked meat are included in the Slicing Hero Meat—Exposing the Interior section.

SAFETY NOTE When handling raw meats and poultry I usually wear vinyl or latex gloves. If you choose to wear gloves make certain you are not sensitive to the type of glove you choose to wear.

Look at the meat to determine whether the overall shape is appropriate for your particular shot. If you need to alter the shape of the meat, it must be cut before it is cooked.

Also, if any excess fat or rough or flimsy edges need to be removed, perform those tasks before cooking the meat.

GRIDDLE METHOD OF COOKING MEAT FOR PHOTOGRAPHY

Preheat a flat cooking surface that is large enough for one cut of the hero meat to lay flat on the cooking surface. The griddle or skillet surface should reach 350° to 375° Fahrenheit. Brush the cooking surface with oil.

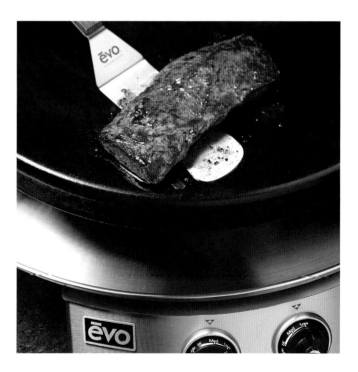

Place one cut of hero meat on the cooking surface and let it cook undisturbed until the meat releases itself from the cooking surface. With a spatula turn the meat supporting the entire cut of meat during this procedure. If the meat is cupping, meaning some of the meat is not touching the griddle surface, you will need to lay the flat surface of the spatula on top of the meat as it cooks and apply some pressure to flatten the meat. This will help ensure that all surfaces of the meat connect with the cooking surface. The goal is to cook the meat until

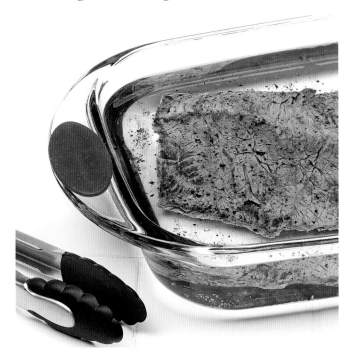

it no longer appears red. You will be adding color to the meat exterior before final photography.

Find a container that has enough room to submerge the meat in vegetable oil. Add room temperature oil to the container. Remove the meat from the cooking surface and place it directly in the container with the oil, making sure the meat is completely submerged. The oil will seal all air away from the meat, delaying oxidation which will darken the meat's exterior color. If you are using large cuts of meat, you can place only one or two pieces of meat in each pan of oil. You will need enough oil for several containers. Repeat the cooking process until all the meats you purchased are resting in oil.

Capture and reserve any cooking liquids that have accumulated in the skillet or on the griddle during the meat grilling process. If desired, these juices can be used on the hero plate as a pool of juices below the meat and to moisten the exterior meat surface before final photography.

> **TRICKS OF THE TRADE** While you are doing these techniques, you will have the opportunity to handle and evaluate all of the hero cuts of meat. As you work, select #1, #2, #3, etc., and mark their containers accordingly so you can easily identify them later when you are ready to build the hero plate or arrangement.

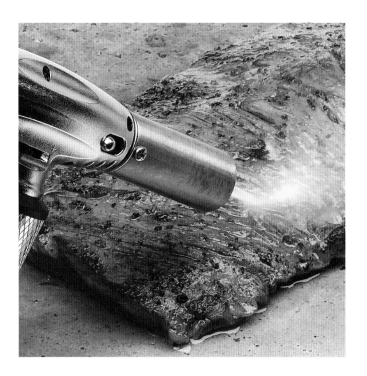

Remove one piece of meat from the oil and lay it on several thicknesses of paper towels. Pat the top and sides of the meat with additional paper towels to remove excess oil. Remove the paper towels and place the meat on a large landscaping stone. Use a handheld torch to brown any edges of the meat that are still pink, especially the edges formed by the top and side of the meat. The torch can also be used to create golden brown areas on any visible fat or connective tissues on the top and sides of the meat.

GRILL MARKS

This grilling technique will work for nearly all foods that need to have a grilled appearance. Grill marks can actually perk up the appearance of foods that are not normally interesting or attractive to the eye.

If you plan to make grill marks on the hero meat, you need to have a clear vision of the pattern the marks will make. Test your grill mark techniques and pattern for the marks on a stand-in piece of meat. Grill marks should approximate a natural mark made by cooking on a grill. The marks can be parallel or more complex with a cross-hatch pattern. If you choose a cross-hatch pattern, keep in mind they can get busy looking to camera. Cross-hatch pattern grill marks are more interesting if made at oblique angles, rather than at perpendicular angles.

Grill marks can be made using an electric charcoal starter. These devices have a long oval heating element loop attached to a handle; however, the grill marks they make are often too wide for photography. It is possible to customize an electric charcoal lighter so the heating element is not as wide. If you want the option of using an electric charcoal lighter as a means to make grill marks, I would recommend you contact a professional metal worker to customize the tool. I prefer this method, and my father customized a charcoal lighter for me many years ago and

I'm still using it. However, metal skewers heated over a flame can also make grill marks for photography. Hold the metal skewer with vice-grip pliers or a well-insulated baking mitt. Place the skewer so about 4 inches of the tip end is in the flame of a gas burner or torch. The skewer will heat quickly. Be aware that it will brand anything it touches.

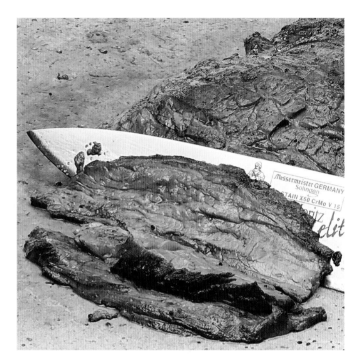

> **SAFETY NOTE** Regardless of the method you use to make grill marks, you're dealing with extremely hot metal that will burn you if it touches your skin. Also, keep in mind that the cord on an electric charcoal starter is short. Work in a place where you can maneuver the tool safely. If you use an extension cord, use a heavy-gauge cord. I tape the electric cord to the tabletop where I am working and put a brick on top of the tape for insurance so the cord will stay put. If the cord crosses the floor, I use duct tape to secure it to the floor. I work on a landscaping stone when I make grill marks because it offers a flameproof surface on which to rest the hot skewers and charcoal starter when not in use. As you finish making torch and grill marks on each piece, place the meat back into the oil, ensuring once again that the meat is submerged in the oil until it is needed for building on the hero plate.

NOTE If you are not slicing or cutting into the hero meat in your shot, proceed to the section on Color for Photo Meat.

SLICING HERO MEAT—EXPOSING THE INTERIOR

> **TRICKS OF THE TRADE** If hero meat is to be sliced, the slicing must be done before any coloring is applied to the exterior of the meat. Once sliced, the meat should not be resubmerged in oil. Sliced meat does not remain hero quality for very long, so you will need to move quickly after meat is cut. Premix any color or sauces, and choose heroes for all other elements in your shot before you proceed to cutting the meat.

Make certain the knife you are using is sharp. Making a one-stroke cut, if possible, is the best way to avoid secondary cut marks. Immediately after the cut is made, you will need to assess the hero quality of the interior of the meat. If it appears to be the correct hero quality for final photography, place a piece of plastic wrap tightly against the cut surface. Make sure the entire cut surface is covered by the plastic wrap, and trim the excess plastic wrap so the edges are not in the way as

you color the exterior of the meat. The plastic wrap will need to remain in place until immediately before final photography.

Use a second piece of the same type of meat as the hero to make meat slices that will be arranged on the hero plate. This secondary cut will need to have the same treatments as the hero meat up to this point. Remove the secondary meat from the oil and follow the hero slicing technique. You need to precut plastic wrap pieces to wrap each slice of hero meat individually. Lay the wrap out flat on the work surface and wrap each slice as it is cut. Make twice as many slices of meat as your shot calls for. Wrap each slice to seal out air with the plastic wrap and lay the wrapped slices in a cool place until they are needed to build on the plate. Notice in the image above that the wrapped slices have a freshly cut appearance. The section of skirt steak that is unwrapped, however, is darker even though it was cut at approximately the same time as the wrapped slices. Unwrapped meat surfaces will oxidize quickly. This is a great example illustrating how the plastic wrap preserves cut meat for a longer time, making styling much easier.

COLOR FOR PHOTO MEAT

The coloring agent for beef, pork, and poultry is basically the same mixture with slight variations for color

differences. The recipe for the coloring agent is the same as that used for hamburger (see Chapter 6, Adding Color to the Burger Patties): On a plate, pour about 2 tablespoons of vegetable oil. To the oil add 1 teaspoon of gravy coloring and 1 teaspoon of Bitters of Angostura plus 1/4 teaspoon of clear liquid dish detergent. Mix the liquids together well using an offset palate knife or pastry brush. The liquids will thicken during the mixing process. With an artist's brush, test a small amount of the color on a stand-in piece of meat.

> **TRICKS OF THE TRADE** In the skirt steak shot accompanying this chapter section, I mixed the coloring agent recipe with a little premixed salad dressing that has a beautiful orange/brown color and herb flakes. I also sprinkled the meat with a rust-colored rub.

If the meat you are styling is to have a barbecue-type sauce, then, as you shop, look at the selection of barbecue sauces in your market. Shop for a sauce that has the color you prefer. Also purchase a bottle each of hoisin and plum sauce, found in the Asian section of the market. Check the color of the sauce by brushing a little of it on a stand-in piece of meat. You can alter the color toward the brown side by adding a little hoisin sauce, or toward a deeper red color by adding plum sauce. The plum sauce also gives barbecue sauce a little sheen that the camera

likes. If the color is perfect without the plum sauce and you want it to have more sheen, add a little Wilton piping gel.

The meat will begin to darken when it's removed from the oil bath because it will be exposed to air. Remove the hero meat from the oil and place it on a few thicknesses of paper towels. Blot the excess oil from the top and sides of the meat. If you are cutting the meat to expose the

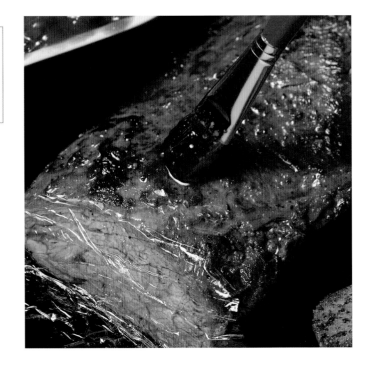

interior, complete that task now and cover the cut area with a piece of plastic wrap. You will need to move quickly toward final photography. Brush the color mixture you have selected onto the outer surfaces of the meat. After the color is applied to the hero meat, avoid touching the meat in areas the camera will see. If spices, herbs, or other condiments are to be applied to the meat, do that now. To maneuver the meat onto the hero plate, use a spatula if possible. Move the meat to the hero plate and transport it to set. Adjust positions of other food items on the plate if necessary. The cooked surface of the meat should look slightly moist, but not soupy. Additional toppings like sauce, pepper, and herbs can be added to the meat at this time.

BUILDING SLICES ON THE HERO PLATE

Slices can be used alone on a plate to represent the type of meat. However, if you are arranging slices on the plate with a section of uncut meat, arrange the slices after the larger cut of meat is colored and positioned on the plate. Look at the slices you've cut and pick the hero slices out of the group. Find the very best one and save it for placement closest to camera. Start building the slices starting with the slice furthest from camera. Unwrap one slice at a time and place it in position on the plate. Work quickly. Do not place the slice closest to camera until you are certain the arrangement of slices

is as you desire. Carefully brush color on the cooked edges of the slices that are seen by the camera. Add the final hero slice of meat to the arrangement. Brush color on its cooked edges. Using a clean brush dipped in cool water, brush any interior surfaces on the meat and on the slices that are seen by camera. Keep the interior of the meat moist with water until final photography is completed.

Supplies used to complete the skirt steak shot:

- evo Tabletop Grill
- Anchor Hocking Premium Grip 9-in. × 13-in. baking pan
- Messermeister Cheflamme professional culinary torch and San Moritz elite 5-inch chef's knife
- STRETCH-TITE plastic food wrap
- OXO Good Grips 12-inch tongs with nylon heads
- Landscaping stone
- Vegetable oil
- Coloring ingredients
- Artist's brush
- Plastic bulb-type droppers

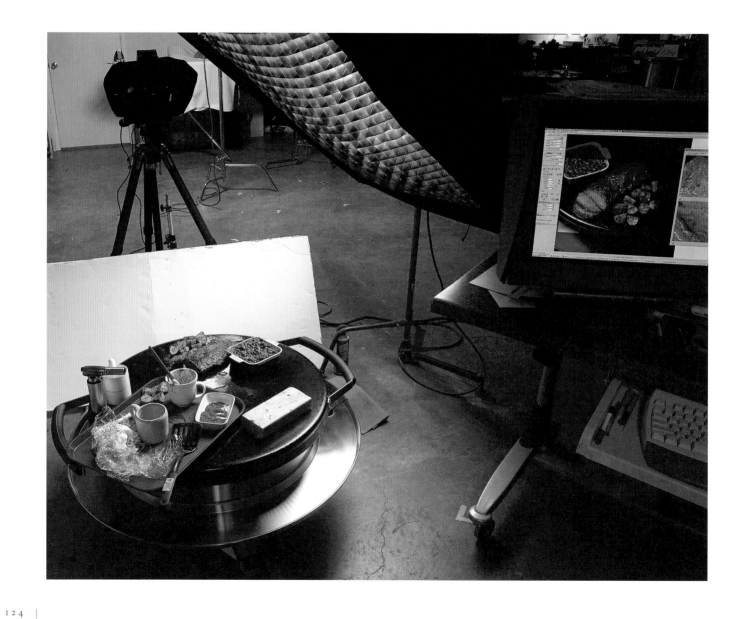

BRAISING METHOD FOR THICKER CUTS OF MEAT

The braising method is used for thicker cuts of beef or pork that will be sliced to expose the interior meat surface to the camera. When cooking meat for photography, the food stylist wants to have a constant reading on the meat during the cooking process. Cooking thicker cuts of meat with this method keeps the meat in an easily observable position. This method is added to the end of the griddle method and is actually performed on the same griddle or skillet surface. Lightly brown or sear the exterior meat surfaces using the griddle method discussed earlier. For thicker cuts of meat, hold the side edges of the meat against the cooking surface to brown them. Use tongs to maneuver the meat during this process so the entire exterior of the meat is seared and no longer red.

By pressing down on a cut of meat with my fingers, I can predict the stage of cooking and the appearance of the interior. However, I realize this method takes a lot of trial and error to learn, and food styling is not an appropriate arena in which to learn this skill. So, I recommend you use a laser style meat thermometer that will allow you to check the interior temperature of the meat and give you an idea of where it is in the cooking process, without making holes in the hero meat. For photography, an interior temperature of rare to medium-rare will produce a pink interior that is usually the preferred appearance for photo beef.

Once the meat is seared on all sides, use a piece of heavy-duty aluminum foil to make a tent that completely covers the meat. The foil should be big enough to flatten around all sides of the meat and against the griddle so that it extends at least 2 inches around the cut of meat. Lower the heat to around 300°F. The foil traps steam from the juices produced by the meat, creating a braising method to cook the item.

TRICKS OF THE TRADE If the meat is dry and not creating any juice on the cooking surface, use a bulb-type applicator to add water around the meat. Check the meat every 3 to 4 minutes, using either your touch on the meat surface or a meat thermometer until the meat is medium-rare. As you work with this technique, carefully lift the foil with tongs to avoid the rush of steam that will escape from under the foil. You do not want the steam to hit your hand or your face so take care.

Supplies used to complete this shot:

- Le Creuset rectangular roasting pan

- Henckels Twin Four Star II 8-inch chef's knife

- Messermeister Cheflamme professional culinary torch

- STRETCH-TITE plastic food wrap

- Landscaping stone

- Vegetable oil

- Coloring ingredients

- Artist's brush

- Plastic bulb-type droppers

PHOTOGRAPHER'S COMMENT—Notes on Beef Filet Set

Ethereal was the key word on this shot. We wanted the background to be a soft white with minimal detail and lots of soft focus. A very shallow depth of field gave us this look. The background is blown out with natural window light. The steak is rich and moist and lit for the cut and face of the meat. My Hasselblad 39MS on my 4×5 camera gave me the focus and crop I needed for this shot.

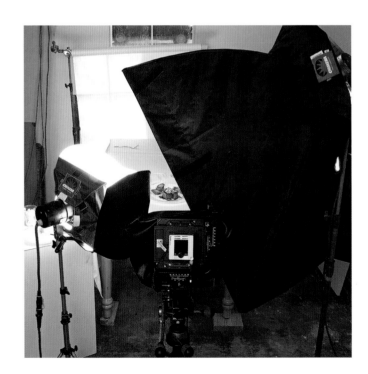

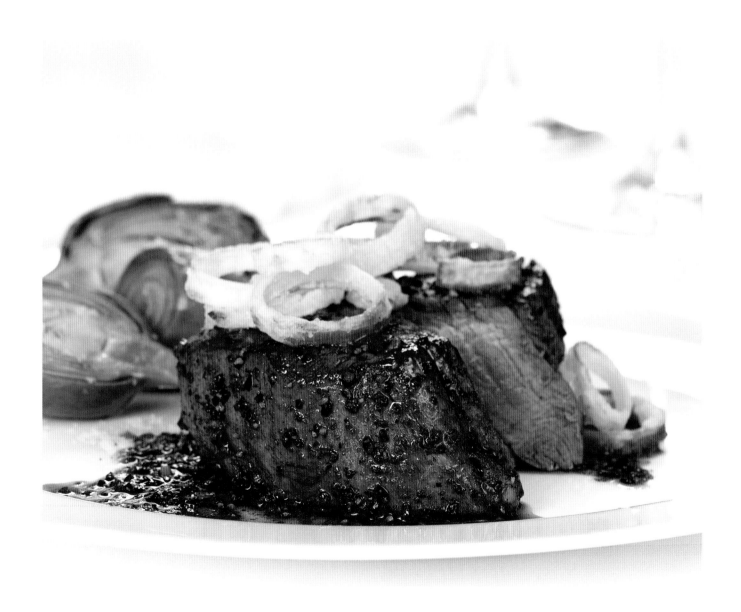

When the meat reaches a medium-rare internal temperature, place it in cool or room temperature vegetable oil. Completely submerge the meat. Reserve any cooking liquids that remain on the griddle or in the skillet for later use on set. Use an angled spatula to scoop up the juices and collect them in a mug or cup until needed on set. Refer to the section on slicing meat earlier in this chapter for cutting techniques and to the section on

coloring photo meat for adding color and interest to the exterior of the hero meat.

Depending on your specific set, the hero plate can be built at a prep table or on set. You will need to assess the time sensitivity of all items on the hero plate to determine the order in which items are to be built onto the plate. If a cut piece of meat is to be in sharp focus, I normally build the plate using a stand-in. My stand-in here is a soufflé cup turned upside down with circles of masking tape to stand in for fried leek rings that will be on the hero. The cup is about the same size as the hero cut of meat, but you can also use a piece of stand-in meat. When the build of other elements on the plate is finalized, I substitute the hero meat, keeping the cut area covered with plastic wrap until final photography, removing it only to check focus and lighting on the cut surface. The clock is ticking at this point and the hero meat will not last for more than 5 to 7 minutes.

STYLING MEAT WITH BONES FOR THE CAMERA

Cuts of meat with bones add one more element for the food stylist to address. Some examples of meat with bones are rack of lamb, ribs, T-bone steaks, and lamb chops. Each of these is wonderful and interesting as the subject for food photography. Once you get your first meat styling job under your belt, don't be afraid to tackle meat with bones. Just be prepared and arm yourself with some styling information.

However, before we talk about techniques, I want to mention stand-ins. In the case of meat with bones, you will need to use a stand-in that is a close replica to the hero. Bones can often be challenging when you are in the process of deciding how to position the meat to camera. It will pay off to do some testing with the stand-in as you plan the shot so that when you are ready to go to hero with the meat, you will have a very good idea of placement for the hero meat in relation to the camera.

Follow the griddle and braising methods discussed earlier for cooking the meat, depending on the thickness of the cut. The rib cooking procedure is different and is described next.

Ribs

Prep and styling techniques for ribs are unique. Because both the top and underside surfaces of a rack of ribs are curved, the griddle method for cooking is not practical. My favorite method to prep ribs for photography is to simmer the ribs in a stockpot of water. This method requires a large stockpot filled with simmering water and a pair of tongs to maneuver the rack of ribs. The ribs must be totally submerged in the simmering water. When the meat is no longer red, allow it to simmer for 10 minutes longer. Remove the ribs from the hot water. If you have other food elements to style for the shot, put the ribs in cool water to rest.

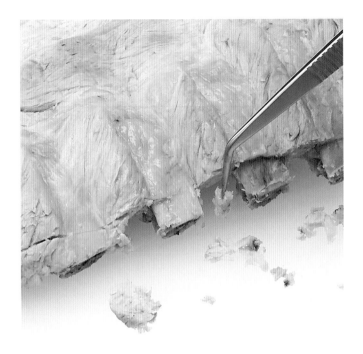

On a rack of ribs, it is normally desirable to have approximately the same spacing between the ends of all the bones and the beginning of the meat. You will most likely need to create this appearance. After the meat is cooked, you can cut and scrape away undesirable meat between the bones to make the spaces appear even. Use a sharp paring knife, tweezers, and scissors to accomplish this task. If meat is stuck to the bones in areas where it is not wanted, use the knife blade to scrape the meat away.

After the meat has undergone basic cooking and any unwanted meat is removed around the bones, use a torch to lightly flame the bone surfaces. The torch can also be applied to areas of the meat to create slight charring for visual interest. Then, as you apply color or sauce to the meat, apply the same color to the bones. The base color of the bones is much lighter than the meat and you may need to reapply an additional layer of color to the bones. A good trick to remember is to brush a light coating of sauce on the meat and bones, followed by running a torch flame over everything. The sugar in the sauce will caramelize as the flame hits, so take care not to burn the sauce in too many places.

When you go to set with hero ribs, check the positioning of the ribs. If it is necessary to make slight position changes for the ribs, do that now. Before final photography you will need to check the sauce on the ribs and bones and apply additional sauce with an artist's brush. Where new sauce was added, be sure to follow with a quick torch flame to blend the color of the new sauce with the existing sauce.

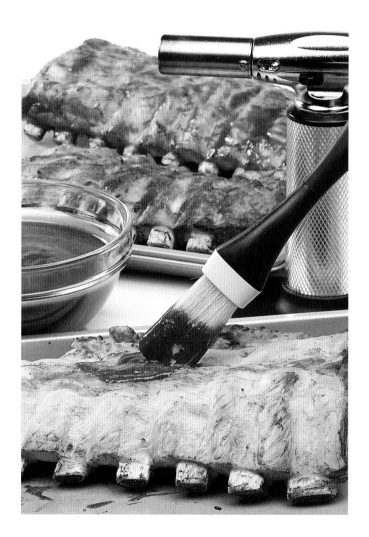

Supplies used to complete this shot:

- Le Creuset stockpot

- OXO Good Grips utility and carving board, Nylon head tongs, 12-inch tongs, and pastry brush

- Henckels Twin Four Star II 3-inch paring knife and kitchen scissors

- Messermeister Cheflamme professional culinary torch

- EMS bent-tip style 24 tweezers

- Two Wilton Recipe Right Non-Stick medium cookie pans

- Cardinal International glass work bowl

- Windex glass cleaner

- Bounty paper towels

- Coloring agents

PHOTOGRAPHER'S COMMENT—Notes on the Rib Set

This beautiful, colorful shot of ribs, corn, and sweet potato shows a lot of texture; texture in the vegetables, meat, and background surface. We rigged the tongs holding the ribs in the set to create a feeling of action in the shot. I used daylight from the window in the back of the set to give me the wonderful highlight across the rack of ribs. I balanced the medium Chimera lightbank with 40% grid and the Chimera lantern to fill the front of the set.

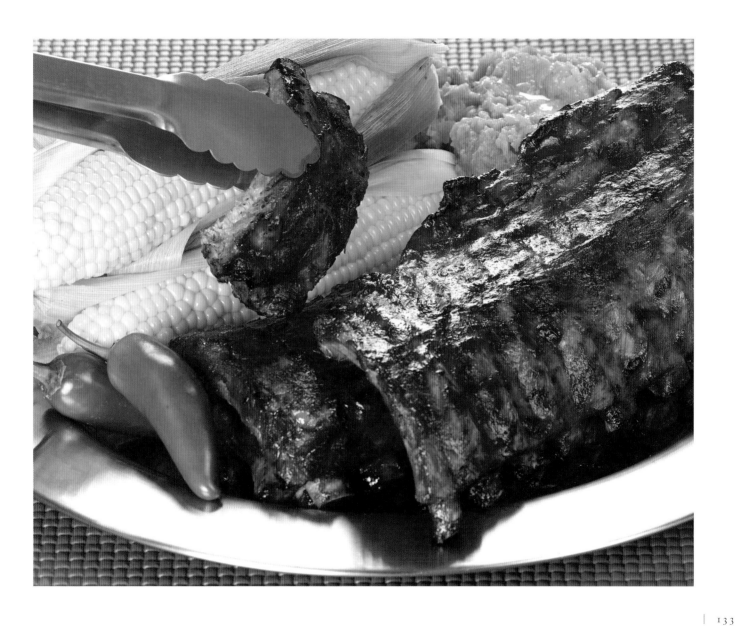

ROASTING POULTRY FOR THE CAMERA

Shopping for Hero Poultry

When you shop for a photo bird, depending on the type of poultry you are using, it's sometimes necessary to give your butcher a week's notice so he can provide fresh poultry. Pick up the fresh birds at the market the day before the shoot. Purchase fresh poultry rather than frozen, because fresh poultry will increase your chances of success for a beautiful roasting. Again, you will need to purchase a minimum of three birds for each hero in your shot, giving you several choices for hero. If you are planning to slice into the meat of the bird for the shot, you would be smart to purchase at least five birds.

As you shop for the photo birds, consider these important things: First, have in mind a size range for the bird. You will want to choose birds that have wide breast areas because they present well to camera. Make certain there is enough skin around the area where the neck was removed to tuck under to the bird's back. Also, look at the skin at the tip of the breast near the stuffing cavity. Sometimes skin in that area is cut or slit during the cleaning process. You want to look for birds that have plenty of skin in both the neck and stuffing cavity area. Choose birds that have no visible blemishes or holes in the skin, especially on the breast area. They should also have complete wings and legs.

As you preplan for a shot including a whole roasted bird, work with a stand-in to determine the preferred position for the bird in relation to the camera.

Turkeys for Photography

Depending on the time of year, it can be difficult, if not impossible, to find a fresh turkey. Be sure to ask the butcher at a good market if he can order a fresh turkey for you. If one can't be found, you can make a frozen turkey work, but you will need to shop carefully. Look for frozen turkeys with packaging that allows you to see the turkey. If that's not an option, you will want to purchase four to six turkeys in the size range you need. You'll be working on blind faith that at least one of the birds will be hero photo quality when you unwrap it. Let the birds partially thaw for 2 to 3 days in a refrigerator before you start to prep them. You may need to rent an additional oven because it is often not possible to bake more than one turkey at a time, depending on their size and the size of your oven.

The following techniques pertain to prepping all types of poultry for photography.

Prepping the Bird

Once you have the poultry at the studio, give each bird a quick rinse in cool running water. Remove any pinfeathers remaining in the skin, rinse the cavities, and pat the birds dry with paper towels. Next, fold two solid white paper towels together into a triangular shape to duplicate the shape of the cavity opening where the neck was removed. Place the paper towel shape into the cavity opening to camouflage the opening with the smooth surface of the paper towel arrangement. Pull excess skin in the neck area over the paper towels at the opening so that the skin wraps around to the back of the bird. Flip the bird over as you are completing this procedure to give you access to the back of the carcass. Using T-pins, secure the stretched skin to the back of the carcass. The next step is to stuff the other end of the bird with crumpled heavy-duty aluminum foil. The foil helps to support the shape of the bird and holds the

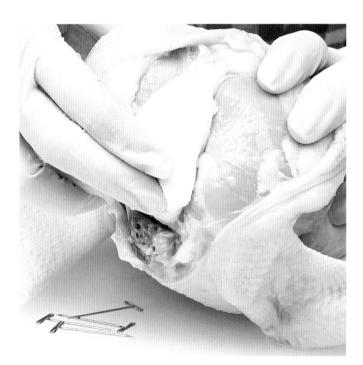

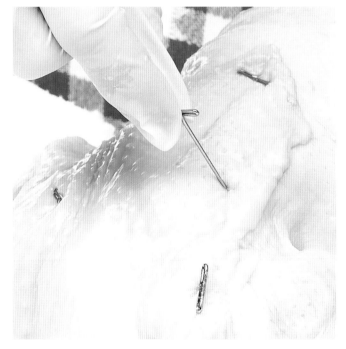

paper towels at the neck cavity in place. Once the stuffing cavity is filled with foil, you will need to stretch the skin covering the breast area so it will tuck under the end of the breastbone and into the stuffing cavity. Depending on how much skin the butcher has left on the bird, either secure the skin with a few T-pins placed inside the stuffing cavity or overlap the skin from both sides of the cavity and pin it together inside the stuffing cavity. The important thing here is to cover the breast

meat with skin and to conceal the T-pins inside the cavity.

Cut circles of heavy aluminum foil approximately 4 inches in diameter to cover each leg bone knuckle of all the hero chickens. Place one circle of foil at the end of each leg bone knuckle. Press the foil around the bone so that it covers the bone and a little of the skin adjacent to the bone. Position the legs of each bird close together and tie with one wrap of cotton string to hold the legs in position.

Next, position the wings of each bird just as they will be in the final shot. If the wings are to be tucked behind the back of the bird, perform that maneuver now. If the birds are to be roasted the following day, place each bird in a jumbo Ziploc bag, remove as much air from the bag as possible, and seal the bag. Set the bags holding the birds on flat trays so the birds are resting on their back with breasts pointed upward and store them in the refrigerator overnight.

On the day of the shoot, about 2 hours before you plan to make final photography, remove all but one rack in the oven, setting the remaining rack on the next to lowest shelf in the oven. Measure the space needed using one of the birds, so the birds and baking sheet will slide into the oven without hitting any oven surfaces. Preheat the oven to 375°F.

> **TRICKS OF THE TRADE** I recommend you cook the #3 and #4 choices for hero first. Cooking the hero alternates first will help you gain confidence in the baking and coloring process. Practice the coloring techniques on the #3 and #4 birds, but treat these birds as hero. It can be hard to predict which bird will be the #1 hero choice until after the baking process is completed.

Spray a baking sheet or roasting pan with nonstick cooking spray. If you bake two birds at the same time in one pan, the birds should not touch each other or the sides of the baking pan. Place the baking pan with the bird in the oven. Depending on the size of birds you are prepping, bake the birds for approximately 25 to 45 minutes or until the outer flesh is cooked, appearing white and the skin has tightened. Because color will be applied to the skin surfaces later, the color of the bird is not crucial at this point.

Carefully remove the baking pan from the oven, holding the tray level to avoid spilling any cooking juices and to prevent the birds from sliding around. Set the baking pan on a heat-resistant surface. Slip a spatula under the bird to ensure it is not stuck to the pan. With a pair of large spatulas, one supporting each end of the bird, lift and transfer the bird to a working surface. Hold the bird level during this procedure because there is certain to be hot liquid within the bird's cavity. Reserve any brown elements in the pan drippings for later use. Wipe the cooking pan clean, respray with nonstick spray, and repeat the cooking process for the remaining birds.

Once again, turn your attention to the partially cooked bird on the working surface. With a spatula under the neck end of the bird, gently tip the neck end of the carcass so any juices collected in the stuffing cavity will drain out. Hold a low-sided dish or several thicknesses

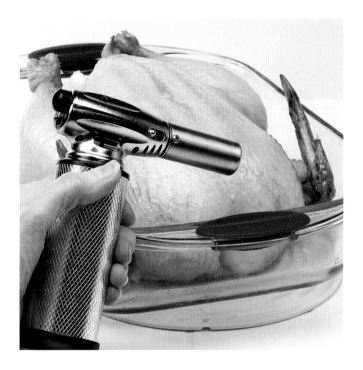

of paper towels to catch the liquid. These liquids could be hot, so take care not to get them on your skin.

During the baking process the bird's skin will tighten, causing the pinfeather bumps to smooth out. Occasionally, some of the bumps don't disappear. If this happens, a torch flame can be lightly run over the bumpy areas to encourage them to flatten. Remove the foil cups covering the leg bones. Lightly run the torch flame over the skin and bone to dry any remaining moisture and to tighten

any bumps remaining on the skin. If you determine that this may be the hero bird, place it on the hero plate and proceed with the coloring techniques. If not, use this bird as a stand-in.

Making the Bird a Hero

To color the skin of the cooked birds, use the coloring agents and techniques described earlier in this chapter. However, use a little less brown gravy coloring for a lighter golden color. For our roasted hen shot in this chapter section, I mixed a little preprepared dressing with the color to give it some extra sheen and to include some herb flecks in the color. Apply the color mixture to the bird exterior with a basting brush. Take care to cover all the skin areas exposed to the camera. For visual interest, apply slightly heavier layers of color to areas like wings and legs. Paint the leg bones with color also. After color is applied to the bird, be careful not to touch the bird's skin during the garnishing process because a mark will result. You can also sprinkle the bird with spices or rub granules for additional visual interest.

With the hero bird on the hero plate, turn the bird to present the best or predetermined position in relation to the camera. Remember, you are the camera as you build the hero garnishes around the bird. This is the fun part! You get to add beautiful food garnishes that you prepped earlier. The garnishes will accent the beautiful bird you've

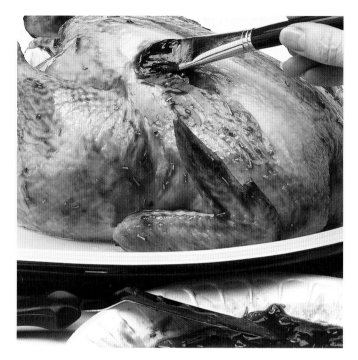
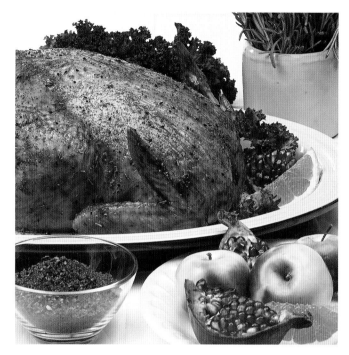

just prepared. Choose a selection of items having a variety of textures and colors complimenting the color and texture of the hero bird.

Supplies used to complete this shot:

- Le Creuset stoneware oval serving platter and Cool Tool
- Anchor Hocking Premium Grip 10-in. × 13-in. baking pan
- OXO Good Grips utility and carving board

- Messermeister Take-Apart utility scissors, and Cheflamme professional culinary torch
- Bounty paper towels
- Aluminum foil
- T-pins
- Kitchen twine
- Coloring agents and rub granules
- Artist's brush

PHOTOGRAPHER'S COMMENT—Notes on the Roasted Chicken Set

Rich, dark, moist, earthy—that's what we said we wanted for this shot. Simple lighting positioned to the right of the set and slightly overhead. The grid on my Chimera lightbank diffused the light to give me the dark but richly lighted set. No fill cards were needed; the fall-off around the chicken and garnish gave us the look we wanted.

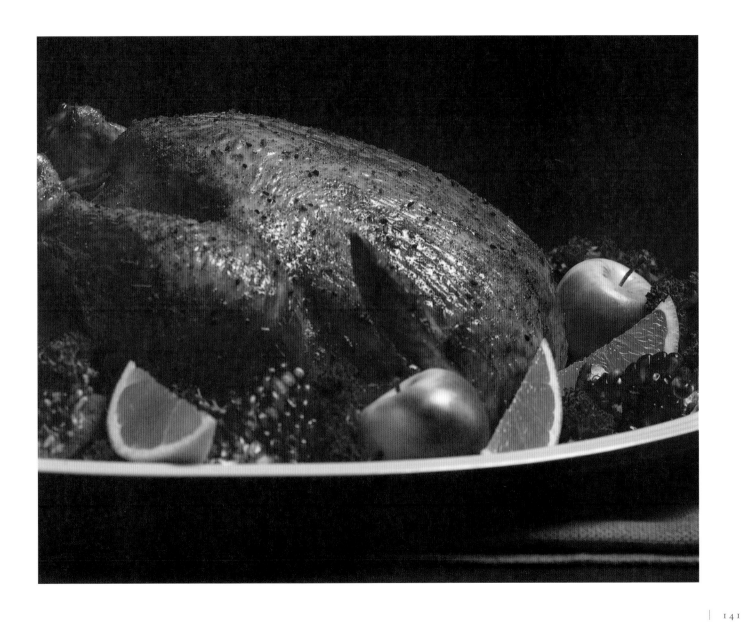

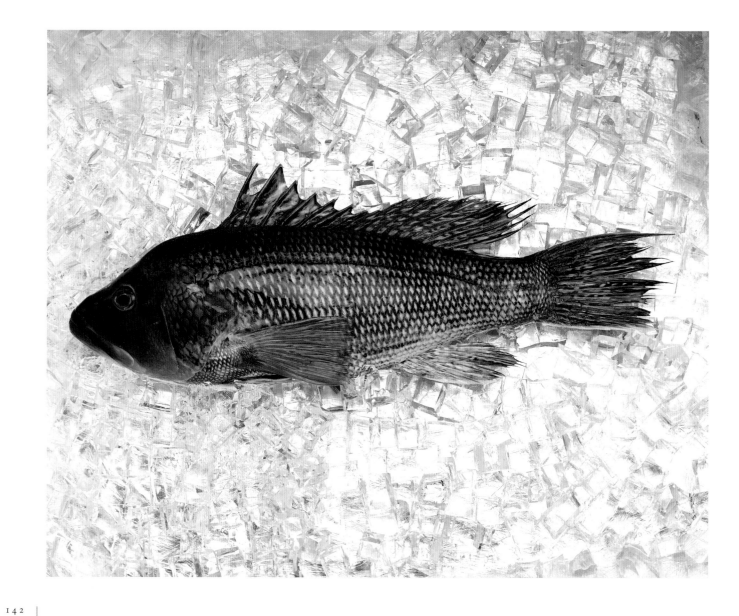

HERE FISHY, FISHY: FISH ARE DIFFERENT CRITTERS

If you plan to photograph a whole, head-on fish you must purchase very fresh fish the day of the shoot. You will need to use something that is a similar size as a stand-in to perfect the set and lighting. When you select hero whole fresh fish, the eyes must be clear, not cloudy, and the gills should be red rather than pink. Also look for a fish that does not have missing scales and whose fins and tail are complete. There should be no cuts or tears visible on the fish. Have the butcher carefully wrap the fish in butcher's paper and ask him to make sure the tail and fins aren't bent during the wrapping process. Carry the fish to your vehicle where you cleverly have a large ice chest, half full of ice, waiting. The ice chest must be big enough to hold the fish without bending it. Place the wrapped fish on top of the ice in the ice chest and pack more ice around the sides of the fish to prohibit it from sliding around as you drive. Transport the fish to the studio in the closed ice chest, and keep it there until time to go to set. Once the hero fish is on set, keep cold, damp paper towels covering the fish whenever possible until time for final photography. Spritz the entire fish with cold water, making sure to spritz the exposed eye before you go to final capture or film.

TRICKS OF THE TRADE Here's a trick that I'm happy to share. The ice in our whole fish shot is actually not real ice. And, it isn't the acrylic ice commonly used in photography for this type of shot. The ice in our shot is a landscaping rehydrating product made by JRM Chemical. Each cube starts out as a tiny 1/8-inch cube and expands to the size of the cubes you see in our shot after spending a couple days in water. If you use this product for photography, plan to soak it a couple days ahead of time. This "ice" will stay on set all day.

The texture of most fish flesh is delicate when compared to beef and pork. For this reason, the styling and cooking techniques for fish are different. Because most types of fish have a texture that flakes when cooked, fish cooked for photography must be handled very carefully. It must be fully supported underneath during styling and during transport to the hero plate or surface.

Like other proteins, fish flesh will tighten up during the cooking process. The tightening of protein will cause the piece of fish to shrink slightly in the surface area it will take up on the plate and it will become a little thicker or taller in size. When you begin the cooking process for fish for photography, there are several advantages to starting the process with well-chilled fish. If the inside

of the fish is very cold, the outer surfaces can be cooked while keeping the center of the fish flesh still intact and not flaky. It's the flaking that makes a piece of fish so fragile for photography.

TRICKS OF THE TRADE Most fish filets or steaks will need to have a support underneath the fish once it is cooked. This support will provide a means to maneuver the fish to the hero plate or surface. When I purchase 1 pound of prepackaged spring mix lettuce and baby spinach, it is packaged in clear plastic boxes. I save the box lids for this purpose. The lids can be cut into the shape of the photo fish, and they are thin enough to easily slide underneath the cooked fish. You can also use acrylic sheets purchased at art stores for this purpose.

Cooking Fish for the Camera

There are two methods for cooking fish with steam. You can place the fish on a support in a steaming kettle for a short time, or place the fish on a landscaping stone surface and use a handheld steamer to cook the outer surfaces of the fish. I often use the handheld steamer method because the fish is totally visible during the cooking process. Both methods of steaming keep the fish moist during the cooking process.

To achieve a broiled appearance, once the fish is partially cooked with steam, place the fish under a preheated broiler for a few seconds. You'll want to watch the fish during the entire cooking process. Place the fish under the broiler just until some areas of the fish's outer surface have a golden browning. You will definitely want to practice this procedure using a stand-in fish before using this technique on the hero because fish is easily burned. Practicing with the stand-in will give you a good feel for the distance between the fish and broiler and will help you gain confidence.

To move the fish to the hero plate, slip a spatula under the fish and acrylic sheet. Hold the spatula with fish over the hero plate. Make certain the fish is turned with the best presentation to camera. Slide the fish assembly onto the plate. Make certain the camera does not see the acrylic sheet. Misting the fish lightly with water will give it a fresh-cooked, moist appearance.

Our cooked fish image is shot within a large skillet that has sloping sides. We wanted our fish to appear as though

steamed on a bed of vegetables. In order to keep the fish on a solid surface, I constructed a support for the fish hero using a STYROFOAM block. The block is held in place with windowpane putty. Once the vegetables were prepped, I built the vegetables around the block and covered the entire assembly with damp paper towels and plastic wrap until the fish hero was ready to be placed into the scene.

Supplies used to complete this shot:

- evo flat top grill (for the photo surface)
- Cardinal International glass prep bowl
- STYROFOAM
- Wilton Recipe Right Non-Stick medium cookie pan
- Le Creuset 5 1/2-quart round roaster with steamer insert
- Henckels Twin Four Star II 5-inch chef's knife and kitchen scissors
- Jiffy International Esteam handheld steamer
- Landscaping stone, used as the steaming surface
- OXO Good Grips large nylon flexible turner
- STRETCH-TITE plastic food wrap
- Brick, to support the skillet handle and stabilize the skillet
- Spritzer bottle with water

PHOTOGRAPHER'S COMMENT—Notes on the Fish Set

Shooting fish to get the texture and flakiness is all about the lighting. We chose to shoot on a dark background so the fish would separate from the background. I used the grid on the Chimera lightbank shifted to the back and right of the set. A fill card in front and my Chimera lantern is positioned in the back to cast a broad highlight over the pan and surface.

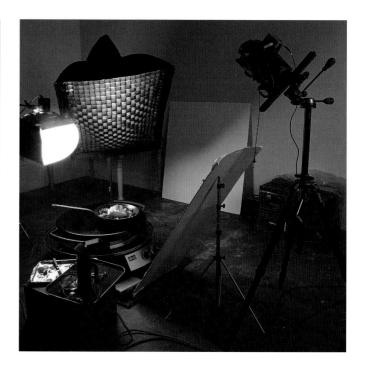

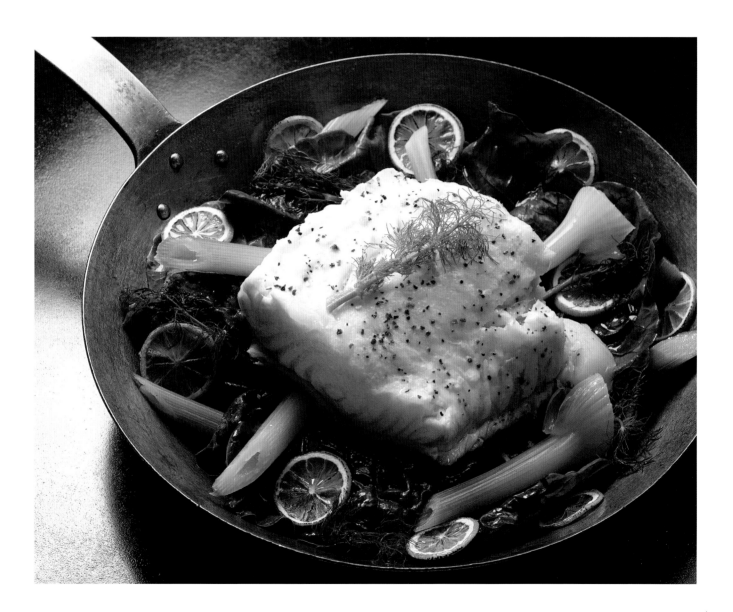

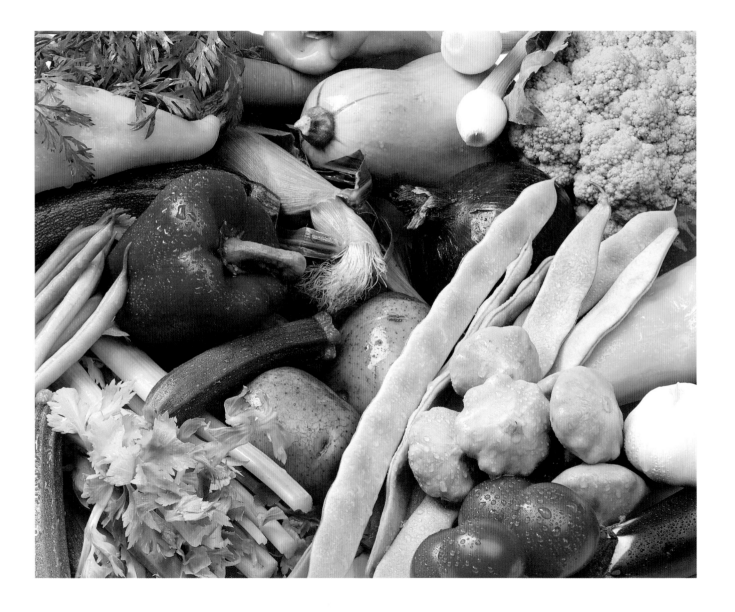

VEGGIE PERFECT

Well, almost perfect, because technically some of the vegetables we refer to as vegetables are actually fruit. According to the *Merriam-Webster's Dictionary* a fruit is "a product of plant growth" that is the "edible and sweet reproductive body of a seed plant." If you give some thought to the definition, it means many of things we call vegetables are actually fruits. However, for our food styling purposes, they will be called vegetables.

SHOPPING FOR VEGETABLES

A good beginning point for this discussion is to mention the standards and techniques used during the shopping phase for the hero shot at the opening of this chapter. I shopped for produce items the morning of final photography. To select hero produce, always look for fresh, blemish-free examples of each item you purchase. You'll need to check each item carefully, looking at the entire exterior. Each item you select for your food styling project should be free of blemishes, firm, and uniform in color specific to each variety.

As I shopped, I chose several hero specimens of each type of vegetable. I also selected a wide variety of colors, textures, and shapes in the overall scheme of vegetables purchased. I did not actually use everything I purchased when I built the hero shot. However, having the wide variety of items available gave me options during the

build and thus provided more opportunities to compose a visually pleasing image.

The differences in color, texture, and shape among vegetables lend visual interest to the overall presentation and contribute to better visual separation of the vegetables within the build. For instance, if all of the vegetables were round or oval with fairly smooth skins—for example, potatoes, eggplants, and onions—the shot would probably not be very interesting. So, mixing textures and growth patterns or shapes is important to consider when shopping for, and constructing, a produce shot. When building the shot and placing items adjacent to each other, keep the colors, textures, and growth patterns in mind. You can offer more visual interest by placing vegetables with different characteristics adjacent to each other.

Vegetables offer a vast range of color and texture to a photo arrangement whether they are pictured in all of their raw bounty as in the chapter-opening shot or cooked and arranged on a plate to accent a featured piece of meat. You may recall from the color wheel discussion in Chapter 2 that the vegetable group offers choices for complementary and contrasting colors that can be used to excite and enhance the colors of a featured item on a plate for photography. These color enhancements should be positioned near the featured item to achieve the pop factor.

PREPPING VEGETABLES FOR PHOTOGRAPHY

Because vegetables come in a variety of types and growth patterns, the discussion of prepping for photo vegetables will be specific to these groupings. However, that being said, each vegetable can be treated with specific styling techniques. Always use clean, sharp knives and tools when working with fresh vegetables and make sure the cutting board surface is clean.

> **TRICKS OF THE TRADE** I clean cutting boards with soap and water between uses, and also in between cutting different types of vegetables. I often treat my acrylic boards with a bleach-water rinse between styling jobs, and when they become stained. If you want to follow this practice, mix 1 part bleach to 2 parts water in an applicator bottle purchased at a beauty supply store. Place the acrylic board in a sink. Squirt the bleach and water mixture on the cutting board surface. Be careful the liquid doesn't splash onto your clothing because it will make permanent spots. Let the bleach water remain on the board for several minutes or until the stains are removed. Repeat the application if necessary to remove stubborn stains. Rinse the board with clear running water and stand it on end to drip dry or dry it with a paper towel.

When purchasing carrots for photography, look for bunches that have the green tops still intact. Also look for carrots that are blemish free and have a rich orange color. The root end should taper to a point. As you prep the carrots at the studio, using kitchen scissors, cut off the green leafy sections, leaving a short length of the stem on the carrot. The length of green you leave attached to the carrot will depend on the look you want for your shot. If the outer stem stalks are damaged or pale, they can be removed. Rather than pare the carrot, work under slow running water or over a bowl of water, and use a Scotch-Brite heavy-duty scouring pad to clean the carrot. The pad can be used to remove all dirt and small roots from

the surface of the carrot. Also, use the edges of the pad or the tip of a paring knife to remove dirt deposits where the green stems grow out of the carrot. Once each carrot has been cleaned, submerge it in ice water or wrap it in a wet paper towel. If you use the paper towel method, place a group of the wrapped carrots in a Ziploc bag until you are ready for the carrots.

If you want to use tomatoes in a dish for photography and do not want to show the skin on the tomato, rather

than using canned cooked tomatoes, better visual results can be achieved by skinning the tomato yourself. There's a quick way to remove the skin while keeping the outer flesh of the tomato intact. Place water in a large pot until it is deep enough to submerge the tomatoes you have purchased. Bring the water to a boil. Insert a long-handled fork into the tomato at an angle of about 45° near the stem of the tomato. The angle will help ensure the tomato does not fall off the fork during the following process. Holding the tomato on the fork, completely submerge the tomato in the simmering water for about 10 seconds. Remove the tomato from the simmering water and immediately plunge it into a bowl of ice water. Remove the tomato from the ice water and remove the fork from the tomato. Grasp the tomato skin and pull it away from the flesh of the tomato. If the skin does not readily separate from the tomato, it may be necessary to repeat the process of submerging the tomato in the simmering water for an additional 10 seconds and then back into the ice water. Use this process for all of the tomatoes you intend to peel. With a sharp knife, cut each tomato in half or quarters. Use a spoon to remove the juicy seed areas in the interior of each tomato since they are not a desirable element for photography. Reserve the thick flesh from the outside of the tomato and cut it to the size required for your shot.

Depending on your shot, during prep time, you may need to cut some of the vegetables. Use a sharp knife and a cutting board. Follow safe knife handling techniques. Depending on your specific project, you may have many options for the shapes and sizes to cut. Consider the overall look for the presentation you want to achieve. And don't be afraid to experiment with different cuts for the vegetables.

All vegetables have specific growth patterns that are fairly predictable. Vegetables in the broccoli and cauliflower family, like the broccoflower pictured here, have growth patterns like that of flowers on short stems. To cut vegetables in this family, you need to look at the individual vegetable. Notice the shape of the flowering heads, and with a sharp knife, cut the stems according to the needs for your shot. If you desire flower heads that are smaller

than the growth pattern of the vegetable, there is a special technique that you can use to avoid a knife mark and "cut" appearance on the flower end. Using a sharp knife cut the vegetable, beginning at the stem end. Bring the knife through the entire stem, but not through the flower end. Remove the knife from the vegetable. Grasp the split stem, holding one side of the stem in each hand. As you pull your hands apart, the flowering end of the vegetable will part with a more natural edge.

Corn on the cob is a unique vegetable to prep. I usually trim the darker areas of the silk with scissors, and then either blanch or steam the corn. It only takes about 10 minutes for the color of the husk and corn to brighten during blanching or steaming. Once that happens, remove the corn from the kettle and plunge it into ice water. When the corn has cooled to the touch, you can gently fold back the husk about halfway down the corn. Grasp the silk at the tip of the ear of corn and pull the silk away. If any stray silk ends are left, remove them with your fingers or sharp scissors.

My favorite display of corn is to completely remove the husk from one side of the corn. Then, using the removed husk, cut or tear two strips about 3/4 inch wide the length of the husk. Tie the ends of the strips in a knot. Hold the ear of corn in one hand, and fold back the remaining husk to create an attractive collar for the ear of corn. Wrap the tied strip around the corn with the knot showing in the front against the exposed corn kernels. With a T-pin, secure the ends of the strip on the back of the ear to hold both the strip and the husk collar in place.

METHODS OF COOKING VEGETABLES FOR PHOTOGRAPHY

The vegetables depicted in this image were prepped using either the steaming or blanching methods

described below. The goal that the photographer and I wanted to achieve with this shot was to illustrate a study of textures using one color. With that goal in mind, I selected vegetables of varying colors in the green family. Once the vegetables were prepped, I began constructing the hero plate using the differences of texture to make the vegetables pop and visually separate within the build. I also wanted the build to create movement to draw the viewer's eyes through the image.

There are four basic methods for cooking vegetables for photography. It might be more accurate, however, to say that there are four basic methods for making vegetables *appear* cooked. In the world of food photography, all is not as it appears. Have you ever noticed, while preparing vegetables at home, that when you first plunge green vegetables into simmering water, the color of the vegetable changes very quickly to a more vibrant appearance? As the vegetable continues to cook, it becomes more water logged or limp and the color isn't quite as vibrant. For food photography, we usually want to capture the vibrant appearance before it goes any further into the cooking process.

Steaming

One of the methods for prepping vegetables for photography is steaming. Additional techniques may be applied to the vegetables after steaming, but steaming

is a very controlled way to begin the cooking process. A steamer usually involves a large pot or kettle that holds a couple of inches of boiling water and some type of steamer insert that fits into the pot. The steamer insert is perforated with holes that allow the steam generated by the boiling water to access the vegetables sitting on the steamer insert. The bottom of the steamer insert should be above the water surface in the pot at all times.

The process of steaming a vegetable enhances the color while maintaining the photo viability of the vegetable. The effects of steaming on the vegetable can be observed if a glass lid is used over the steaming pot. Most vegetables will achieve color enhancement within a minute or two of steaming. Use tongs to remove the vegetable from the steaming pot and immediately submerge the vegetable in a bowl of ice water. I often leave the vegetables in ice water until they are needed to build the hero plate. However, another method involves removing them from the ice water and placing them in Ziploc containers or on trays. Cover the trays of vegetables with plastic wrap. They will need to be refrigerated until you are ready to construct the hero plate. Steaming works especially well for larger vegetables such as broccoli, cauliflower, or corn because after steaming, these vegetables are easily handled with tongs without causing damage to their appearance.

Blanching

Another method for cooking vegetables for photography that achieves an effect similar to that of steaming, is blanching. Blanching is a better choice than steaming when you are prepping tender and small vegetables. The simmering water surrounds the small vegetables and cooks the outer surfaces evenly and quickly. Remove small vegetables such as peas and green beans from the

water with a mesh strainer as soon as the optimum color is reached. Larger vegetables can be more easily removed from the water with tongs. As you add vegetables to the simmering water, it works best to blanch small batches at one time. This keeps the water temperature even, allowing for more controlled and even cooking of the vegetables. To stop the cooking process once vegetables are removed from the simmering water, plunge them into an ice water bath. If you are blanching or steaming

several batches of vegetables, it may be necessary to replenish the ice often.

TRICKS OF THE TRADE If you have a large number of vegetables to blanch or steam, use a large kettle or clean sink to hold the ice water. Set a colander into the ice water and make sure the level of ice water is ample to cover the vegetables as you place them into the colander. This technique keeps the vegetables in the colander and separate from the ice. This will save you from having to dig through the icy water for the vegetables and it also protects the vegetables from being agitated in water with rough ice edges. Be sure to keep the ice replenished in the sink or kettle as needed. If you are blanching or steaming small, delicate vegetables, such as peas or beans, you can keep them separated from ice and larger vegetables by placing them in a wire mesh strainer suspended in the ice water.

Once all of the vegetables for the image have been steamed or blanched and are well chilled in the ice water, they are ready to be built on the hero plate. If your project calls for using vegetables prepared this way to enhance or garnish a plate with other foods, for instance, a steak, the prepped vegetables can remain in ice water until you have the other items ready to build on the hero plate.

Supplies used to create this shot:

- Le Creuset 5 1/2-quart round french oven and steamer insert

- Henckels Twin Four Star II 8-inch chef's knife and 3-inch paring knife

- Messermeister San Moritz elite 6-inch chef's knife, and jumbo slotted turner

- OXO Good Grips Y peeler, swivel peeler, 12-inch tongs with nylon heads, 6-inch strainer, and carving and cutting board

- Cardinal International salad bowls

- Arcoroc oval dinner plate

- Scotch-Brite heavy-duty scouring pads

- Artist's brushes

- Spritzer

- Ice

- Hand-painted surface by Brad G. Rogers

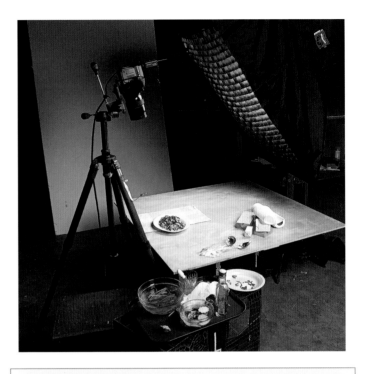

PHOTOGRAPHER'S COMMENT—Notes on the Steamed Vegetable Plate Set

Simple, soft, beautiful light. Let the color and shape of the vegetables be the hero of the shot. We used a simple set and a soft background, with tone on tone for both the food and the set. I placed a medium Chimera lightbank and grid to the back of the set and overhead, but no fill, to give deep rich color and soft shadows in front of the plate. My Gitzo Studex tripod gave me the stability I needed for an overhead shot.

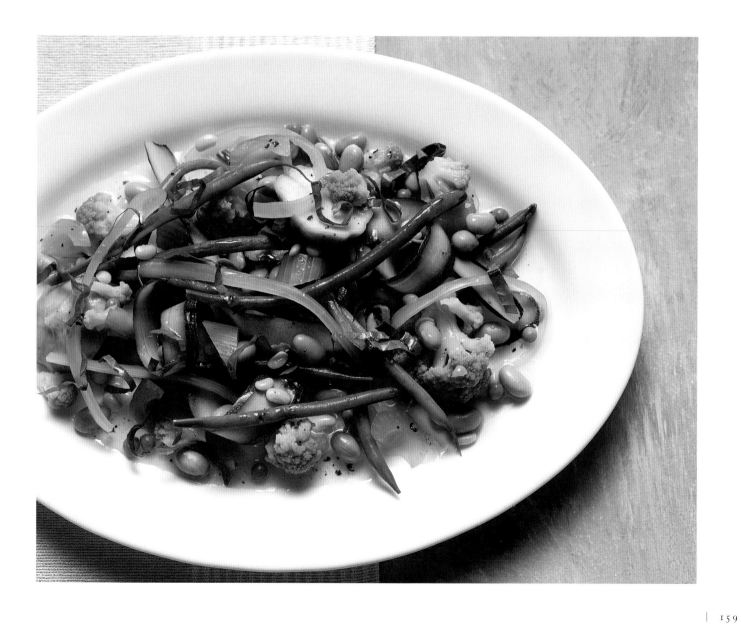

Cooking Vegetables on a Griddle

Cooking treatments for vegetables lend a variety of controlled appearances for the vegetables, and each treatment is appropriate for specific projects. Whereas blanching and steaming bring out the intrinsic color of vegetables, cooking on a griddle and baking techniques add browning effects or caramelization on the surface of the cooked vegetable. Vegetables with higher water content like tomatoes are best if baked to accomplish a caramelized appearance. After completing the griddle or baking process, you can add grill marks to make vegetables appear as though they were cooked on a grill.

If vegetables are to appear grilled, the sequence of techniques can start here, with a few exceptions. Normally I blanch potatoes for a few minutes and drain them thoroughly before placing them on a griddle to brown cut surfaces. Cooking vegetables on a griddle should be accomplished shortly before building the hero plate.

To prep vegetables on a griddle, preheat the griddle surface to 325° to 350° Fahrenheit. Brush the griddle surface with vegetable oil. Work with only a few pieces of vegetables at one time because you will need to check them often during the cooking process. Lay the vegetables cut side down on the griddle and cook

them until they have a light golden color. If you choose to use a spatula or tool to remove them, make sure the implement does not mar the vegetables' surfaces. As the vegetables complete the browning process, place them hero side up on a tray until needed for construction of the hero plate or on set. Cover the vegetables with plastic wrap.

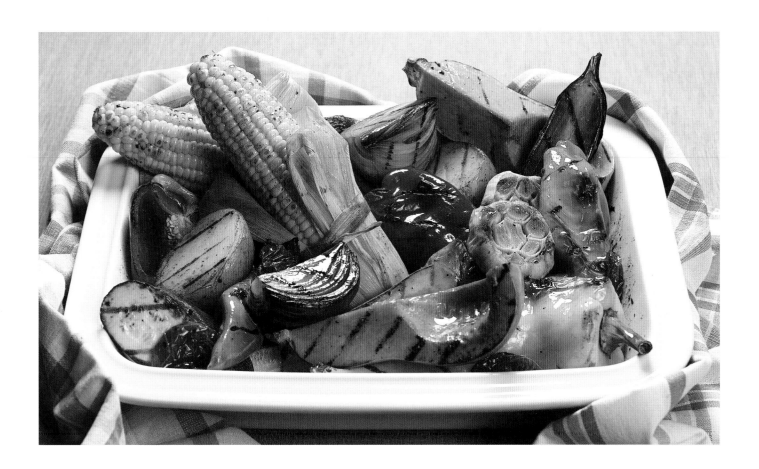

Baking Vegetables

Cooking tomatoes with the skin on is best achieved in the oven. The tomatoes can be cut in half or quartered. Remove the seeds and liquid interior with a sharp-edged spoon. I use my trusty metal camping spoon but a grapefruit spoon works well too. Place the tomatoes on a baking sheet and sprinkle them with olive oil. Bake in a preheated oven at 350°F for 25 to 45 minutes, depending on the size of the tomatoes. Remove them from the oven when they have a little browning on the edges. When the tray has cooled to the touch, cover the tray of baked tomatoes with plastic wrap until needed to build the hero dish.

> **TRICKS OF THE TRADE** A good trick to remember is that the caramelized residue on the baking sheet after tomatoes are baked is a good enhancement to baked foods. Use an offset spatula to scrape the caramelized drippings from the tomato baking pan. Place the residue on the hero food or plate with an artist's brush.

Some vegetables can be baked or partially baked as a prep method. The oven can also be used to steam certain vegetables, like potatoes and large squash, by sealing the vegetable with a small amount of water in an aluminum foil pouch before baking.

MAKING GRILL MARKS ON VEGETABLES

Most vegetables that will appear grilled to the camera are treated first by steaming, baking, or cooking on a griddle surface and then grill marks are added. Regardless of the cooking method, the vegetable must appear cooked. Refer to the discussion about making grill marks in the chapter on meats (Chapter 7). The electric charcoal starter appliance or hot metal skewer technique both work well for making grill marks on vegetables. A torch or electric charcoal starter can also be used to create browning along the edges and in selected spots on the surface of the vegetable. Once the grill marks are applied, additional coloring, oil, or other treatments can be applied to the surface of the vegetables if desired.

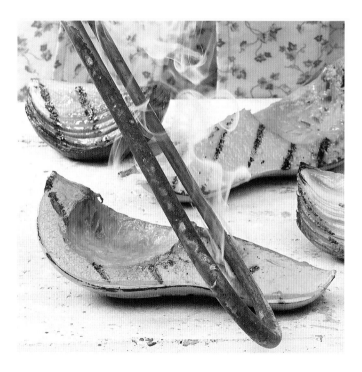

Supplies used to complete this shot:

- Totally Bamboo cutting board
- Presto Tilt'N Drain griddle
- Messermeister 5-inch serrated tomato knife, kitchen scissors, nylon turner, and San Moritz elite 6-inch chef's knife
- Wilton Recipe Right Non-Stick medium cookie pan
- Le Creuset stockpot and 3 1/2-quart rectangular baker, pearl
- Electric charcoal starter
- T-pins
- Artist's brushes
- Landscaping stone

VEGGIES ON SET

Arranging vegetables on the hero plate requires consideration of the color, texture, and shape of the vegetables in relation to each other and to other ingredients on the plate. Unless you are specifically drawing the viewer's eye to a focal point, the factor you want to build into your shot is visual flow. For visual flow, the eye of the viewer should move through the plate in a diagonal or S curve. Avoid abrupt edges unless they are a planned, integral part of your design.

As a general rule, most vegetables in a photo image, both raw and cooked, look better to the camera moist, not dry. When styling raw vegetables in a display like the shot at the beginning of this chapter, most of the vegetables are spritzed with water. However, there are a few vegetables that should not be misted when raw. Examples of these are onions that have their outer paper skin covering intact, garlic, and acorn squash and other fall harvest squash including pumpkins. When applied to these vegetables, water mist does not look good to the camera.

Depending on the specific presentation of vegetables on your set, cooked vegetables will require either an application of water or vegetable oil periodically while on set and immediately before final exposure or capture. If the vegetables are incorporated in a recipe having a liquid base or sauce, you have the option to use the sauce to moisten the vegetable. If the sauce has oil as an ingredient, add a small amount of additional oil to some of the reserved sauce or use plain vegetable oil to keep the vegetables looking moist. Apply liquids to the vegetables with an artist's brush.

Vegetables that were steamed as the only technique for camera presentation will need to be brushed with an artist's brush wet with water or misted with water occasionally while on set and immediately before final capture.

Vegetables appearing either grilled or browned will need a light application of vegetable oil applied with an artist's brush occasionally while on set and immediately before final capture.

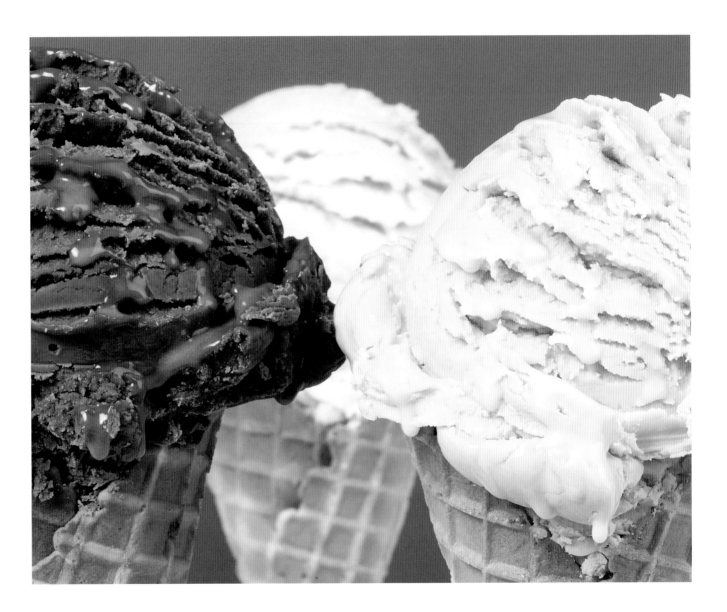

ICE CREAM FOR HOT LIGHTS

THE REAL DEAL

I have styled a lot of ice cream, both real and fake. The legal guidelines for food photography used for advertising purposes are very specific. I am not an attorney, and will not recite the law; however, I can offer an interpretation to give you an example of how the law applies to food advertising. For instance: If you are selling ice cream, you must photograph the real thing, but if you're selling the topping on the ice cream, you can use fake ice cream.

Styling real ice cream requires special equipment, mainly in the freezer category, warm clothes for the entire crew (especially for the stylist), and a lot of hard, fast work. Styling ice cream without a stylist is extremely challenging, to say the least. But if shooting real ice cream is something you crave to do, let's start the discussion with a few techniques for styling the real thing. (Can you tell I'm trying to talk you out of it?) Assuming you're a glutton for punishment, oops, I mean challenges; here are a few hints to get you started.

Rent a chest-type freezer a few days before you plan to shoot, so it can come to the appropriate temperature, around 0° to 10° Fahrenheit. Purchase ice cream scoops the size you choose for your hero scoop. You'll need a minimum of three scoops because they need to be cleaned and dried between uses. Purchase the ice cream, flavor of your choice, in 1-gallon containers. The round containers work best. You'll want lots of ice cream, because you'll need to practice scooping until you get comfortable with the technique. When you're ready to start scooping, first put on your sweater and gloves. Open the chest freezer and, bending at the waist, work in the freezer. All the scooping and styling will be performed as you bend over the open chest freezer. Shall I go on? Your back may not want you to.

A GREAT FAKE

Let's talk about styling with fake ice cream instead. Many years ago, fake ice cream was made with a base of instant mashed potatoes. It did not look realistic, and I never personally used that recipe. The first time I made fake ice cream, the base ingredient was solid white shortening. It wasn't bad-looking fake ice cream, but the process of making it was tedious. There were several ingredients and I often had difficulty getting the proportions just right because humidity and room temperature had to be accounted for. Then I chanced upon another recipe, which has never failed me: store-bought ready-made frosting and confectioner's sugar. This mix can be colored, swirled, and solid ingredients can be added for chunks. It also mixes well with Elmer's Glue-All to make melted ice cream to create the drips that convey a realistic appearance.

Before I go any further, I need to add that regardless of whether you are using real or fake ice cream, styling ice cream requires a lot of upper body strength. The process of scooping and releasing numerous scoops from the scooper is strenuous. After a day of scooping, my shoulders, arms, hands, and back are sore, despite the fact that I work out regularly.

The task of mixing fake ice cream is made easy if you use a Cuisinart food processor. Place one container of pre-mixed frosting purchased at the local grocery into the processor. Start with a color of frosting that is in the same color family as the desired final outcome. For example, use French vanilla flavor frosting to make fake vanilla ice cream, strawberry flavor frosting for a pink-colored fake ice cream, and chocolate flavor frosting for chocolate fake ice cream. Coloring in the form of paste food coloring is needed to create colors not found in premade frosting. For example, for the green ice cream in our shot, I used a cream cheese frosting and added a tiny amount

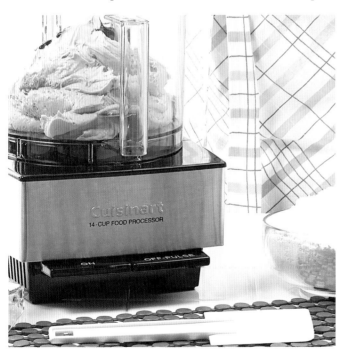

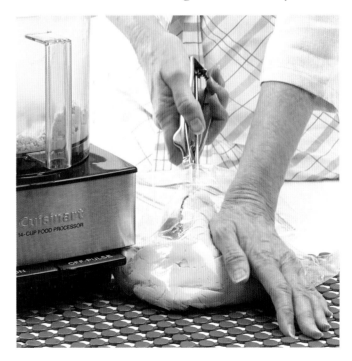

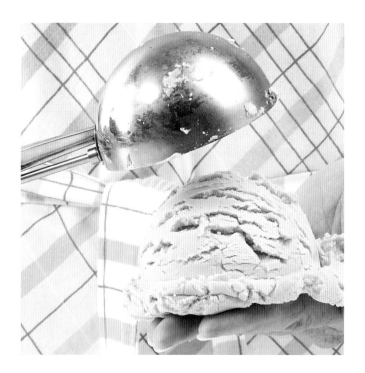

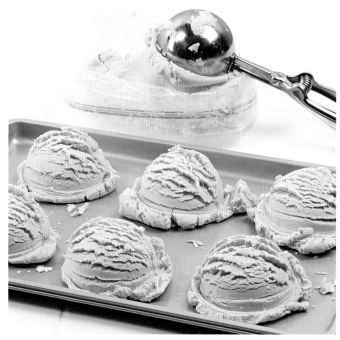

of green Wilton paste icing color. The paste icing colors are very concentrated. It takes very little of the concentrate to color one batch of fake ice cream. I dipped 1/2 inch of a wooden skewer into the paste icing color, and the small amount that stuck to the skewer was added to the frosting. That was enough to create the pale green fake ice cream. The addition of confectioner's sugar will slightly dilute the color of the frosting, but not much.

I cannot tell you exactly how much confectioner's sugar to add, but I can say that it normally takes more than two-thirds of a 2-pound bag to get the right consistency for fake ice cream. There are about 1 1/2 cups remaining in the bag when I've finished one batch. But you need to add the confectioner's sugar in stages. Start out with the frosting mix in the food processor bowl, using the metal blade. Pulse the frosting a couple of times. If you are adding paste icing color, add it at this stage. You cannot

add it later because it will not blend evenly. Add about one-third of the bag of confectioner's sugar. Put the top on the processor. Before you pulse or mix with a processor containing confectioner's sugar, fold a damp towel to create a square covering and place it over the processor's tube opening. This technique will help trap the sugar dust that might otherwise pollute the air.

Pulse the processor a few times to mix the ingredients well and to incorporate all of the sugar into the frosting. The mixture will still be sticky. Using a rubber spatula, scrape the sides of the processor bowl. Add additional confectioner's sugar so that half of the bag is in the processor, and run the processor until the contents form a large ball. With a wooden spoon, break the ball up into smaller sections. Add about two cups more of confectioner's sugar and run the processor again until the sugar is incorporated into the frosting.

In ice cream language, the term *barking* refers to parallel crevices that appear on the surface of a scoop of ice cream. Barking is good. And this recipe will bark when the right amount of confectioner's sugar has been added. You will need to test the mixture to determine when it's at the proper barking stage. I can usually tell when the mix is ready by cutting into it with a wooden spoon and noting whether barking is taking place. However, the best way to test the mix is to pack the fake ice cream mix into an ice cream scoop. Working over the open processor bowl, depress the scoop's releasing mechanism so the scoop of fake ice cream is released onto the palm of your hand. If the mixture is a little sticky or if there is no barking pattern in the fake ice cream, you will need to add more confectioner's sugar.

When the mix is ready, you will notice that it is no longer sticky and that it has a looser texture. It will look similar to dry biscuit mix, but it can still be formed into a ball. Once you are satisfied with the fake ice cream mix, put the batch into a 1-gallon Ziploc bag. Squeeze all air out of the bag and seal. Knead the mixture through the bag to form it into a solid ball.

TRICKS OF THE TRADE Removing the air from the plastic bag is an important step, because it helps prevent the fake ice cream mix from drying out too quickly. When the mix is exposed to air, it starts to form a crusty surface and harden. This is a good/bad thing. It's good after the scoops are styled, but during styling, the mix works much better if it is soft and moist. After you have several hero scoops, they can sit on a cookie sheet and will not change in appearance as they harden. However, the optimal time to take the hero scoop to set is soon after it is made. After 10 to 15 minutes, the ruffle edges (see the following discussion) will not easily adhere to the scoop.

Work inside the plastic bag to fill the scoop with fake mix. Place the scoop into the bag. With one hand holding the scoop and the other hand on the outside of the bag, press the mix into the scoop. You will notice that some mixture will extend outside the scoop. This is a good thing because real ice cream does the same thing. This small shelf around the fake ice cream scoop will provide a place to position ruffle edges and drips later in the process. Make a number of scoops by holding the filled ice cream scoop over your hand or over a cookie sheet. Depress the releasing mechanism so the scoop is deposited flat side down in your hand or on the cookie sheet. If you make a scoop that doesn't meet hero standards, immediately put that scoop of fake mix back into the plastic bag. Squeeze the air out of the bag, zip it closed, and knead the scoop back into the mixture. Continue making scoops until you have two or three hero scoops for each ice cream of that color in your shot.

BUILDING CONES ON SET

Regardless of the number of hero cones in your shot, you will want to select the hero cones and position them on set before making the fake ice cream mixture.

Prepackaged cones were used for the shot in this chapter. However, waffle cones can be ordered from an ice cream specialty shop. Regardless of the type you use, as you

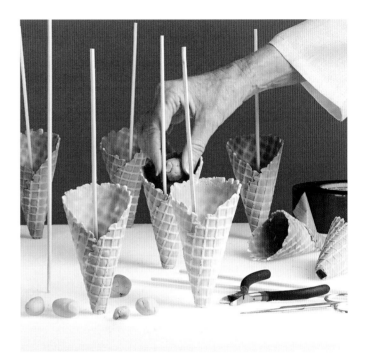

choose the hero cones, look for even color, well-formed waffle marks, and front edges that are not broken. Because the tip ends of the cones in our shot weren't planned to be in view of the camera, the task of securing the cones was not too challenging. To achieve the same cone relation to the camera for your shot, you will first need to cut away the very tip end of each cone with a sharp scissors to create a hole large enough for a thick wooden skewer to be inserted into the cone.

Determine the final positions for the cones on set by inserting a skewer into the STYROFOAM to represent each cone. Slide stand-in cones over the wooden skewers to help align the cones to the camera. Once positions are final, replace the stand-in cones with hero cones. Place a small amount of craft clay inside each cone around the skewer to ensure the cone is standing straight to the camera. If the cones you are using have a high shoulder on the back side, use sharp scissors to cut away some of the height on the back of the cone. When the fake ice cream scoop sits on the cone, it will rest on the ledge of the back of the cone. Therefore, if the back of the cone is too high compared to the front, the scoop will face downward, creating an unseemly presentation.

After the fake ice cream mix is made, fill the cones with the mix up to the back ledge of the cone. Pat the top of

the mix down gently to create a flat, level surface. This will provide a flat surface on which the scoop will sit. Filling the cone with the fake mix also gives a camera view of the fake ice cream at the exposed V-shaped front of the cone.

At this point, use a wire cutter to cut the skewers so the end of each skewer extends 1/2 inch above the fake mix surface you just built. The 1/2 inch of skewer will help hold the hero scoop in place.

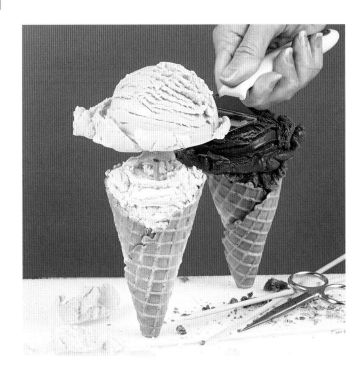

The surface of the fake ice cream scoops cannot be touched with hands or tools in any place the camera will see. Practice your positioning techniques with a stand-in cone and scoop until you are comfortable with the procedure. Select the hero scoops and reserve the best scoops to be positioned on cones closest to the camera, or where the camera focus will be sharp. Beginning with the cones furthest from camera, begin to place the fake ice cream scoops on the cones. Using a cookie spatula inserted under the back, non-hero, side of a scoop, lift one scoop off the cookie sheet. Set the cookie spatula/scoop assembly on a clean cutting board surface. Look at the scoop once again to determine the exact camera front. Hold the cookie spatula/scoop assembly over the selected cone. Working with your face at camera level, align the scoop so it will be centered over the cone. Using your free hand or the flat side of an artist's palate knife against the back side of the fake scoop, push the scoop from the cookie spatula to rest on top of the cone. If the scoop does not sit solidly on the cone, insert the artist's palate knife about 1 inch deep into the center back of the scoop at an angle that is horizontal to the set surface. Very gently press the spatula downward. This motion should help secure the scoop on the cone.

After the scoops are positioned on all cones, you may need to add additional ruffles of the fake mix around the

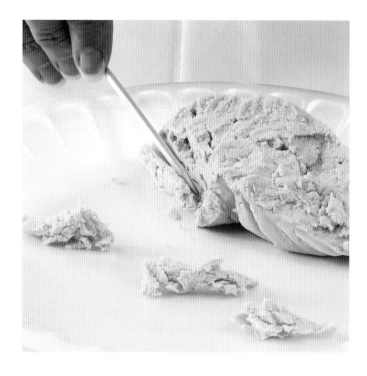

scoop for a more pleasing visual presentation. To make the ruffles, first remove a chunk, about 1/4 cup, of the fake mix from the plastic bag. Be sure to remove the air from the bag and seal it after opening. Place the mix on a plastic or paper plate. Using a wooden skewer held at a horizontal angle to the plate, cut into the edges of the mix so the skewer presses through the mix and touches the plate. In effect, the edges of the fake ice cream are being cut away from the larger portion. These slender

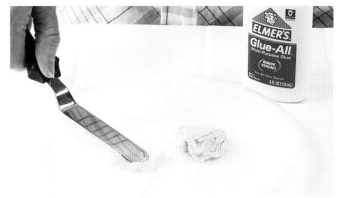

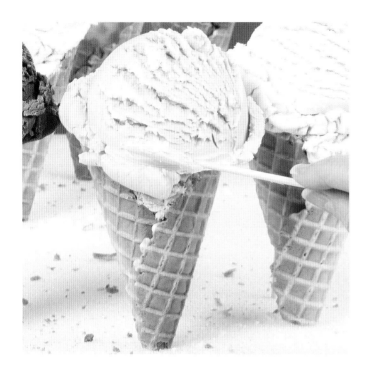

pieces will be the fluff or ruffled edges around the bottom circumference of the scoops. Position each fluff piece by maneuvering it with a wooden skewer or on the spatula. Hold the fluff piece next to the ridge along the bottom edge of the scoop. Using the wooden skewer or spatula, move the fluff against the fake scoop. Place the bottom or flat side of the fluff against the area where you want to position it. In an area of the fluff ruffle that the camera will not see, gently press with the flat end of the skewer

to adhere the ruffle to the scoop. If the outer surface of the scoop is too crusty to stick to the fluff, use an artist's brush wet with water to slightly moisten the surface where the fluff will be placed. Apply the fluff to the area where the water was brushed. With your eyes at camera, build the fluff around the front and sides of each scoop for a realistic presentation.

FINAL TOUCHES TO THE FAKE ICE CREAM ON SET

When all of the cones are in position and the fluff is built around each scoop, double check that the cones are in good position. When you have made any necessary adjustments and are ready for final photography, you will have one more step to perform. To make a realistic presentation for the camera, the "ice cream" will

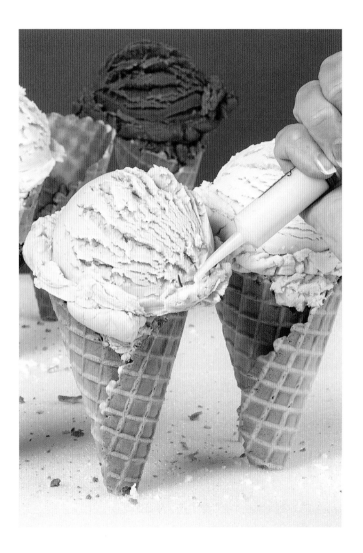

need to appear to have some small areas of melting. To achieve this look, you will need to make melt for each color of fake ice cream on your set. Place about 1 tablespoon of the fake mixture on a plate. You will need a separate plate for each color of fake mix. Add about 1 tablespoon of Elmer's Glue-All to the plate and mix the two substances together using a Wilton 9-inch angled spatula. The mixture needs to be perfectly smooth. The mixture also needs to have a consistency that can be administered using a plastic syringe applicator. If the mix is too thick, add a little more glue. This is the "melt."

Place small amounts of the melt in strategic areas on the ice cream. Placing a few dots or ridges of the melt along the top ridge of the barking crevices creates a believable appearance. Also, melt looks good on the ridges and bumps in the fluff area, and can be used for drips if you want them.

Supplies used to create the ice cream cone shot at the opening of this chapter:

- Cuisinart Custom 14 14-cup food processor (DFP-14/BC)

- Three 2-pound bags of confectioner's powdered sugar (one bag for each flavor)

- One container each cream cheese, chocolate, and strawberry ready-made frosting

- Wilton kelly green icing color concentrated paste, three Wilson Recipe Right Non-Stick medium cookie pans, 9-inch Comfort Grip angled spatula, and cookie spatula

- Ziploc bags, gallon size

- Four 3-foot × 1-foot × 1-inch-thick STYROFOAM sheets

- OXO Good Grips medium silicone spoon spatula

- Elmer's Glue-All

- Three plastic syringes or eyedroppers

- Sturdy wooden spoon

- Ice cream or food portion scoop size 8

- Long, thick wood skewers

- Wire cutters

- Duct tape

- Plastic or paper plates

- Waffle ice cream cones

- Fisherman's fly-tying scissors

PHOTOGRAPHER'S COMMENT—Notes on the Ice Cream Cone Set

Even though using fake ice cream gives the photographer more time to work lighting, you still have to be ready to shoot because the "melt" moves. Your set has to be lit, prepped, focused, and ready to shoot when the cones are ready. The ice cream cone set has a bright pink seamless background behind the cones and is lit with a medium Chimera lightbank that fills the set. The key light is a small lightbank set to the side that provides a raking effect to give texture to the cones. The low angle of the camera will give you a better shot of the face of the scoops and the front of the cones. I used a Hasselblad H3D camera with a 50–110-mm lens.

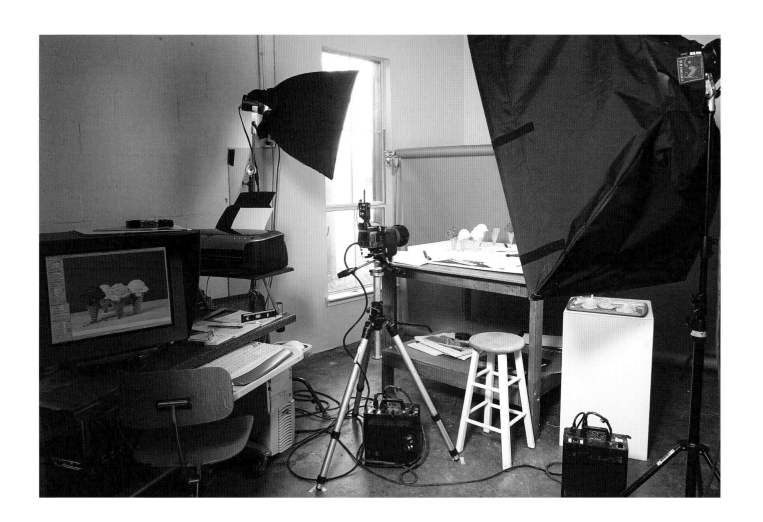

A BOWL OF ICE CREAM

Now let's move on to creating the bowl of ice cream shown in the accompanying shot. Because we wanted to convey a premium quality vanilla ice cream, we chose to add real vanilla seeds to our fake ice cream mix. To remove the seeds from vanilla beans, use a sharp paring knife to cut the vanilla beans open lengthwise. The easiest way to achieve this is to lay one bean on a cutting board. Stick the end of a paring knife through the center of the pod, near one end. Hold the knife in one hand and the end of the bean pod with the other hand. Using your hand holding the pod, pull the pod away from the knife. This action will cut the pod open lengthwise making the seeds accessible. Scrape the tiny seeds from the center of the pod onto a plate with the end of the knife or with a skewer. Mix seeds from two vanilla bean pods into each batch of fake mix for a homemade vanilla ice cream appearance.

Techniques for building a bowl of fake ice cream are the same with regard to the fake mix; however, the bowl will require some special techniques. Because the fake ice cream mix is heavy, a large scoop or several smaller scoops in a grouping will require a solid base for support.

The safest and easiest thing to use in the bowl to support the hero scoops is the fake ice cream mix itself. Pack the mix tightly into the bowl and form a flat, level surface on

which the hero scoops and fluff will sit. The mix should fill the hero bowl to within 1/4 inch of the top rim. If the support is further down than 1/4 inch from the rim of the bowl, you will lose the height advantage of the hero scoops.

Position the back two hero scoops of fake ice cream first. Use the same technique described earlier in this chapter for positioning scoops on cones. Make sure the hero side of each scoop is facing the camera and the scoops are at

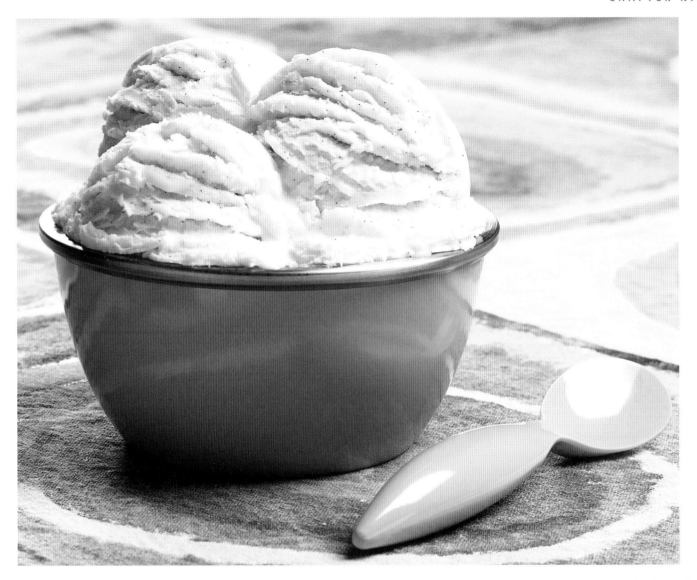

This shot is dedicated to the National Breast Cancer Foundation. The Zak Designs patented Gemini bowl and ice cream spoon were both created in honor of the foundation.

the height you choose. It may be necessary to create a riser or lift under the fake scoops to achieve a better presentation for each. If you need to make adjustments that require moving or lifting the hero scoop, use an offset angled spatula inserted under the back of the scoop to lift or leverage the scoop. Use a piece of the fake mix inserted under the scoop as a riser. The front scoop may need to be trimmed to fit into the bowl with the other scoops. I cut away almost one-half of the back side of the front scoop in our shot. I also removed about 1/2 inch of the bottom of the scoop so it would be shorter.

Make the fluff ruffles as described earlier in this chapter and position them alongside the scoops within the bowl. The bowl and flat surface of fake mix will give extra support for the fluff ruffles, making the job of positioning ruffles a little less challenging than for a cone build, where the edge of the fake mix is suspended in air!

As described in the ice cream cone section of this chapter, apply melt to the scoop and ruffles before final photography.

Supplies used to complete the ice cream bowl shot:

- Zak Designs patented Gemini bowl and ice cream spoon

- Cuisinart Custom 14 14-cup food processor (DFP-14/BC)

- Henckels 3-inch paring knife

- Ziploc bags, gallon size

- Le Creuset spatula

- Elmer's Glue-All

- Wilton medium cookie pan, 9-inch angled spatula, and cookie spatula

- Two 2-pound bags of confectioner's powdered sugar

- Two containers cream cheese ready-made frosting

- Four vanilla beans

- Sturdy wooden spoon

- Long wood skewer

- Plastic syringe

- Ice cream or food portion scoop (size 10)

- Plate for mixing melt

- Hand-painted tablecloth provided by www.bamsart .com

PHOTOGRAPHER'S COMMENT—Notes on Ice Cream Dish Set

My favorite way to light food is with a mixture of ambient light and strobe. On this hero shot, I used natural backlight. In my studio I have windows with southern and western exposure giving me good daylight all day long. For the ice cream texture I have placed my small Lightbank to the right of the set and slightly overhead. My small white fill card is in the front of the set to light the bowl but not the ice cream. I used a 4X5 camera with Hasselblad 39MS digital back.

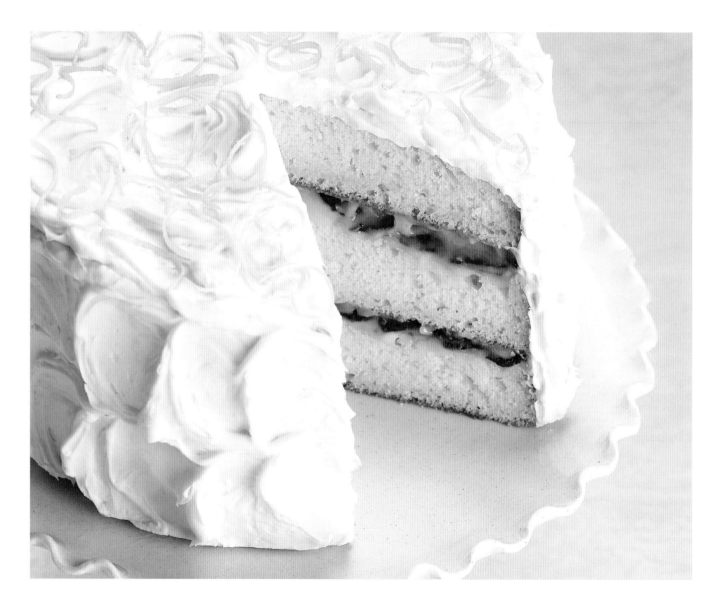

DESSERTS

My employment background as a pastry chef really helped give me a boost with dessert styling. I have been hired by clients to style literally thousands of desserts. I could write an entire book—and perhaps several volumes—about desserts. However, my goal with this chapter is to provide you with some very basic styling techniques that you can rely on for general dessert styling.

Let's start with cake. But before you begin styling, you must make some decisions. Are you showing a whole cake? Or, are you cutting into a cake and showing the interior of the cake to the camera? Are you showing a piece of cake? Look at printed tear sheets of cakes if you are unsure. These go-bys will give you valuable suggestions as to the look you want to achieve in your shot.

WHOLE CAKES

First you will need to determine the finished shape of your hero cake. Then you can adapt the following technique to meet your project requirements. Let's assume you're planning to photograph a whole, circular frosted cake. Purchase four STYROFOAM 8-inch or 9-inch rounds. Stack the rounds so they are aligned, and secure them together with three wooden skewers. Cut the skewers level with the top piece of STYROFOAM. Insert two heavy wood skewers into one side of the stack a couple of inches apart so they can serve as handles, allowing you to maneuver the fake cake as you put frosting on it. The handles also provide control of the cake for easy placement on a plate or shooting surface. Once frosted, you can add decorations, stick on candles, sparklers, etc. The beauty of using "fake" cake is that the cake is perfectly level, and you can frost it as many times as necessary until you love the look of the frosting. If you don't like the frosting appearance, scrape it off and

start over. You can also scrape off the frosting after final photography and use the fake cake in the future.

Showing a Cut Cake to the Camera

If you are planning to photograph a cake with a slice or section removed, or if you are shooting a slice of cake, you will, of course, need real cake. You have the option of baking the layers yourself or ordering unfrosted layers from a bakery. If you choose to order from a bakery, ask them to put each layer in a separate box so they will not be stacked on top of each other.

I normally choose to bake the cakes myself because the results are more predictable and because I know the cake will be fresh and moist. When the camera focus is tight on cake, it needs to look moist. To achieve a moist appearance, use a prepackaged cake mix and add 2 tablespoons of mayonnaise to the other ingredients called for on the box. To begin our lemon cake shot, I used two lemon cake mixes, making one at a time and dividing the batter from one package between two 8-inch round cake pans. I followed the recipe on the box, but added 2 tablespoons of mayonnaise to each cake mix. After the first two cake layers cooled for 10 minutes, I removed them from the pans to cool completely on a flat surface covered with Wilton parchment paper. I washed the pans, and mixed and baked the second batch, giving me a total of four 8-inch round cakes. I will only use three of the layers for

the whole cake. If you are showing a slice of cake in your shot, the remaining cake layer can be used to create it. The remaining cake layer is also a good insurance policy in case one of the other cake layers presents any problems like cracking, large holes, etc.

When the cake layers have completely cooled to room temperature, wrap them securely in plastic wrap until you are ready to build the hero cake the following day. The cakes should rest overnight at room temperature until you are ready to build the hero and complete photography. Find a safe, flat area where the cakes can await the building process. Make sure they are clearly marked with a sign to indicate they are hero and not for consumption.

When cakes bake, the top surface will rise to a dome, brown slightly, and may have little rises and pits in the surface when it cools. Before building the hero cake, you need to remove any abnormalities from the tops of the cake layers and make sure the layers are the same thickness. This is achieved by removing the top dome of the cakes. You can use a Wilton cake leveler to complete this task. Follow the instructions on the packaging for safe use and for making blade-height adjustments. Leveling the cake layers is an important step. Doing so creates layers for the cake that are exactly the same thickness which helps to ensure that the finished cake will be level

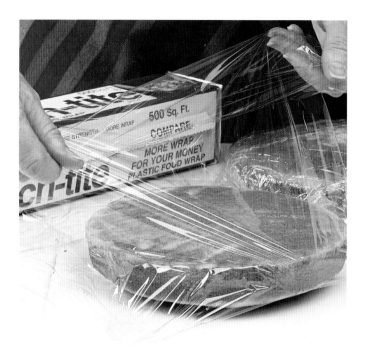

on the top, and makes the task of applying even thicknesses of filling and frosting much easier.

If you plan to photograph a cake with a section cut away, exposing the interior layers and filling, we now discuss how to accomplish this. Note that this technique is written for a circular cake, but can be adapted to cakes of other shapes. The purpose of this technique is to ensure that the thickness of filling between the cake layers is consistent. The cardboard templates will mimic the thickness of the filling. They also support the cake layers, maintaining a level, sturdy cake structure.

Start by cutting a circle of paper the size of your cake. Determine the center of the circle and draw two lines from the center to help you determine the size of the opening for your cake. When you are pleased with the size of the opening for the cake, use a pair of scissors to cut the opening and remove it from the paper pattern. Reserve the paper pattern for later use. Next, make a

The skewers will stabilize the structure. Transfer the location of the removed squares to the paper pattern and reserve the paper pattern for later use.

Use the cardboard template as a guide to create the number of templates needed between the cake layers. Depending on the thickness of cardboard you use, you will probably need two cardboard templates placed together to create the desired thickness between two cake layers. The number of layers in your cake, and the thickness of cardboard used to create the templates, will determine the number of templates you'll need.

If you ended up needing two templates to make one unit to go between two cake layers, align the edges and square holes of the templates and tape them together. Make as many template units as needed to place one unit between each layer of your cake. Note that the template units should match in height.

If you choose to show a slice of cake in your shot, you will need to build templates to insert between the cake layers of the slice where the filling will be viewed. No, you don't just cut a piece of cake to get the hero slice. It must be built independently because when you cut a real cake, the action of the knife cutting the cake pulls the frosting and filling over the cake surface, so the frosting

template of the paper pattern shape using cardboard. Trim the cardboard template as follows: Remove 1/2 inch of the diameter, rounded edges, and 1/2 inch on both sides of the opening of the removed section. Draw three 3/4-inch squares within the interior of the cardboard template and, with a sharp edge tool, remove those squares. These square holes will provide openings for skewers to be inserted through the cake once assembled.

is always smeared over the surface of the cake. You might think that you could use a wire cake separator, but the vertical wires will leave marks in the frosting, filling, and on the cake surface. So, the hero slice needs to be built from scratch.

First, determine the size of the hero slice using a paper pattern. Then, make a template of the shape out of cardboard. Trim away 1/4 inch from all sides of the template. Cut a triangular-shaped opening in the interior of the slice template to provide an opening for skewers to be inserted. The skewers will hold the slice assembly together. Use the cardboard template as a pattern to make the total number of templates needed. Again, depending on the cardboard you are using, it may take two layers of cardboard to achieve the desired thickness to mimic the filling. If you use more than one template between the cake layers, tape the cardboard together. Make enough template units to go between all layers of your cake slice.

Now it's time to cut the cake. If your shot includes both a cut cake showing a section removed and a slice of cake, I would recommend working with the larger cake first since doing so will give you some knowledge as to the texture of the cake. This knowledge will help as you work with the slice because it will be more fragile than the larger cake.

BUILDING THE CAKE

Working with one of the cake layers, place the original paper template on top of the cake so that it is centered on the cake. Remember the paper template will indicate the size of the opening in the cake and the cardboard templates will be 1/2 inch smaller all around. Use a knife with a sharp serrated edge to cut the cake. Align the knife blade with the opening of the paper template.

Apply enough pressure in a slow sawing motion to cut the cake without tearing it. Be careful to keep the knife blade straight and not angled. Repeat this process for all the layers of your hero cake.

Place one cake layer on the clean hero plate. Cut 3-inch-wide strips of parchment paper and tuck these strips under the edge of the cake layer so that the entire exposed surface of the plate is protected by the paper. Also lay strips inside the cut opening of the cake. Next, place one template unit on the cake layer aligning the template to maintain a 1/2-inch margin around all edges. Continue this process of alternating cake layers and templates, and top the assembly with a cake layer when the desired height is reached.

Make sure the cake edges are even and level to camera. Align the paper template on top of the cake to indicate the position of the square holes you cut in the templates, and insert a skewer through each of the three square holes so the skewer passes through the cardboard templates and the cake. With a wire cutter, snip away any skewer that extends above the top layer.

The filling only needs to be applied to the interior edges of the cake that the camera sees. Once filling is inserted between the layers, the cardboard templates will be hidden from the camera. Apply the filling between layers using a pastry bag and tip, as described in the chapter section below for the hero slice, and trim or smooth away the excess filling. Refer to the section on frosting the cake and slice for frosting techniques.

BUILDING A HERO SLICE OF CAKE

Next, it's time to cut wedges of the cake that will become the layers of the hero slice. Use the extra cake layer, or the leftover sections removed from the layers of the larger cake, to cut wedges for the hero slice. Use the paper pattern you created to determine the size of the slice as a guide. Apply enough pressure with the serrated knife, using a slow sawing motion, to cut the cake without tearing it. Be extra careful as you cut toward the tip of the wedge shape because it can easily tear.

The triangular holes in the cardboard templates allow wooden skewers to be inserted to help hold the layers and templates together and to keep them aligned properly. Depending on the size and fragility of the cake, use either two or three thin skewers to secure the slice assembly. Note that at this point, the assembly may not be totally stable.

It is easier for me to build the hero slice on the hero plate rather than building it on another surface and then transferring it to the hero plate later. Even if the hero slice is built on a piece of acrylic sheet and then transferred to

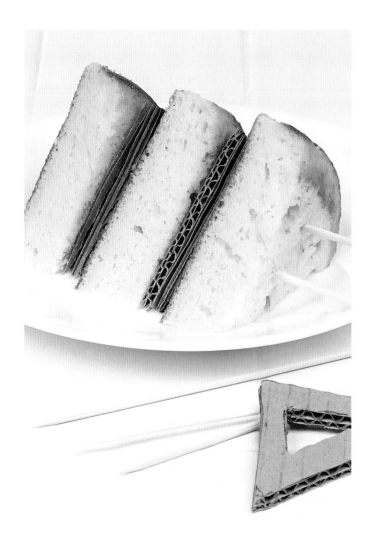

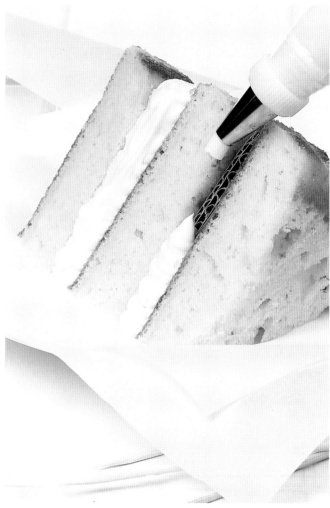

the hero plate, when you move it, everything moves. Filling, frosting, and cake repairs may be necessary. So I like to build the hero slice of cake on the hero plate. After the slice layers and cardboard spacers are skewered together, place the assembly on the hero plate. With wire cutters, snip off any skewer extending outside the cake. Then tuck parchment paper strips, cut to about 3 inches wide, around all sides of the hero slice to keep the hero plate clean.

When filling is inserted between the layers, it will help stabilize the slice. Place filling between layers only in areas that the camera will view. Using a pastry bag and tip with a 1/4-inch round opening, deposit the filling mixture into the space created by the cardboard. The filling will conceal the cardboard edges. You want to deposit enough filling so it extends slightly above the cut edge of the cake layer.

To convey realism, the edge of the filling must appear to be cut. To achieve this appearance, dip a clean knife into warm water, and, holding the knife even with the cake, cut the filling at the same height as the cake layers. Remove any smeared areas of filling that might have deposited on the cake surface with tweezers. Note that if the filling in your cake is a fluffy or pudding consistency, you will use an additional technique. In this case, you will use the rounded end of an artist's palate knife to gently swirl some areas of the filling.

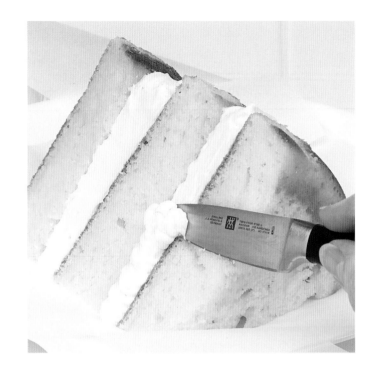

FROSTING THE CAKE AND SLICE

Your choice of frosting type and frosting color should be determined during the planning stage of your shot. For the sake of simplicity, especially since cake styling can be tedious, I chose to keep the frosting choice as simple as possible and selected a ready-made frosting. The techniques for frosting apply to both the cut cake and slice.

Before the cake is frosted, the area on the exterior of the cake between the layers needs to be filled to give the cake a smooth vertical profile. With a pastry bag filled with frosting, run a band of frosting around the exterior of the cake, inserting frosting into the spaces created by the templates between the cake layers filling the indentations. With a 13-inch spatula, smooth the exterior profile of the cake by holding the blade of the spatula flat against the side of the cake, touching all layers at the same time.

With the tip of the spatula touching the table surface, hold the blade vertically straight against the cake. In a smooth motion, slide the blade around the cake to even out the frosting between the layers. Check to see that all indentations are filled and that the vertical alignment of the cake appears straight from the camera view. Clean the blade of the spatula, dip the blade in warm water, and make a final pass around the cake to smooth the frosting.

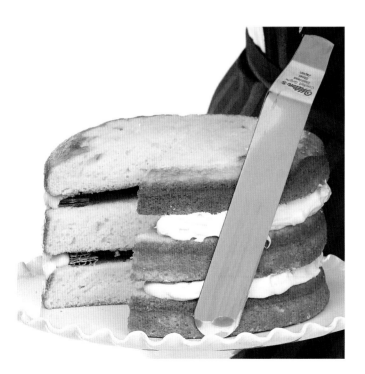

TRICKS OF THE TRADE Cover the exterior of the cake with a very thin layer of frosting as a base coat. Any crumbs generated by this process should be removed with tweezers. After this base coat is finished, allow it to rest for a few minutes so the frosting can firm up. At this point, more frosting can be applied without the threat of crumbs contaminating the final hero frosting appearance.

After the thin base coat of frosting is applied to the cake, you can apply additional frosting to achieve the depth of frosting that you want. Begin by frosting the sides of the cake. Once the sides are frosted, frost the top. Depending on your preference for the frosting appearance, make it smooth with the flat side of the spatula, or create swirls with the spatula tip. Because prepared frosting forms a crust within a short time, you will want to make any changes in the frosting designs now rather than later.

23232222332

232222222222

As with the filling, the frosting along the edges where the cake and slice were cut will need to appear cut. To achieve this look, when you frost the cake and slice, let the frosting overlap and extend beyond the cut edges just a little. Make sure the depth of the frosting along these edges is even and is the thickness you desire. The techniques used for cutting an edge on the frosting and filling are basically the same. First dip the knife or spatula blade into a cup of warm tap water. The water is used to warm the blade so a clean cut will be made in the frosting. Tap the knife or spatula on the cup to shake away any excess water and immediately cut the frosting in a straight, even line that is aligned evenly with the edge of the cut cake. With your other hand, if necessary, catch the frosting as it falls away from the cake to prevent it from touching the cake surface.

TRICKS OF THE TRADE Once you determine that the filling and frosting applications are hero quality, run a knife that has been dipped into warm water between the frosting and the parchment paper strips covering the hero plate. The paper strips can be gently pulled away from the cake and frosting without disturbing the frosting.

Arrange garnishes and make final adjustments to the set and lighting.

Supplies used to complete this shot:

- Zak Designs medium 3-quart Gemini Bowl
- Hamilton Beach hand mixer
- Anchor Hocking Three-Way Pour 2-cup measuring cup
- Two prepackaged lemon cake mixes (and ingredients called for on the package)
- Four tablespoons of mayonnaise; 3 lemons for zest garnish
- OXO Good Grips zester and spoon spatula
- Henckels Twin Star II paring knife
- Two Wilton Performance Pans, 8-inch round, 2 inches deep, Bake Easy spray and parchment paper, Comfort Grip 13-inch angled spatula, and 9-inch angled spatula
- Wilton pastry coupler set and pastry tip on a Wilton disposable pastry bag
- STRETCH-TITE plastic food wrap
- EMS style 24 bent-tip tweezers
- Copy paper
- Cardboard
- Office scissors

- Wood skewers

- Small wire cutters

- One jar lemon cake filling

- Three containers of prepared cream cheese frosting

- Hand-painted surface by Brad G. Rogers

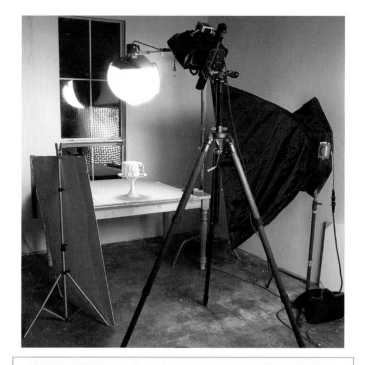

PHOTOGRAPHER'S COMMENT—Notes on Lemon Cake Set

White icing and yellow cake. How do we keep detail in both? I used a Chimera lightbank overhead and somewhat to the back of the set and a medium lightbank with a 40% grid on the right side with a fill card to the left—not too close. The grid over the lightbank fractures the soft light, giving you the light you need for texture in the icing. My 4 × 5 camera with Hasselblad 39MS digital back is at a high angle and supported by a really strong Gitzo Pro Studex tripod. Never put a 4 × 5 or medium-format camera on a small tripod when shooting from a high angle.

CHEESECAKES ARE DIFFERENT!

Even though "cake" is a part of the name, styling cheese-cake is nothing like styling cake. The techniques for styling cheesecake are unique to cheesecake. The texture of the body of the cake is smooth, yet it can be very textural when cut. For photography, one of the requisites of a cut cheesecake is that the surface of the cut area has good texture.

TRICKS OF THE TRADE It is important to keep cheesecakes in the refrigerator until you are ready to make cuts. When you bring the cakes to the studio, look at them carefully to identify the hero cakes and mark the packaging accordingly. Let them chill overnight and keep them in the refrigerator until you are ready to make cuts.

The thing about cheesecake is that when it bakes, a skin is formed on the top of the cheesecake surface. This skin has a very smooth texture and is unlike the cut interior texture of the cake. It's not impossible, but it is difficult to repair divots and dents in the top surface of a cheese-cake. By working with several cheesecakes, your chances of finding a hero cake are greater. I have learned to ask a client to provide a minimum of four cheesecakes to produce one hero slice. If the client wants to show a cake with the slice removed plus a hero slice, I'll ask for a minimum of eight whole cheesecakes. Remember, if you will be removing a section of a whole cake to show in your shot, you can cut away a portion of the cake that has imperfections. Always select the whole cake hero first and set it aside on a tray marked as hero before looking for cakes to cut and remove hero slices.

When you style cheesecake, the exposed interior of the cake and slice should reflect both smooth and textural areas. Cheesecake crusts have a separate set of challenges for styling because they can be made out of a variety of different mixtures, from pastry to graham crumbs to chocolate cookie crumbs. The cheesecake texture and the crust texture and appearance need to be addressed separately.

Before you begin cutting slices, determine the size of slice needed in the shot. Use a stand-in or non-hero cake to cut a stand-in piece to help determine the size. Use the cake you used to remove a stand-in slice from as the stand-in for the whole, cut cake. Determining the size of the opening in a cut cake is usually driven by lighting issues. The opening has to be wide enough to light the interior of the cake. Removing around one-third of the cake seems to be a fairly reliable standard to allow lighting in the interior of the whole, cut cake.

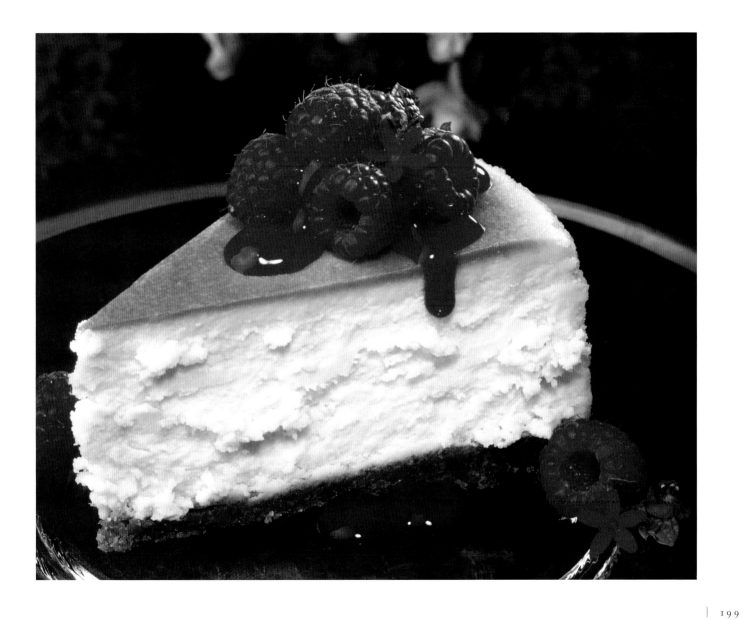

When selecting an area of cheesecake from which to remove a hero slice, the top cheesecake surface is actually the most important element to consider. Look for a piece with a smooth top without divots, color imperfections, or bumps. Be extremely careful not to touch the top surface of the cheesecake hero with fingers or tools. The top surface is easily marked by fingerprints and can be difficult to repair.

I use two 10-inch chef's knives to cut cheesecake. This process is easier if you have an assistant. Select a cheesecake having a hero area of surface as well as a hero exterior crust from which to remove a hero slice. Place the cheesecake on a solid surface so it is 6 inches away from the edge of the table. Hold one of the knives over the surface of the cake, with the handle of the knife raised to a 45° angle to the surface of the cake. The first knife will be used to create the right side of the hero slice; the second knife will make the left side of the slice. Beginning with the tip of the knife in the center of the cake, push the tip of the blade through the cake until it touches bottom. In a smooth downward stroke, push the back of the knife completely through the cheesecake and crust. Don't move the knife and don't pull it out of the cake. Let go of the handle. The knife is now imbedded in the cake along one side of the hero slice.

Now use the second knife to cut the other side of the hero slice. Align the knife over the cake where the cut will be made to create the size of piece needed for the shot. Starting with the tip of the knife so it touches the knife already placed in the cake, make the second cut by using the same technique as the first cut. Make sure the tip of the knife goes all the way through the cake and crust before pushing the back of the blade through the cake and crust. Now you have two knives in the cake with

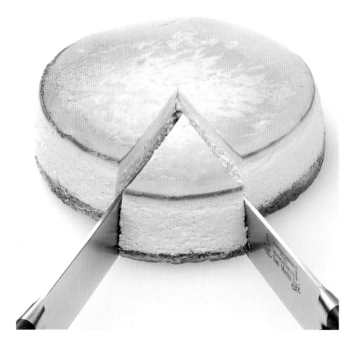

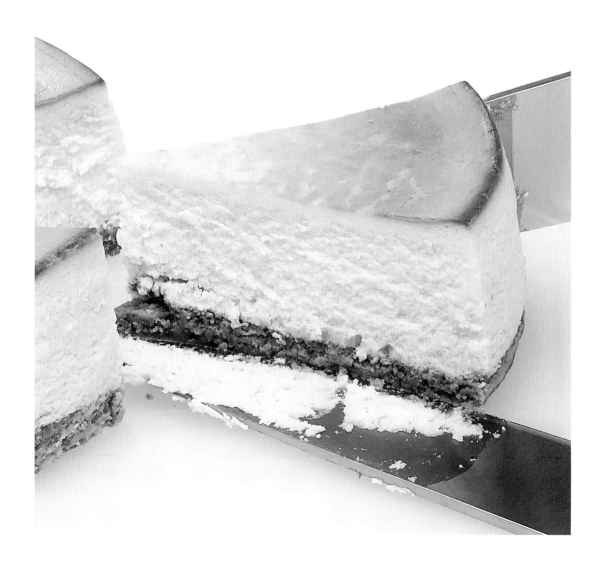

both handles pointing toward you. Ask your assistant to gently but firmly hold the back side of the cake, keeping all fingers away from the knives. With even pressure on the knives, you will pull the knives toward you. The slice of cake will drag away from the whole cake. Read the next step for the technique to remove the knives from the slice.

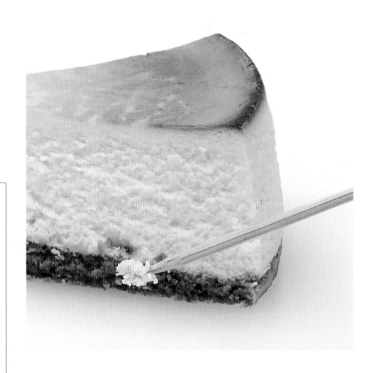

> **TRICKS OF THE TRADE** The way you remove the knives from the slice or cut cake is extremely important for the creation of cheesecake texture. Begin with the knife on one side of the slice. Keep the bottom sharp edge of the knife in place. Gently pull the top edge of that knife away from the slice in a motion that will lay the knife flat on the cutting surface with the sharp edge still next to the cake. Remove the knife. Repeat this process for the knife on the other side of the slice. This technique is one that I find most likely to result in good texture on a cheesecake slice. Cut slices until you have one of hero status.

Once you have selected the hero, if it's necessary to fill holes or correct texture in specific areas, you can work texture into small areas on the cut surfaces that the camera will see. As you work the cut surface, stay away from the edge of the top of the cheesecake. I normally don't get closer than 1/4 inch to the top if possible, because the edge can break away. If this happens, you will need to choose a new hero slice. Using a wooden skewer and a piece of non-hero cheesecake for extra cheesecake material, you can make repairs and add small areas of rougher texture to the cut surface of the hero slice if desired. Hold the wooden skewer parallel with the cut surface of a non-hero piece of cheesecake. Pick up a small amount of cheesecake from the non-hero slice on the end of the wood skewer. Apply the small texture piece to the hero slice in a predetermined location.

Be careful not to include any of the cheesecake area in the chunk of crust. Working on a work plate or cutting board surface, break the chunk of crust into crumbs. The crumbs can be maneuvered by using the small spatula. Push the crumbs into place in the hero crust to create a straight edge with the back of the spatula. The cut crust edge should appear straight to camera on the plate.

Supplies used to create this shot:

- Five 5-pound cheesecakes provided by Collin Street Bakery of Corsicana, Texas
- Two Messermeister San Moritz elite 10-inch chef's knives
- Wilton Comfort Grip 13-inch angled spatula and 9-inch tapered spatula and applicator bottle
- EMS style 24 bent-tip tweezers and style 24 straight-tip tweezers
- OXO Good Grips utility cutting board
- Arcoroc dessert plate
- Wood skewer

Transfer the hero cheesecake slice to the hero plate or shooting surface using a spatula to support the slice. Slide the spatula under the backside or curved edge of the slice. Lift the slice and transfer to the hero plate. Once the piece of cheesecake is in position, you can make any necessary repairs to the crust. Use a non-hero slice of cheesecake and a small tapered spatula or small knife. Cut away a chunk of the non-hero crust to use as filler for the repair.

HAVING VISUAL FUN WITH COOKIES: TECHNIQUES FOR BUILDING STACKS

Stacking can be a fun way to present some bakery products. Cookies, petit fours, small cakes, brownies, or other baked pastries that are normally cut into squares can be stacked for the camera when a square or vertical crop is desired. The visual display of stacking can be made more interesting by creating an off-balance look to a few of the items within the stack. This is a good technique that will cause the viewer to wonder "How in the world did they do that?"

Select hero pastry items for the stack. You will want to have plenty of cookies or pastries available to achieve the final stack. I purchased three dozen cookies for our hero shot. Because the items are handled during the building process, and because they are impaled with toothpicks and skewers, there is potential for breakage. Use stand-ins to accomplish a rough build for the camera. The stand-in can give you a good idea of where misalignment of the elements within the stack would be appropriate for visual interest. Building the stand-in stack will also help you gain knowledge of how fragile the cookies or pastries are. Use short pieces of toothpicks to connect all the cookies or pastries in the stack.

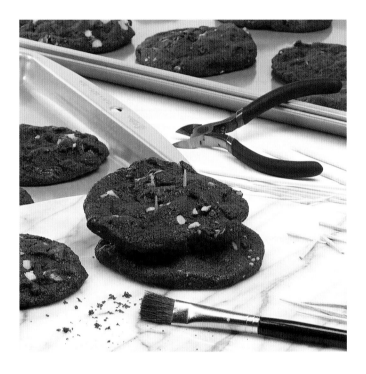

Before you place the top cookie or pastry on the stack, pause to consider whether it is necessary to run a long skewer all the way through the stack for stability. If your arrangement is unstable, you might feel it's necessary to secure the entire stack. If so, practice the procedure with a stand-in stack. Run a skewer all the way through the

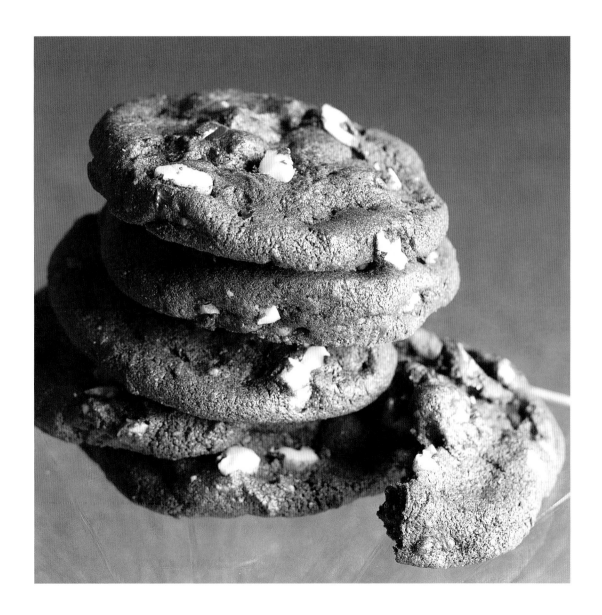

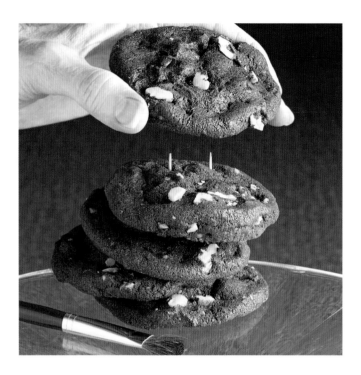

stack from top to bottom. This will give you an idea of whether this technique will work for your specific pastry items. If the operation is a success, you will feel more comfortable performing this procedure on the hero stack. On the hero, run the skewer through the stack before placing the top item on the stack. Cut the top of the skewer with wire cutters so that it is even with the cookie or pastry. Insert two toothpick pieces into the same cookie or pastry to help hold the top piece in place. Position the top cookie or pastry and gently press downward to impale the pastry on the end of the two toothpicks.

Supplies needed to complete this shot:

- Three dozen cookies
- Wood skewer
- Toothpicks
- Small wire cutters
- Soft artist's brush
- Wilton Recipe Right Non-Stick medium cookie pans
- EMS style 24 straight-tip tweezers

BREAKING COOKIES

If you ever need to style a broken cookie, here are a few tips. Break cookies by holding the cookie in both hands. Align your thumbs together along the top of the cookie where you hope it will break. Keeping your thumbs in position, bend your hands to break the cookie. Practice this move a few times on stand-in cookies before you break hero cookies. Once you have a few hero broken cookies, you may want to position cookie ingredients such as chocolate chips, coconut, or nuts in the area of the break. Use tweezers to accomplish this task.

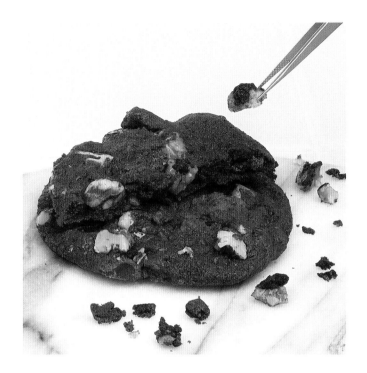

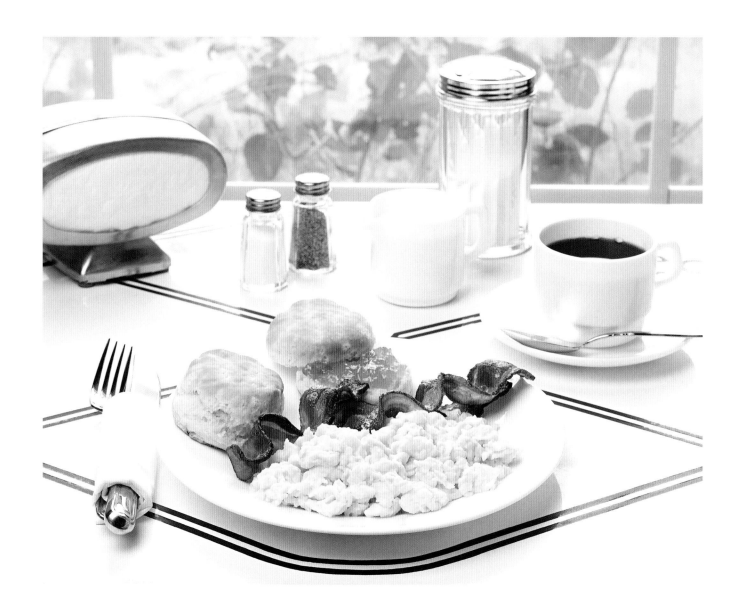

Breakfast for the Camera

Let's call this section Breakfast 101 and keep things simple. Making a full breakfast for photography, as pictured here, isn't rocket science. However, a working knowledge of a few basic techniques and tricks will certainly make the task easier. One of the most important things, as always, is the order of preparation. Pancakes can be frozen, biscuits can be frozen or held for most of a day after cooking, bacon can be prepped early the day of photography; but almost all types of cooked eggs need to be prepared right before they are built on the hero plate.

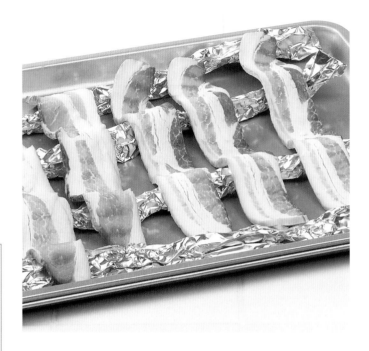

| TRICKS OF THE TRADE | The liquid in the coffee cup in our shot is a mixture of brewed coffee and water. For photography, coffee needs to be diluted with water since it appears very black if used at full strength. Dilute the coffee until it has a rich brown color when viewed from camera.

MAKING BACON FOR THE CAMERA

Rather than laying flat on the plate, some movement along the length of each piece of bacon is nice for photography. The movement, or undulations, creates interest and catches light. You could bake or fry bacon all day and perhaps get a few hero slices with movement. But, you may want to instead resort to a few tricks that can turn each slice of bacon into hero quality for the camera. Bacon can actually be prepared the morning of the shoot, but it will need some additional attention before it is built onto the hero plate.

Shopping wisely always pays off. For the chapter-opening shot, I chose bacon from the butcher's case because it had a high proportion of meat to fat and because it was a nice width. Some prepackaged bacon is very narrow and is also cut very thin. It does not photograph as well as wider, thicker bacon like the type found in the butcher's case.

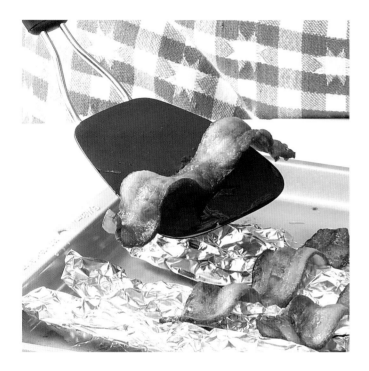

to sag slightly between the foil ropes. Keep the bacon strips from touching or overlapping. Place the pan of bacon in a 350° Fahrenheit preheated oven. The amount of time needed for the bacon to turn golden will vary. After 8 minutes, check the bacon. It can take up to double that time, but check it every couple of minutes. If you overcook the bacon, you'll need to start with a fresh batch. It should be golden, with no areas that appear raw. Once it reaches this stage, carefully remove the pan from the oven and let it cool at room temperature for about 10 minutes before removing the bacon from the pan. Place the bacon pieces, without touching, on paper plates. Invert additional paper plates over the top of the bacon to protect it from drafts and from hungry staff. Set aside until time to go to set. Remove the drippings from the baking pan and replace the foil ropes in the pan. When you are ready to go to set, you will need to pop the bacon back on the same pan, laying over the ropes as before. Put the pan in the oven at 350° for about 5 minutes. The bacon slices are now ready to build on the hero plate.

Tear off several 5-inch-wide strips of heavy-duty aluminum foil. Crumple the foil strips into rope shapes about 1/2 to 5/8 inch in diameter. When you are ready to work with the bacon at the studio, make sure the bacon is cold so the slices will separate without tearing. Lay the foil ropes on a baking pan about two inches or so apart. Choose only bacon strips that are fully intact with no tears or holes. Place the bacon across the foil ropes as shown in the accompanying photo, allowing the bacon

BEAUTIFUL BISCUITS

Aren't they beautiful! And, yes, there are tricks for biscuits too. The trick is to purchase preformed frozen biscuits that you take back to the studio, place on a baking pan, and follow the directions on the package

for baking. These look beautiful and work very well for the camera, unless you prefer to find a recipe and mix them yourself.

SCRAMBLED EGGS

Let's look now at some of the techniques I use to make scrambled eggs for photography. Note that scrambled eggs will not remain hero quality for very long after

cooking, so I usually scramble them immediately before building the hero plate.

Here are a few tips to use when cracking eggs to avoid shell shards and spots in cooked eggs. Place a paper towel on a clean flat surface. Holding one egg firmly, sharply strike the egg on the paper towel area to crack the shell. Open the egg over a small bowl. If there are no shell

pieces or discolored areas, pour the egg into a larger bowl where all eggs will be whisked together. Proceed cracking one egg at a time until all the eggs you plan to scramble are in the bigger bowl. If you find shell shards or discolored areas in an egg, while it is still in the small bowl, use a half of the egg shell to scoop out the shell sliver. It might be necessary to use tweezers to remove any discolored spots from fertilized eggs if you can't pick it out with the shell.

For our hero shot, I used a dozen large eggs and whisked them with about 1/3 cup of half-and-half until thoroughly blended. Eggs cook evenly and more quickly if they are room temperature, so they were pulled out of the refrigerator at the beginning of the day to allow them to come to room temperature. The trick is to use a large non-stick skillet over low to medium-low heat and stir constantly during the entire cooking process. I prefer a wooden spoon for this job. The constant agitation and stirring motion helps the eggs to form small-sized curds as they cook. When the entire pan of eggs has formed curds, change the motion from stirring to gently lifting and folding over a spoonful of eggs at a time. Keep the motion constant so the eggs stay fluffy and don't stick. When the consistency changes from liquid to fluffy, and the color lightens up just a bit, they are ready to build on the hero plate.

BUILDING THE HERO PLATE

Position biscuits on the plate and then determine where the bacon and eggs will reside on the plate. Build the eggs by placing a small group of curds in the center of the designated egg area. Build outward until the predetermined size for the egg mass is reached. Then build height into the eggs by placing a small group of curds at a time on top of the base egg area. I like using a small metal spatula for this job because the eggs transfer

easily to the plate. Continue building the eggs to achieve desired height and shape. If there are holes in the egg build that need to be filled, use tweezers to place individual egg curds in these areas. Place the bacon on the plate after the egg build is completed.

TRICKS OF THE TRADE *A word of caution:* Try to avoid filling in all holes and shallow places, because the scrambled eggs will look too formed and will lose the interest created by some variations of height and depth.

ON SET

Before you go to set, make sure your set tray has everything you will need. Your set tray should include samples of all food elements on the hero plate; a cup with bubble liquid for coffee, a cup with bubble liquid for bacon foam (see below), along with separate dispensers for each; glass cleaner; cotton-tipped swabs; paper towels; a small container of clear corn syrup; a syringe; an artist's brush; and tweezers.

When the plate is on the set, it is time to check the positions of all elements on the plate. Make any necessary corrections before proceeding. There are several techniques to apply before final photography of these specific breakfast foods. The order of performing these techniques

is important. Some techniques, like bubbles in coffee and on bacon, and glisten added to eggs, do not last very long. So these will need to be completed last. You can start by adding the jam or jelly to the cut biscuit. I built some height in the jam in our shot so light could play across the surface for visual interest while conveying freshness.

The undulations in the length of the bacon create peaks and valleys. These areas are treated differently by the food stylist. With an artist's brush dipped in corn syrup that

has been slightly diluted with water, touch the brush to the peak areas of the bacon pieces. In some of the lower areas or valleys of the bacon, use a bulb applicator to apply a few tiny bubbles resembling foam that is normally created on bacon as it cooks. Make the bubbles for the foam with water and clear dish detergent.

Place a couple of larger bubbles made with the hero coffee mixture and clear dish detergent at the edge of coffee liquid in the cup. With either the syringe loaded with some clear corn syrup or an artist's brush, touch the eggs lightly in several places to give them a perkier look. If the eggs no longer look perky, chances are you may need to rebuild the eggs. The idea is to keep them looking fluffy and light. Clean any smudges on the plate with the glass cleaner, cotton swabs, or paper towels.

Supplies used to prepare this shot:

- Two Wilton Recipe Right Non-Stick medium cookie pans and 9-inch Comfort Grips angled spatula
- OXO Good Grips whisk and nylon flexible turner
- Cardinal International large prep bowl and small work bowl
- EMS style 24 bent-tip tweezers
- Bounty paper towels
- Windex glass cleaner

- Anchor Hocking small creamer and bowl
- Zak Designs bowl
- Arcoroc hero plate
- Several paper plates
- Heavy-duty aluminum foil
- Two bulb-type applicators, one for bacon foam and one for coffee bubbles
- Fork to split biscuit
- Brewed coffee

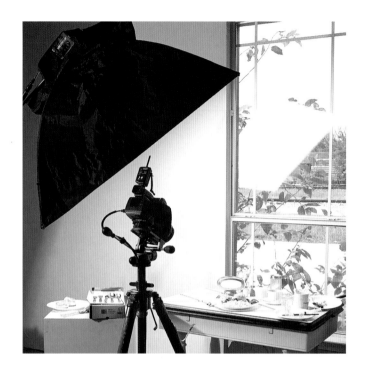

PHOTOGRAPHER'S COMMENT—Notes on the Breakfast Set

This environmental shot needed to feel like the real deal: a beautiful sunny morning. We put fake pink flowers outside in the bushes and I balanced the natural light with my strobes set on very low power. The H3D gave me the perfect ratio choices in camera settings. You must be sure not to overfill the set and keep detail within the shot.

A SOUTH-OF-THE-BORDER VERSION OF SUNNY-SIDE-UP

It's not hard to make eggs sunny-side-up for photography. For some reason, lots of people are intimidated by making them for the camera. I'm guessing it is because they have been frustrated by efforts to make them at home. Since sunny-side-up eggs can be used in numerous photographic presentations and for meals other than breakfast, it's a good trick to have up your sleeve. And, if you follow the techniques discussed next, these beauties will hold for an hour or more.

Making Eggs Sunny-Side-Up

Having the right tools for this job is an absolute necessity. You will need a flat, non-stick griddle. Make certain there are no scratches or blemishes in the finish. You will also need a turner or spatula with a beveled, straight front edge, also without blemishes or imperfections. But, most importantly, you'll need to follow these techniques to be successful.

Use extra large fresh eggs. In this application, it helps to have the eggs chilled and straight from the refrigerator because the cold temperature helps maintain a tighter radius when the egg is poured onto the griddle. Preheat a large griddle to 250°F. Even though you're using a non-stick surface griddle, brush a light coating of vegetable oil

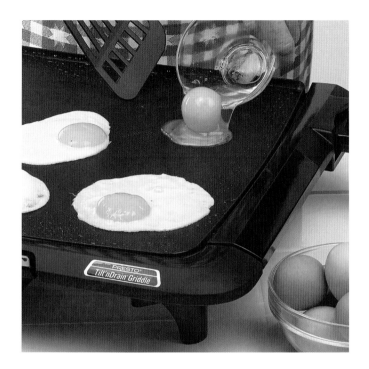

side of the yolk for a few seconds until it starts to firm up on the bottom. I recommend cooking only one or two eggs at a time because you will need to watch them closely to determine when they are ready. As soon as the entire white of the egg becomes opaque, the egg needs to be removed from the griddle. Use the preoiled spatula to lift each egg onto one of the oiled plates. Gently sprinkle about 2 tablespoons of additional vegetable oil on top of the eggs. To further protect the cooked eggs, invert a paper plate over each plate holding the heroes and set aside.

Building the Hero Huevos Rancheros Plate

I began the build of the hero plate with a nest of refried beans. The beans were removed from a can and placed into a large bowl. With a large spoon I removed a spoonful of refried beans and plopped it onto the griddle. With the back of the spoon, I flattened the bean mound but was careful to let the edges form naturally as I applied pressure to the center of the mound. Pushing the bean mounds down with the back of a spoon forces some of the whole beans to the outer edges. These whole beans along the edges create visual interest. Enough bean mounds were placed on the griddle to create an outline of beans on the hero plate. Once the outline was formed, since the beans in the center of the plate would not be viewed by the camera, I filled in the center area with beans from the bowl.

on the griddle surface and on the spatula you'll be using to remove the eggs from the griddle. You will need to have one plate or paper plate for each egg you plan to cook. Pour 2 tablespoons of vegetable oil onto each plate and set them aside. Break one egg into a small bowl. Remove any discolorations or shell fragments. Gently pour the egg onto the griddle. If you want to position the yolk in the center of the white, you can gently nudge it into that position using the edge of the glass bowl if you work quickly, before the egg starts to cook. Hold the bowl against the

The tortillas were placed on top of the beans. With the flat of my hands, I gently pressed down on the tortillas to force the beans to be pushed outward slightly until they reached a good position to outline the edges of the tortillas on the plate.

The hero eggs were selected because of the pleasing shapes of the whites and by the equal size of the yolks. The plates holding the hero eggs were tipped to one side to drain excess oil. I then slid the eggs onto the nylon spatula and placed the eggs on the tortillas. The ranchero sauce was made with canned enchilada sauce combined with an orange-colored prepackaged salad dressing containing bits of cooked onions. The combination of the two mixtures gave some texture and a beautiful rich color. The salad dressing contained enough oil to give the sauce a nice sheen for the camera.

Our garnish is a salsa made with small squares of tomato flesh, red peppers, pablano peppers, rings of the white bulb portion of green onions, and scissor-snipped cilantro. Also as part of the garnish we added a wedge of lime and fresh sprig of cilantro. I tipped the lime up on one end so it would catch light. This is a good trick for any food item, like citrus, that permits light to bounce through it.

Supplies used to create this shot:

- Presto Tilt'N Drain Griddle
- Messermeister nylon egg flipper and kitchen scissors
- Arcoroc hero plate and work bowl
- Henckels Twin Four Star II 6-inch chef's knife
- Paper plates
- Vegetable oil
- Pastry brush
- Hand-painted surface by Brad G. Rogers

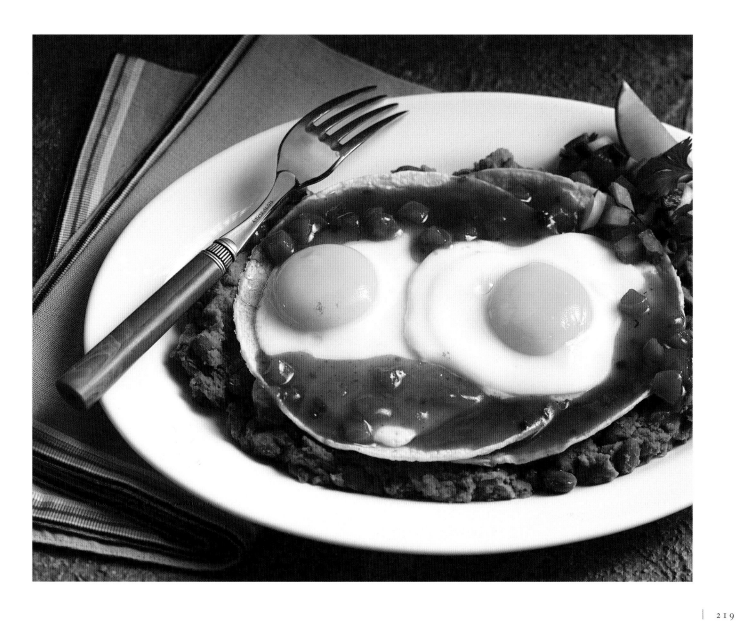

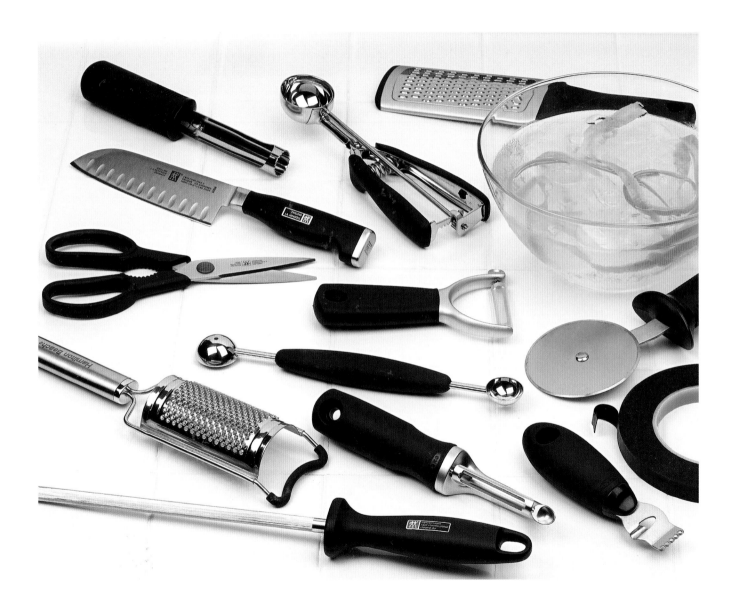

GARNISHING BASICS

GARNISHING GUIDELINES

Making beautiful garnishes begins with having the right tools for the job. A sharp knife, peeler, zester, etc., will make achieving a beautiful garnish a lot easier. The second crucial element is having fresh produce or herbs to create the garnish. As always when working with food for photography, it's vital to shop wisely. Shop for the very best example of each item you need and purchase several examples of each item for insurance. If you asked me to name a third element necessary for making beautiful garnishes for photography, it would be ice. Many garnishes are kept fresh, trained into shape, and freshened with a visit in or brushing with ice water.

Most garnishes need to be really, really fresh. Herbs, gourmet greens, and citrus are examples of this. When working with herbs and gourmet greens for garnishes, I usually give them a shower in the sink when they arrive at the studio whether they come from the grocery store or the garden. To wash herbs at the sink, hold them upside down, so the tender leaves will be protected from the force of the water. Gently shake the majority of water from them, snip the stem ends with scissors, and plunge the freshly snipped ends into a wide-mouthed glass waiting with a couple of inches of cool water in it. Invert a plastic bag over the herb and glass assembly and put it in the refrigerator until you are ready to add them to the hero plate just before the final capture. The garnish is typically the last thing to be added to the plate before final photography. Garnishes in the herb and gourmet green variety will hold in the refrigerator for the day while awaiting their short life of stardom on the set.

CITRUS GARNISHING IDEAS

Citrus garnishes won't hold all day; in fact, they need to be cut immediately before being placed on the hero plate on set. I often cut citrus fruit garnishes on a work table near the set after final adjustments are made to the other food on set. All fruit elements of the citrus shot in this chapter were cut and placed on the plate immediately before final photography. Both the fruit and plate were spritzed with cold water in this shot to convey freshness as well as to keep the fruit in hero condition. A variety of cuts for citrus fruits are depicted in this shot. Because most citrus fruits have seeds, good hero slices and wedges can occasionally be hard to find. When you plan to cut citrus fruits for photography, it's a good idea to over purchase those fruit items.

Lemon slices or "wheels" can be built into hero glasses with ice or acrylic ice for beverages, as I did for the iced tea shot in the beverages chapter (Chapter 3). Purchase three lemons for every slice you think you'll use. A good lemon slice for this application is an even, thin slice about 1/8 inch thick. Make sure you use a sharp knife with a

blade long enough to slice through the lemon without using a sawing motion. You will want to cut the hero slices closer to the end of the lemon where the fruit has some slope for some natural contour. Taking slices from this area will create a lemon wheel with a rim of rind color on one side. That is the side of the slice you'll want to expose to the camera.

Zesting the exterior of a fruit or vegetable before slicing will give another option for presentation of garnishes. Cucumbers, radishes, zucchini, and other soft-skinned squash varieties are interesting when zest is artfully removed. When the vegetable is sliced, the edges of each slice have a delicate scallop pattern created by the zester tool. After zesting and slicing any vegetables or fruit, immerse them immediately into an ice water bath until they are built into the hero plate or until they are cooked, if appropriate to your plans.

The zest of citrus fruits is also a garnish appropriate for several applications. For example, lemon zest was used as a garnish on the lemon cake in the dessert chapter (Chapter 10). For the lemon cake garnish, I used only short, curly pieces of lemon zest. These zest curls were made immediately before final capture. I placed them on the cake using tweezers. In general, zest is very sensitive and will not hold long without discoloring and wilting. However, it will hold for a short time in a bath of ice water.

An interesting use for zest is to combine it with other ingredients to create a garnish. Traditional combinations of herbs often include lemon or orange zest like the Italian gremolata depicted here. The combination of lemon zest, garlic, and flat leaf parsley chopped together is the garnish I chose to use on the pasta shot in this book (see Chapter 5).

Often, when a citrus fruit is cut into a wedge shape, the whitish membrane that runs through the center of the fruit can create an unwanted appearance on the narrow edge of the wedge. The best way I have found to deal with this situation is to cut away the membrane with fine-tipped sharp scissors. I use fisherman's fly-tying scissors. The same scissors can be used to snip away ends of wedges not appearing straight to the camera.

BE PICKY WITH HERB GARNISHES

When snipped herbs are used as a garnish or element in a dish, the best way to get hero quality shapes and

pieces is to cut the herbs with sharp scissors. Because small quantities of items are used for garnishing, and since they are usually a strong interest element in photography, you want to start with beautiful examples of the specific herbs you choose to use. Due to the tender nature of herbs, chopping with a knife can often bruise them. If camera focus is sharp where the herbs will be placed, the bruising will show. Scissors help to reduce the appearance of bruising. Again, the herbs should be snipped immediately before they go to set as a garnish. When I cut cilantro or parsley with scissors, I usually cut the interesting outer edges of each leaf. This gives a pleasing shape to the individual pieces and makes the garnish identifiable.

Once herbs are snipped, they are extremely tender. If you try to pick them up with your fingertips, they will crush together, sticking in a clump. They will also bruise. The best way I've found to distribute them onto the hero food is to slide a small spatula under them and to tap the spatula with my finger or another spatula to shake them off. If you hold the spatula directly over where you want to place them, the pieces will fall in a random pattern most pleasing for a sprinkled appearance. If any of the flakes or herb pieces land where you don't want them to reside for final photography, remove them with tweezers.

A DANDELION IS ON MY PLATE!

A pretty garnish appropriate for a number of dishes is a dandelion onion. This garnish resembles a white carnation and can help with color separation between items in a salad or on a plate. A green onion with a 1/2- to 3/4-inch-diameter bulb works best to make this garnish. Use a sharp paring knife to remove the root plus about 1/4 inch of the bulb. Make a cut perpendicular into the center of the cut edge where the root was removed, being careful not to cut through the top of the bulb, as shown.

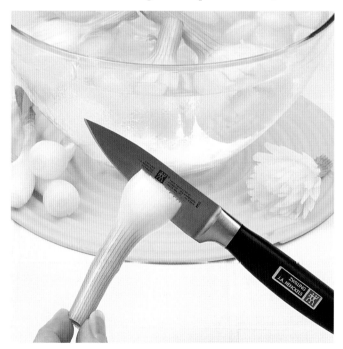

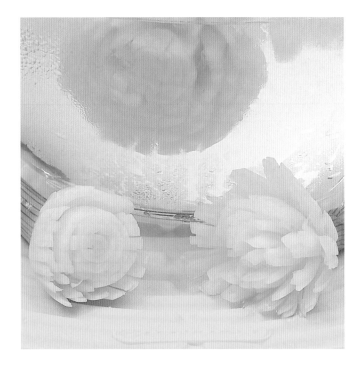

Make a series of parallel cuts about 1/8 inch apart on each side of the center cut. Turn the onion and make a cut into the middle of the same edge at a perpendicular angle. Repeat the cuts 1/8 inch apart across the cut surface of the onion, resulting in an even grid pattern.

Place the cut onion into a bowl of ice water, completely submerging the bulb of the onion. The image above shows an onion after being cut before the ice water bath, and another onion after being submerged in the ice water. As

you can see, after about 10 to 20 minutes, the onion will expand, creating a flower. Onions cut this way will hold in ice water during the day until needed on set. They can be used with the entire green top still intact or with the top removed to within 1 inch of the flower.

USE ICE WATER TO MAKE CURLS

One of my favorite garnishes can be used as an element in a salad or vegetable presentation. The loose curls created by this technique are beautiful and visually interesting. With a paring tool, slice the entire length of a carrot or zucchini to remove only one strip of the outer skin, exposing the interior of the vegetable. The next slice, removed with the paring tool, will be edged with the vegetable's natural covering. Roll this long slice into a tight roll and then choose one of two methods to hold this roll together. In the first method, a square of plastic wrap can be tightly bundled around the roll to hold it in the rolled position. The plastic-wrapped vegetable can then be plunged into ice water. Use ice to hold the bundle submerged in the ice water. For the second method, wrap black matte tape around the rolls to hold them in position. However, you must be careful not to get the tape wet while you are wrapping it around the roll because the tape will not stick to itself if wet. Wrap the tape around the rolled vegetable, beginning with the middle of a 4-inch length of tape. When the tape has

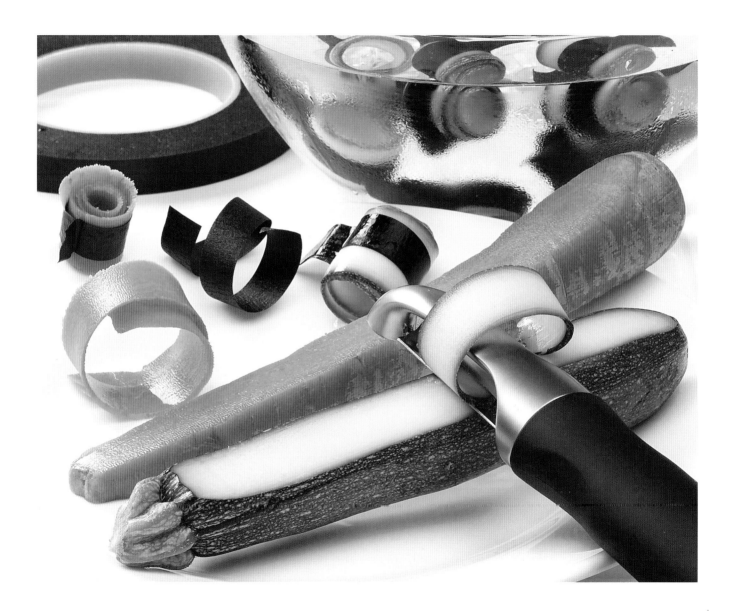

reached around the vegetable roll, the ends of the tape will stick together if still dry and will stay together in the ice water. Plunge the taped roll into an ice water bath for at least 15 minutes. These taped rolls will last most of the day until needed on set. You will need to keep ice present in the bowl. Note that carrots will bleed a little color into the water if left for over an hour. When you are ready to place the vegetables on set, carefully remove the tape and the vegetable roll will unwind slowly. They don't last long on set, so have alternate heroes waiting in the bowl of ice water with tape still in place.

TAME AND REVIVE STRAWBERRY AND TOMATO TOPS

This wonderful trick works on strawberry tops and on tomato tops. Cut a square of paper towel that is just the right size to cover the green top of the fruit. If the fruit has a stem, cut a slit from the outside edge of the paper towel square into the center to make room for the stem to extend out of the paper towel topper. Wet the paper towel. Holding the green top of the vegetable down in place with your fingers, lay the wet paper towel over the green top. It's sometimes necessary to use a piece of plastic wrap to wrap around tomatoes to hold the paper towel and greens in place. The plastic wrap also forces the top to lay flatter and in a preferred position on tomatoes. The fruit tops will both perk up and hold the shape you

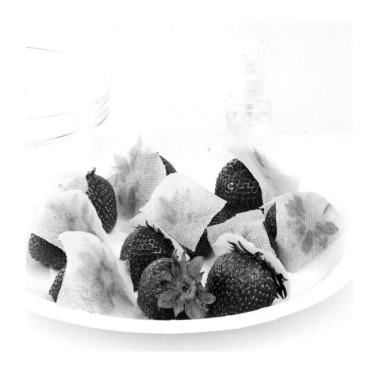

have given them after about 1 hour, so prep them with this technique early on shoot day. Keep the paper towel damp and they will hold a few hours while waiting to go to set. If the fruit is not wrapped with plastic wrap, it will be necessary to spritz the paper towel regularly with water to keep it moist until the fruit is needed on set.

SAUCE A PLATE

Applicator bottles have a variety of uses in food styling. They are perfect to apply sauces to food on set. The tips

of the bottles can be cut with sharp scissors so the nozzle end will accommodate thicker sauces and sauces having small chunks. Be sure to test the applicator bottle with the specific sauce you are applying so the size of the opening of the tip can be adjusted if necessary before you go to set. Keep in mind that if the opening is too small or too large, the application of sauce might not give you the desired results. Always test the sauce and applicator bottle before going to set. Note that it may be necessary to strain larger chunks out of

a sauce if they clog the tip of the applicator bottle. You will need to determine if another application method would be easier for your particular sauce. If the chunks are a desired element in the appearance of the sauce, and you want to use the applicator bottle method to apply the sauce, the chunks can be added to the sauce areas with tweezers after the sauce has been applied to the hero plate or food.

DON'T FORGET FRYING

Deep fried garnishes can be beautiful. They are also beneficial for contributing a higher profile to the silhouette of a shot or specific food item. The filet in the Chapter 7 is topped with deep-fried leek rings that were lightly breaded with a tempura batter. Tempura batter mix can be found in most markets and is easy to use. Tempura batter makes a light coating to vegetables and other foods for deep frying. One garnish that is beautiful and not used often is deep-fried parsley. It can be dipped into tempura batter or fried au natural. Just make sure the parsley is not wet before plunging it into hot oil to deep fry.

Once fried, place the items on a tray lined with a couple of layers of paper towels. Immediately take the tray outside or into a well-ventilated area and spray the fried items with two coats on all sides with Krylon Crystal Clear spray paint. This coating will keep most fried items

looking fresh for 1 to 2 hours. It might be necessary to respray the items before building on the hero plate. However, if the fried food items become limp, there is nothing you can do to revive them and you will need to fry additional garnishes.

Supplies used to complete garnishing techniques in this chapter:

- Henckels 3-inch paring knife, kitchen scissors, and sharpening steel

- Messermeister 6-inch Santoku knife

- OXO Comfort Grips utility cutting board, herb stripper scissors, lemon zester, Y peeler, swivel peeler

- EMS style 24, part #72880-DB 90% bent-tip Dumont tweezers and style 24, #72880-DS straight-tip tweezers

- Hamilton Beach grater

- STRETCH-TITE plastic food wrap

- Cardinal International glass prep bowls

- Arcoroc oval plates

- Wilton applicator bottle, 9-inch angled and tapered spatulas

- Le Creuset Cool Tool

- Fisherman's fly-tying scissors

After all of the hard work of designing a food shot, shopping for that perfect "strawberry" to shoot, styling the food items, and lighting the shot for the master-piece you hope to create, other aspects must still be considered to produce an image that will make viewers or clients want to taste or buy or, even better, pay you for your efforts. If you have not taken steps prior to shooting, during shooting, and then after shooting to handle the files correctly to match output for print or the Web, you and your client might not be satisfied with the final results.

The following is in no way inclusive of all of the steps one needs to take to ensure a successful result when shooting food and processing files. After all, there are entire books dedicated to these subjects. Rather this is a brief explanation of how the files for this book were handled, including the steps taken prior to shooting, and how the files were handled to prepare them for print.

The major aspect to strive for is COLOR! *Correct* color. Accurate color that can be reproduced from the product itself, to the camera, to your monitor, and to your printer

or printing press is the goal. No one wants to eat or pay for green eggs, gray meat, or blue bananas.

The first step is to make sure your monitor is calibrated. This will help ensure that your images are displayed cor-

rectly on your monitor with the correct brightness, color, and without unwanted color casts. You are looking for a neutralized gray. The hardware calibration system used for our monitors is the X-RITE Eye-One Display 2 professional monitor calibration system. I used the D65/6500 K setting for the white point with a gamma of 2.2. This is the minimum to produce accurate color prior to shooting food.

While on set, after the lighting is just the way you want on the subject, place a gray card or color-swatch chart such as the GretagMacbeth Mini ColorChecker in the center of the shot. Most camera software packages have ways to find a neutral gray; the usual way is with an eyedropper symbol somewhere on the gray area of the card that you click. One click and those blue bananas turn to the wonderful soft yellow that tell us that is the

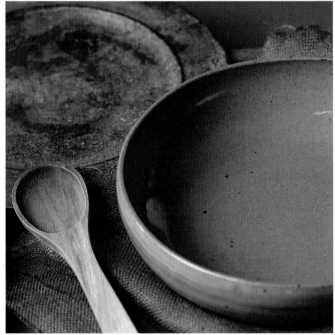

correct color for a banana. In our case the large bowl with the wooden spoon had a bluish cast to it.

Place the gray card in the shot, expose the shot, use the eyedropper symbol, click, and presto we have an accurate image of a greenish bowl with a golden spoon. The shot becomes warm and inviting instead of a cold hard shot with a bluish cast. It is that simple!

All of the images for this book were shot in a 16-bit RAW format. The 16-bit files were processed into 16-bit TIFFS and edited in Adobe Photoshop. All digital images should be evaluated for digital noise as the first step after processing. Each image was viewed separately and utilizing the Nik software, Dfine 2.0, the noise was reduced. The next step each image went through was "cleaning up the trash." This is the process of removing

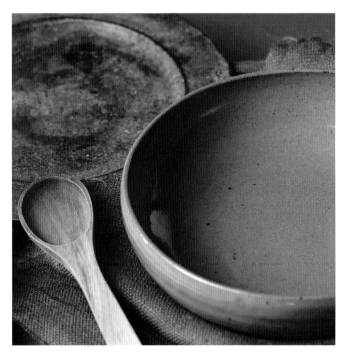

black and white specks such as dust particles on the sensor or lens that were captured on the image. The white and black points were found, the contrast adjusted and the files were ready for the final step, sharpening. Nik Sharpener Pro 2.0 was used to make the final sharpening.

The files were converted to 8-bit files, burned to DVDs, and sent off to the publisher. You just hope that the printer will take as good of care of your "babies" as you have throughout the planning, shooting, processing, and editing stages of the project.

Ambient light: Naturally occurring light or room light that affects the exposure in a photo.

Backdrop: An element in the distance of an image that provides boundaries for the depth of the photograph. A backdrop can be fabric hung or draped over a rigid rod, a large photographic representation of a scene that is placed behind a photographic surface, etc.

Background: A part of an image represented as being at maximum distance from the camera. The background can simply be surface area behind the focal point of the image or it can be a separate element, for instance a wall, landscape, or backdrop.

Backlight: Light coming from behind the object.

Barking: Term used to refer to the appearance of the parallel rows of crevices with craggy texture seen on scooped ice cream.

Basic lighting: Lighting established on a photography set by using stand-in or non-hero items. When the hero items are placed on set, the lighting is adjusted to accommodate the hero.

Blow out: An area of the set with intense lighting that makes details disappear.

Break the edge: When one element visually interrupts the line of another item; for instance, when food on a plate extends in height or breadth to interrupt the perimeter of a plate as seen by the camera.

Camera front: Area of a specific item facing camera and as seen by the camera.

Capture: Result of photographic endeavors in a digital medium.

Client: Person or group using the professional services of a photographer and/or stylist.

Down shot: See *overhead shot.*

Fabric content: Types of fibers used to construct or weave cloth.

Fall-off: The effect of light not directly hitting an object. For example, the focal point of an image is lit in a way

that the light does not hit the background behind the focal point, causing the background to darken increasingly behind the focal point.

Fill card: Usually a white or silver card of varying size positioned to reflect light from a light source onto a photography set.

Fill light: A light used to eliminate or soften shadows caused by the main source of illumination.

Fill line: The top of a liquid within a specific container.

Final capture: A saved photographic representation of the ultimate goal of a specific photography assignment in a digital medium.

Final image: A saved image representing the ultimate goal of a specific photography assignment in any photographic medium.

Focal point: The center of attention in a photographic presentation.

Food shoot: A photographic assignment or session involving food as a subject.

Food stylist: A designer and consultant who specializes in food presentations for commercial photography. (There are several kinds of stylists with expertise in specific fields

in commercial photography; however, because this book is about styling food, the term *food stylist* is used interchangeably with *stylist*.)

Go-bys: See *tear sheets*.

Hero: An ideal representation of a specific item.

Hero process: A systematic series of actions directed toward finding the ideal representation of a food element for photographic purposes.

Highlight: A small area of intense light to emphasize shape or form.

Image: The result from photographic endeavors in film, digital, or video media.

Knuckle: A specialized metal clamp with segments that tighten independently, enabling it to hold more than one object at a time.

Non-hero: A representation of a specific item used to stand in place of a hero item on a photographic set during the preliminary stages of photography.

Out of crop or off-camera: Occurring as part of the actual film but outside the range of view selected to show the spectator.

Overhead shot: A photographic image or project that places the camera directly, or almost directly, above

the subject matter of the image. Also called a "down shot."

Photo food: Food that is the subject of or an element in a photographic assignment.

Photo life: Length of time the quality of a specific item remains ideal for photography.

Pop: The process of making an element stand apart and distinct, so that it gets more visual attention than other elements within a photographic presentation.

Portfolio: Compilation of selected examples of work achieved by an individual that are used to promote the individual for business purposes.

Prep: Preliminary preparation of individual food components.

Production team: Any number of persons associated with or participating in the action of completing assigned photography.

Reflector: See *fill card.*

Selective focus: Focusing the camera lens to be crisp in detail on a certain area in a shot while letting the perimeter areas go soft.

Separation: Elements made to stand apart and distinct within a photographic presentation.

Set: The background, lighting, and camera involved in a photograph. The camera is placed in a predetermined position to focus on the set. Lighting equipment, reflectors, fill cards, etc., are arranged around the set to create the desired lighting effects. (The sets for the majority of the images in this book were created on surfaces much like sturdy tabletops. The tabletops are covered with selected fabrics, hand-painted flats, etc., to create the desired surface for photography. If the camera view extends beyond the surface, a wall, backdrop, or background is used to complete the depth of the set.)

Set tray: Portable tray that holds assembled tools and supplies used by a stylist when working on a photographic set.

Shoot: Photographic assignment or session.

Shot: One specific photographic assignment or representation.

Stand-in: Substitute for the hero during the preparation of lighting, camera, etc.

Style: To bring a food element or elements into conformity using specific techniques.

Surface: Area of a photographic set where items are placed in view of the camera. The surface is generally a

sturdy or rigid area of varying sizes depending on specific requirements for the photographic assignment.

Sweep: Fabric hung or draped over a rigid rod to create a depth boundary for a photographic set.

Tear sheets: Printed photographic representations collected for referencing specific elements, techniques, lighting, presentation, etc.

Tight shot: Photographic image in which the subject is shown in an extreme close-up.

Time frame: Period of time shopping, prestyling, and styling will take place before photography is completed.

Work bowl: A non-hero bowl used to perform tasks during the prep phase of photography.

Work plate: A non-hero plate made of either ceramic or plastic used to perform styling techniques during the prep phase of photography.

INDEX